The Exile's Return: Toward a Redefinition of Painting for the Post-Modern Era gathers together essays by noted critic Thomas McEvilley. McEvilley first presents a revisionist view of the mainstream of painterly meaning from about 1850 to 1960, then documents and analyzes in detail the fundamental changes that have taken place in painting from the 1960s to the present.

Sometime during the 1960s, the ideology of Modernism began to be perceived as a collapsing structure. In terms of the visual arts, this perception focused primarily on the tradition of easel painting, which was declared dead. Its "death," however, turned out to be only a temporary exile. After two decades, around 1980, painting revived or returned. Its return from exile, however, signaled new aims. Incorporating elements of conceptualism and performance, painting has assumed a new theoretical basis in post-Modern cultural theory.

Demonstrating the failure of artistic Modernism in social and cultural terms, McEvilley elucidates the new theoretical context in which easel painting is practiced today. He shows painting to be a more versatile and flexible medium than previously known, as well as a means of expression that can incorporate a variety of social and theoretical stances without compromising its focus on pictorial reality.

THE EXILE'S RETURN

CONTEMPORARY ARTISTS AND THEIR CRITICS

General Editor

DONALD KUSPIT
State University of New York, Stony Brook

Advisory Board

MATTHEW BAIGELL, Rutgers University
DIANE KELDER, The College of Staten Island and the Graduate
 Center, City University of New York
ANN GIBSON, State University of New York, Stony Brook
SUSAN DELAHANTE, Museum of Contemporary Art, Houston
UDO KULTURMAN, Washington University
CHARLES MILLER, *Artforum*

Other books in the series

Building-Art: Modern Architecture Under Cultural Construction, by
 Joseph Masheck
Psychoiconography: Looking at Art from the Inside Out, by Mary
 Matthews Gedo
Signs of Psyche in Modern and Postmodern Art, by Donald Kuspit

The Exile's Return

Toward a Redefinition of Painting
for the Post-Modern Era

THOMAS McEVILLEY

CAMBRIDGE
UNIVERSITY PRESS

Published by the Press Syndicate of the University of Cambridge
The Pitt Building, Trumpington Street, Cambridge CB2 1RP
40 West 20th Street, New York, NY 10011-4211, USA
10 Stamford Road, Oakleigh, Melbourne 3166, Australia

First published 1993
Reprinted 1995

Printed in the United States of America

Library of Congress Cataloging-in-Publication Data is available

A catalogue record for this book is available from the British Library

ISBN 0-521-41672-8 hardback

The pool paints Narcissus.
Philostratus, *Imagines*

CONTENTS

ILLUSTRATIONS

SOURCES OF PREVIOUSLY PUBLISHED ESSAYS

Most of the chapters in this book have been published elsewhere, as follows:

2 *La couleur seule: L'expérience du monochrome,* exh. cat. (Musée St.-Pierre, Ville de Lyon avec la collaboration des Musées de France et le Centre National des Arts Plastiques, 1988), pp. 15–33

3 *Artforum* 25, no. 7 (March 1987): 84–91

4 *Artforum* 25, no. 10 (Summer 1987): 94–99

5 *Artforum* 30, no. 10 (Summer 1992): 92–96

6 *Focus on the Image: Selections from the Rivendell Collection* (Art Museum Association of America, 1985), pp. 13–18. © 1985 ITA Corp.

7 *Julian Schnabel* (Museo d'Arte Contemporanea Prato, October 14, 1989–January 15, 1990), pp. 96–109

8 *Georg Baselitz: The Women of Dresden* (New York: The Pace Gallery, October 19–November 24, 1990), pp. 7–15

9 *Carlo Maria Mariani, Piacerde, Bello, Sublime: Ovvero si'alla ribellione dei tempi nuovo!* (New York: Hirschl Adler Modern, October 11–November 3, 1990)

11 *Parkett* 30 (1991): 32–40

12 *Mike Bidlo: "Not Léger,"* exh. cat. (Zurich Galerie Bruno Bischofburger, 1992)

13 *Leon Golub,* exh. cat. (Malmo Konsthall, 1992), pp. 7–63

14 *Julian Schnabel: Fox Farm Paintings* (New York: The Pace Gallery, December 1, 1989–January 6, 1990), pp. 5–11

INTRODUCTION

Painting's Exile and Return

S
INCE the Renaissance, painting has represented the soul of Western visuality. Despite occasional challenges by other media – now architecture, now photography, now cinema – painting has by and large remained our primary way of seeing the world, and of seeing ourselves, on a plane above the affairs of everyday life yet still involved in its passionality. But at the same time, painting has undergone a variety of ideological pervasions that have created strongly conflicting feelings about it in different eras. No conflict in its history, perhaps, has been as severe as that of the last generation: painting's disgrace and exile, around 1965, and its return, around 1980, with reformed manners – or disguises. These events were dramatic, and unfolded in scenes.

By the mid-twentieth century abstract painting had come to represent the visual identity of the West as a culture self-consciously involved in the project of civilization. Abstraction pointed specifically to the idea that this culture was near its culmination, its transubstantiation as it were. Then around 1960, without forewarning, the meaning of abstract painting seemed to change. We gazed at it in horror as on a Veronica's napkin where one's own face changes before one's eyes. What had recently seemed our assured identity suddenly seemed an unkind trick we had fallen for. Painting, our quintessential mode of visual expressiveness, seemed to have betrayed the principles of the culture it supposedly represented. The painted picture of the self was condemned to exile, as a representative of old ways gone corrupt. The "death" of painting was announced. There may have been some elementary foolishness involved – not unlike killing the messenger or blaming the weapon. And it is true that the charges were never entirely spelled out; still, the main ones

were well known: illusionism, death wish, superstition, pietism, fakery – basically the charges that are made against any religion. In terms of the discourse of the day, the real problem with painting was its history of deep complicity with Modernism.

Modernism – with a capital *M* – is not of course equivalent to "modern," which simply means recent and is not an *ism*. Modern*ism* does not necessarily involve recentness; it is an attitude compounded of two elements. The first is the idea of history as a narrative of progress – the idea that human events are following a hidden agenda and will necessarily go in a certain direction. This idea underlay the account of events given by Thucydides in the fourth century B.C. and, for the modern (meaning simply recent) world, was articulated most definitively by Hegel in his *Philosophy of History*. On the Hegelian view, history is the process by which a confused and forgetful Universal Spirit reestablishes its unitary self-awareness. This process unfolds as a linear array of linked causal sequences tending toward a conclusion. That conclusion will be the end of history, but not the end of the world, just the end of the need for further change, since Universal Spirit will have reached the eternally stable mode of self-comprehension which historical change was its means of approaching.

In the European Modernist era – roughly the eighteenth through the twentieth centuries – this myth of history, translated into concrete political terms, served as a justification for global expansionism. In Hegel's view, history, though it had an inner directive of progress, could not act it out without the help of specially dedicated humans – "world historical" individuals. In order to fulfill their historical role, these individuals had to understand history as Hegel understood it. So they were necessarily European – and later, after the Second World War, American. As world historical individuals, they saw their duty and they did it – and their duty consisted in the subjugation of most of the world's nonwhite peoples.

On this theory of history, cultures which seemed to lack the inner imperative of change – whose statesmen did not seek always to drive their societies onward into some new condition – cultures which emphasized stability and stasis, were regarded as ahistorical. China, India, Africa, indeed most of what today is called the Third World, were regarded as outside of history; they needed to be forcibly enlisted in the cause of progress (what Hegel called the "Work") by

Western world historical cultures, which were led by world historical individuals. This doctrine was the primary theoretical justification for nineteenth- and twentieth-century imperialism and colonialism.

The second essential Modernist idea also had classical origins (this time in the work of Plato) and also reached its fullest articulation for modern times in a work of German metaphysics – in this case Kant's *Critique of Judgment*. This was the idea of the objectivity and universality of value, and hence of the value judgment when properly made – an essential doctrine, since only a transcultural value judgment could buttress the idea of progress. Colonialism was justified by the claim that Western cultures were more advanced along the arc of progress than others and hence had to accept the responsibility of leading the others, for their own good. But without universal values, the claim that one culture was farther along than another could not be justified. Thus, the belief in the transcultural objectivity of the value judgment meshed with the belief in history-as-progress to create the onrushing machine of Modernist expansionism. Western civilization was to lead the world, and it was to be its own arbiter of how well it was doing so.

In nineteenth-century Europe this ideology was expanded and ramified to include cultural as well as political events. In relation to the visual arts in particular, a solemn responsibility was assigned. As a play of pure form, art could embody in a stripped-down display like a clock-face the process of historical advance; this was the service that the ideology as a whole came to require of it. The movement of history toward its goal was felt to be mirrored, or embodied as in a test case, in the aesthetic advances of the arts. If the arts advance steadily, through clear and demonstrable step-by-step sequences of linked formal problems and solutions, they provide a visible guarantee that history as a whole is advancing toward its culmination. So artistic innovation at the level of pure form became an imperative of staggering significance. The artist, forging ahead along Hegelian lines, and warranted along Kantian lines by the critic's judgment, became a new type of world historical individual. To the devotees of the cult of art, Titian as much as Napoleon, Van Gogh as much as Bismarck, represented the cutting edge of history.

This two-limbed ideology permeated the making of art in the West in the Modernist era. As one of its epiphenomena, it laid heavy psychological burdens on the artist. If he (for this era pretty much excluded women from world historical

3

roles) rejected the ideology, he was left out of the critical discourse. If, however, he accepted it, then severe restrictions were placed on his oeuvre. Its making was bound to a historical rack which stretched it out in exquisite and excruciating precision, as the sequences of historical progression developed a crypto-religious aura of internal necessity. When Titian followed Michelangelo, or Friedrich Fragonard, or Stella Noland, these world historical moments were not regarded as arbitrary outcomes from an array of possibilities, but as inevitable by-products of the onrush of history toward its goal. Oil painting, as the world historical visual medium above all, rose to the top of the ocean of visuality, as poetry rose to the top of language. The poet scratching at night by his candle stub was legislating for all humankind. The artist tentatively feeling his way on the canvas was intuiting nothing less than the spiritual temper which would make possible the next step in the history of the world.

In time, painting came to be regarded not only as a glimpse into the abyss of the unknown, but as an actual opening into it. The correctness of the artist's intuition came to seem necessary to the world's advance. In a *post hoc ergo propter hoc* reasoning, the symptom of history's advance could be conceived as the force that was driving it on its way. Thus, art history was enshrined (at least in the minds of its practitioners and devotees) as the hidden Logos of history, and each element within it was fixed in its place in a sequence and attained meaning primarily through that placement.[1]

The breakdown of this ideology constituted the end of Modernism and was brought about by the fact that history did not seem to be responding well to the value projections placed on it. The daily news became a nagging problem. History as experienced in the twentieth century seemed to confute the idea of an inner imperative leading inevitably toward better things. To a mind aghast at the world wars, the Holocaust, the exploitation of the Third World by colonialism and imperialism, and the ecological failure of technology, it became increasingly awkward – even comical in a dark way – to live with the fiction that all was well with the world and that history was taking us where we wanted to go. The threatened destruction of the earth by nuclear and ecological endgames gave a horrifying new specificity to the idea of the end of history. That end, it came increasingly to seem, would not be a utopia but many Hiroshimas; the spiritual reunification would be a nightmare of disease and exhaustion. Modernism brought Western civilization to the

edge of the abyss and pushed it over to look right in. The napkin's image shifted as the stage howled with crawling. Post-Modernism was born from a horrified realization of the dark sub-text of the myth of history; it was the attitude of a mind reeling back from that gaze into the abyss. This happened in a series of irregular steps from the end of World War II until the end of the Vietnam War.

When Western culture lost its faith in history-as-progress, it had two ways to go. On the one hand, there was the revival of pre-Modern attitudes and ways of life, which occurred in the culture of the flower child, the ecology movement, the revival of myths of matriarchy, and so on. Pre-Modernist revival became one of the post-Modernist array of options. The other way was the turn toward post-Modernism proper – the attempt to relativize the cultural absolutes and to flatten the cultural hierarchies that had sustained Modernism while still, paradoxically, retaining some sense of going forward rather than backward.

When the idea of historical advance collapsed, the idea of the universally valid value judgment went with it. A period ensued when it no longer seemed self-evidently true that Western culture was a superior mode of existing in the world in comparison with all others. The linear mainstream view of history was replaced by a tangle of many histories tending in many directions; the idea of the value judgment became layered and complex, involving the counterview, the counterview to the counterview, and so on.

In the realm of visuality, parallel reconceptualizings occurred. The formalist view of art as a series of historically necessary developmental sequences was more than discredited; insofar as it had functioned as a kind of cover story for the claim of the superiority of Western culture and the centrality of its history within the whole, that view of art came to seem not merely misguided but positively harmful and, in puritanical abreaction, a kind of force of evil. Painting seemed, as it were, caught red-handed. This phase, at full power from about 1965 to about 1980, was characterized by Conceptual art's reductio ad absurdum of the idea of the beautiful, and a variety of related phenomena, including a pre-Modern-flavored performance art. (In a later book, I will give a detailed account of these developments.) This period might be called anti-Modernism, as its agenda was simply the reversal of the Modernist program. It was not noticed at first that in its polar opposition anti-Modernism exhibited a puritanism much like that of Modernism – that it too im-

plied the existence of universals to legitimate its judgments or feelings.

This period of severe abreaction featured an ethical prohibition against painting, the Modernist medium par excellence. Painting, seen as ideologically polluted by its complicity in the sins of the hierarchical colonialist era, went in disgrace into a kind of exile. Its exclusive aestheticism in the Modernist era – understood as a conspiratorily or at least complicitly produced smoke screen to distract attention from social realities – was a leading cause of its disgrace. Its appeal to pure form was seen as an implied claim of the superiority of Western civilization. Abstract art came to seem the ultimate self-delusion of Euro-Modernism, no longer to be viewed with a reverent gaze but with a knowing smirk. Malevich's *Black Square* became the flag on the masthead of the slave ship, flapping sinisterly in the breeze of history.

The exile of painting held sway from the mid-1960s until the late 1970s. But even while this consummation was stunned by its own intensity, the countermovement built. It became increasingly clear that post-Modernism could not adequately define itself through puristic and exclusionistic strategies which involved, however hiddenly, the invocation of absolutes or universals. Modernism's hierarchies had been reversed, but they were still hierarchies. Another kind of cultural impasse seemed to be approaching in which culture would symbolically destroy itself through its auto-critique. In the visual realm this was apparent through the absence of new forms. The 1970s went so far in the affirmation of pure cognition, in the triumphant negation of the discredited objecthood of art, that the decade became almost invisible in the art museums of the world. It is like a gap or lacuna in the serial tradition of painting.

A genuinely post-Modernist cultural atmosphere, it came to seem as the 1980s dawned, would have to involve relativizations and compromises and would emerge as a set of impure and conflated positions which gave up no options. This was the atmosphere in which, marked by dramatic stages under high-contrast lighting, the "return of painting" occurred. Yes, it brought with it a whiff of the McCarthy era, but it also, paradoxically, brought a breath of air. For the exile itself could not be disregarded; it became a major part of painting's meaning for a new generation of artists.

Like Orestes, the hero who peeped around corners in his return from exile, painting was wily and cautious. To salvage what it could of the wreckage of Modernism, it incor-

porated elements of Conceptualism as of a redeeming ichor. As if to demonstrate its awareness of its past sins, it returned from exile with a self-critical manner. As if to redress its former arrogance, it returned with self-mockery. As if to offset its former elitism and puritanism, it returned in a costume of rags collected from everywhere. It returned as Conceptual painting and found a variety of new uses for the medium.

Some new forms of the genre transposed to the painterly format the Conceptualist project of inverting Modernist ideas of progress, originality, and historical inevitability. Others combined a more or less straightforward Modernist aesthetic feeling with post-Modernist relativizations and overlaid both with Conceptualist elements of cognition. Language increasingly invaded the canvas. The formal increasingly appreciated the cognitive. The absolute made a point of adapting to history.

By the mid-1980s the distinctions that had obtained ten years before, in the age when painting seemed regressive and Conceptual art the new form of progress, had grown blurred. By the late 1980s, a new conception of the painting-as-artwork had arisen, no longer puristically aesthetic but charged with counterforces and reversals – even featuring them in an aesthetic of discord. Dialectic seemed to have reached a polar moment of the swing from the One to the Many. Difference held sway and one awaited, from within it, the new form that Sameness might take.

The essays collected in this book grew out of that series of events. Written between 1977 and 1991, they record the reasons for painting's exile, the end of its exile, and the decade of redefinition of its means and purposes which followed. Though written at different moments of the flow, taken together they constitute a kind of history. The cultural moment that we see in them is the end of Modernism and the beginning of post-Modernism as that complex event was embodied in visuality through the medium of painting.

To an extent the impulse to dissect such a moment still involves a Hegelian-like sense of the importance of history. Here a familiar (and ancient) dialectical impasse arises – whether one can deconstruct thought without deconstructing the deconstruction of thought. In the heat of the engagement such questions fade. Taking the edifice of history down, tearing it apart and throwing its timbers about, becomes a new kind of creative act, a new expression of optimism and constructive idealism – or a new disguise for them.

"Seeking the Primal through Paint: The Monochrome Icon," the next essay in this volume, traces the climax of the Hegelian model of art history, which culminated in the tradition of the abstract sublime – the ultimate expression of the exclusively aesthetic approach to the picture – and brings out the dark side of that movement and the death wish inherent in its love of beauty. "The Opposite of Emptiness" discusses some of the psychological repressions and hidden contradictions of the ideology of abstraction. "*Grey Geese Descending:* The Art of Agnes Martin" and "Absence Made Visible: Robert Ryman's 'Realist' Painting" regard the works of two late members of that tradition whose pictures are quintessential distillations of it. In "The Figure and What It Says" a variety of pictures of the 1980s demonstrate that when painting returned from exile it returned not as abstract but as figurative: it returned bearing as offerings the very signs that had been sacrally forbidden before. The figure, in effect, brought social concerns back into the practice of painting, as the incorporation of language brought cognitive ones. Language and the figure became the new numinosa, to be revered and incantatorily worshiped through a prayer of deconstruction and a psalm of blame.

The remaining essays analyze the ways in which various artists, some of them of sufficient age to have been formed by the Modernist agenda, have redefined the practice of painting for a post-Modern age. These include Julian Schnabel's partial reconstitution of Abstract Expressionist elements in a linguistic conflation, Georg Baselitz's upside-down affirmation of the painterly, Carlo Maria Mariani's humorous yet serious restructuring of history, Pat Steir's staged confrontation with it, Sigmar Polke's introduction of nature, as a wild card, into the equation, Mike Bidlo's quotational conundra, and Leon Golub's assertion of strong content. The volume concludes with the claim that a new model of the painting-as-artwork has emerged through the work of these artists and the post-Modern synthesis of their solutions.

SEEKING THE PRIMAL
THROUGH PAINT

The Monochrome Icon

THE monochrome painting is the most mysterious icon of Modern art. A rectangle of a single more or less unmodulated color is erected on the wall at eye level and gazed at by humans standing before it in a reverential silence. What is happening? The painting is not impressing the viewer through a display of skill. In it skill is negated. Draughtsmanship is negated. Compositional sense is negated. Color manipulation and relationship are negated. Subject matter, drama, narrative, painterly presence, touch are absent. The color may have been applied with a roller or spray gun; it may even be the natural color of the unpainted fabric. One might as well be looking at the wall the picture is mounted on. Yet here, in this ritual-pictorial moment, the deepest meanings of Western Modernist art are embedded – its highest spiritual aspirations, its dream of a utopian future, its madness, its folly.

In Western culture the theme of unity is occult; the everyday model of the world presents many separate things held together by relationships. The idea that an underlying but usually invisible unity may be a more fundamental reality than the surface world of separate things is found mostly in offbeat occult schools: Theosophy, Rosicrucianism, Cabala, and so on. Most of these traditions derive, at least in part, from the Neo-Platonic system, which was articulated most fully by Plotinus in the second century A.D. This philosophy focused on the Problem of the One and the Many – the contradiction between the appearance of cohesiveness in the universe and the equally convincing appearance of fragmentation. For Plotinus (as for many other philosophers both East and West) the universe seemed in essence one and undifferentiated, only in appearance many and governed by difference. His philosophy (and its descendants) was intended

9

to promote the intuition of Oneness behind the appearance of the Many.

Here and there in human history the One–Many theme has come to the forefront of the visual arts: in Egyptian funereal art, especially that of the New Kingdom; in Chinese landscape painting; in the Tantric art of India; and in the art of the sublime in the Modern period of Europe and America, especially that of the abstract sublime and, within the abstract sublime, quintessentially in the tradition of the monochrome. In European painting, the Problem of the One and the Many has resided primarily in the figure–ground relationship. The ground represents the one ground of being, or potentiality, which acts as support for the many different figures which rise from it, somehow, and dissolve into it, somehow, again. The monochrome painting, by portraying the ground alone, with no figure, asserts the primacy of the One. This assertion is characteristic of the tradition of the sublime.

A text from antiquity, *On the Sublime,* by a Roman literary critic known today as Pseudo-Longinus, began it. "Longinus" spoke of the sublime in terms of "dignity and elevation," "majesty and grandeur," and "vast cosmic distances." He said that it was "suggestive of terror," and discussed a sublime image in which, he said, "the whole universe is turned upside down and torn apart."[1] The sublime, in other words, is other than the ordered universe in which separate individuals live in societies together; it is vast, untamed, irrational, and overpowering. In the view of "Longinus," art and literature have the ability, when practiced at their highest pitch, to lock the sublime inside a finite object or text. This paradoxical event involves a negation of the boundaries of ordinary selfhood, a negation at once exalting and terrifying. One of the examples given by "Longinus" is a passage of Sappho (fr. 31) in which she describes an erotic frenzy coming over her like death. The sublime is the destroyer of form and thus essentially different from beauty, which is a quality of form. In terms of the Problem of the One and the Many, the sublime is the One, the beautiful is the Many.

Plotinus taught an interestingly similar view.[2] In the one passage where he discusses art, he held that the artist is able to portray things higher than the particulars of everyday experience and closer to the ultimate reality of the One. The genuine artwork, then, would contain a special metaphysical essence quite apart from the pleasure of aesthetic form, which

can reside in everyday things. While exhilarating, this can be dangerous, as "Longinus" implied in his imagery. The reality of the One, being infinite, cancels or voids all finite realities such as the appearance of a self or of a social realm of interaction among selves. A sublime art could function, in other words, as a channel leading from the everyday toward the beyond, toward the infinite which is the death of the self and the destruction of the finite universe of form.

In the early eighteenth century, the century in which Western aesthetic views were formulated for the Modern age, the sublime again entered the discourse on art, after a long period in which form and beauty had prevailed. In the milieu of the Cambridge Platonists, Anthony Ashley Cooper, the third earl of Shaftesbury, revived the ancient view, asserting that it was the destiny of art to unveil higher metaphysical reality – setting in motion a long tradition, in which the German philosopher F. W. J. Schelling would later say that a great painting pulls away the curtain from the realm of Platonic forms.[3] In the middle of that century, Edmund Burke, following hints in the text by "Longinus," refocused the debate on the sublime, which he described as vast, dark, solitary, awesome, and threatening. It is the reality that is posited on the annihilation of the self. Later in the same century Immanuel Kant wrote that the sublime is that which, by its immeasurable vastness and uncompromised otherness, dwarfs and threatens to extinguish the realm of the individual. This style of discourse is essentially religious, traditionally used to describe the ineffable godhead. The sublime, as defined in these terms, is equivalent to the *mysterium tremendum* – literally, "the mystery that makes you tremble."[4]

The belief that art's destiny was nothing less than to embody the *mysterium tremendum* became central to the Romantic view of things. The philosopher G. W. F. Hegel, following Plotinus, regarded art as an embodiment of the infinite – a contradiction in terms of the type that was central to Romantic discourse. Schelling similarly said that art was the resolution of an infinite contradiction in a finite object.[5] James McNeil Whistler, later in the same tradition of discourse, said that art was "limited to the infinite" – that is, limited to the unlimited.[6] Still later, Van Gogh would remark in a letter to his brother Theo, "I paint infinity."[7] The act of really seeing a sublime picture, then, would involve a special kind of seeing related to that of the mystics, as when P. D. Ouspensky described his experiences in the fourth dimension by saying, "I 'see' infinity."[8] Such locutions came

to dominate the Romantic discourse on art, the "infinite," the "absolute," and the "sublime" functioning loosely as synonyms.

The confrontation of an individual person with the sublime or the infinite was considered the climax of the Romantic heroic adventure, a glorious transfiguration of the self into something other than and greater than a self. But there is a dark side to this exaltation: from the standpoint of the world of the body, the sublime is dangerous. It can be seen as a suicidal concept – even worse, as an aggression against history, civilization, and the entire world of form. The desire to vacate one's selfhood involves abandoning the body and annihilating the world it lives in, as the infinite annihilates the finite. In Johann Wolfgang von Goethe's quintessentially Romantic novel, *The Sufferings of Young Werther,* the hero in effect falls in love with the sublime and under its spell kills himself ecstatically. Werther was the prototype of Romantic artists from Shelley to Pollock whose muse was the sublime (and whose end was often early death).

In the late eighteenth and the nineteenth centuries the sublime in the visual arts was conceived primarily as a landscape theme: the awesome vastness of nature towering over the simultaneously exalted and intimidated human observer, as in many paintings by François Boucher, Jean-Honoré Fragonard, northern Romantics such as Caspar David Friedrich, and others. In works such as Fragonard's *Fête at Saint-Cloud,* for example, though the ambience is of social pleasantry, the overhanging dark and shadowy irrationality of nature looms like a *memento mori* above the doll-like festivity. As the figure shrinks on the canvas, the vast surround of the universe is terrifyingly revealed. Behind such paintings lurks the Hegelian dread of culture dissolving into the vast irrationality or valuelessness of nature, of the dream of civilization's advance sinking into the swamp.

The fascination with the sublime progressively ate away at the figure and hypostatized the activated ground. In the twentieth century it devolved finally on the monochrome surface, the pure ground into which all figures have dissolved, as its central icon, representing the blank of the erased cultural world, or the blissful sleep of the soul which has returned to the One. The evolution of the sublime from a landscape theme into the pure one-colored surface was foreshadowed in Goethe's book *Farbenlehre (Theory of Colors)*, published in 1810. In this work, in addition to various optical studies, Goethe attempts to bring the realm of color

experiences into a unified Neo-Platonic view of the cosmos. The desire for unity leads him to the monochrome idea. Beholding an unbroken expanse of a single color, he says, awakens awareness of universality. As such it has a tonic effect on the mind and tends to harmonize the individual beholder with the basic unity of things. The one-color presence is a channel into the mystery of Oneness. He recommends living in a room which is all one color and looking at scenery and at paintings through a unicolored lens, and so forth – practices which have close parallels in Tantric Buddhism. The relationship between universality and the monochrome is illustrated in a similar poetic mood by Stéphane Mallarmé's remark that the perfect poem would be a blank sheet of paper, which, containing nothing (in actuality), would contain everything (in potentiality).

J. M. W. Turner read Goethe's *Theory of Colors* and made at least two paintings to illustrate points in it. In his old age, Turner's work underwent a shift which has been called the beginning of Modern art; it was in effect a shift away from the figure toward the ground. In the years 1840–45 his sea-

J. M. W. Turner, *Sun Setting over the Sea* (1840–45). The Tate Gallery. Courtesy of Art Resource.

scapes changed. The horizon line disappeared, and so did almost everything else. Boats dissolved into the sea, waves merged imperceptibly with light, all the elements mixed as in a huge cauldron and returned partway along the road back to primal chaos. The drifting cloud-like mix of sea and sky is a visual analogue of the state of potentiality, or "chaos," described at the beginning of Ovid's *Metamorphoses*. It is the state of being that prevailed prior to the separation of opposites from the One – prior to differentiation – the state which Anaximander called the Boundless or Infinite, the substrate which has no qualities yet from which the distinctions which make qualities mysteriously emerge. This is the state of the primal ocean before the first dawn in the Egyptian funereal iconography which underlies the first verses of *Genesis*. There is a subtle and interesting polychromy in these paintings, but it is a vestigial polychromy, a mere remnant of the separation that once existed on the artist's palette; it is as if the artist had begun to mix the colors back to neutral grey and had stopped just short of this, while streaks and smears of differentiated hues could still be seen. The surface of these paintings (e.g., *Sun Setting over the Sea, Sunrise with Sea Monster, Sunrise with a Boat Between Headlands*) has become a glimmering and shifting veil, totally ambiguous in terms of depth or flatness, often seeming while almost flat yet to reach back to infinity not just at a vanishing point but in all directions: every point has become a vanishing point!

Turner has dissolved the figures into the ground, the Many into the One, which is conceived as an oceanic womb. Through purifying loss of adventitious differentiating qualities, all things are restored to primal unity. In terms of cyclical views of time such as are found worldwide in pre-Modern cultures, this is the state at the end of the world, when particulars dissolve into the universal, often mythologically conceived as a sinking into a cosmic sea.

The monochrome tendency gained strength in the latter half of the nineteenth century, as the cult of the sublime intensified. Whistler, for example, exhibited it in three different styles: (1) the "color symphonies," works in which he emphasized one small area of the spectrum and played with the tension between figure and ground by making them either close-hued or identical in hue; the most familiar examples are the *Symphonies in White*, especially *Symphony in White No. 1, The White Girl* (1861–62), in which the girl's white dress plays metaphysical games with the white drap-

ery of the ground (foreshadowing Malevich's *White on White* paintings); (2) a group of paintings, mostly seascapes (such as *Nocturne in Blue and Gold, Valparaiso, 1866*), in which figures and ground are close-hued blues interpenetrating and surrounding one another; (3) a group of paintings such as *Harmony in Blue and Silver, Trouville* (1865), in which almost all the canvas is covered by a flat unmodulated field of a single color (foreshadowing the flat monochrome of the twentieth century), cut by a single flat band of contrasting hue (usually horizontal, but still foreshadowing Barnett Newman's "zip") and similar strategies to activate the ground by contrast.

The tendency to simplify, learned from the Japanese, combined with his own growing detestation for the conventional subject matter of paintings – whether Courbet's realism or Ingres's story-telling – led Whistler in the 1860s to the verge of the abstract painting with a strong tendency toward monochrome. The Valparaiso seascapes of 1866 are near-monochromes with tonal gradation. The famous *Nocturne in Black and Gold: The Falling Rocket* (1875) – the work which touched off the Ruskin–Whistler trial – and *Nocturne in Blue and Gold: Old Battersea Bridge* (1872–75) show the same formula: monochrome surface with tonal gradations spotted here and there with complementary colors which serve to "activate" the monochrome surface. Perhaps the most extreme examples are *Nocturne in Blue and Silver: Trouville* (1865) and *Nocturne in Blue and Green: Chelsea* (1871).

In these years Whistler's portraits also show the holistic monochrome surface activated by small contrasting areas (face, hands, collar). The titles reflect this: *Arrangement in Grey and Black, Arrangement in Black, Arrangement in Black and Brown,* and so on. The near-monochromaticism of these works was offensive to many of his contemporaries; one critic, describing the paintings at the Grosvenor Gallery show of May 1871 (the show which led to the suit against Ruskin), said the Whistlers were just "one step nearer to pictures than graduated tints on wallpaper." A more appreciative critic, Henry James, invoked the presence of the spirit, in commenting that Whistler's technique was "to breathe on the canvas."

In the 1880s and 1890s, Van Gogh and others were increasingly wooed from the figure to the ground. In a letter of 1888 Van Gogh commented on this: "Beyond the head, instead of painting the ordinary wall of the mean room, *I paint infinity*, a plain background of the richest, intensest

blue.'"[9] Mallarmé had also regarded blue as a special analogue of the sublime, and this identification recurs frequently in the monochrome tradition; blue of course is associated with both sea and sky, the most illimitable external objects which humans experience. After about 1887 the treatment of the ground as a symbol for infinity became more or less standard in Van Gogh's work. At the same time the figures became increasingly close-valued with the ground, protected only by their black outlines from melting into it, in canvases that are 80 or 90 percent monochromatic. Famous examples include *Wheatfield with Reaper* (1889), *Winter Landscape* (1889), *The Sheafbinder, after Millet* (1889), and *The Starry Night* (1889).

Perhaps it is no accident that these paintings all date from the three years before the artist's suicide, as Turner's hypostatization of the ground occurred only in the last five years of his life. In both cases, as the artist approached contact with the ground of being, as he prepared to yield up the limitations of his separate personality and return into the Boundless, his work reflected this in a shift of emphasis from figure to ground.

Something similar happened in the case of Claude Monet. In his work the monochrome tendency is first strongly apparent in the systemic studies of Rouen Cathedral, of haystacks, and of poplar trees, which, as one critic has said, "expressed a cosmic pantheism" and "are passive modulations of a wholly immaterial life."[10] But for Monet, as for Turner and Van Gogh, the monochrome tendency became overwhelmingly strong as the end of life approached. In the late water-garden paintings he was intuitively attuned to the philosophical and mythological implications of monochromaticism. An acquaintance who saw *Les Nymphéas* in the artist's studio expressed it well: "In that infinitude, water and sky have neither beginning nor end. We seem to be present at one of the first hours in the birth of the world."[11] These words could as well describe the late works of Turner – though the end of the world has flipped to the beginning. In Egyptian mythology, Hindu mythology, and many others, the ground of being is represented by a primal and terminal ocean. All the gods – that is, all potentialities and forces – are held to reside in a seed state in the primal sea from which they separate out at the beginning of the world, when a lotus blossom emerges on the surface of the ocean as the vaginal beginning of the parade of forms. Monet's lilies also mark the transition point at which phenomenal pluralism rises from the zero-point of beginninglessness.

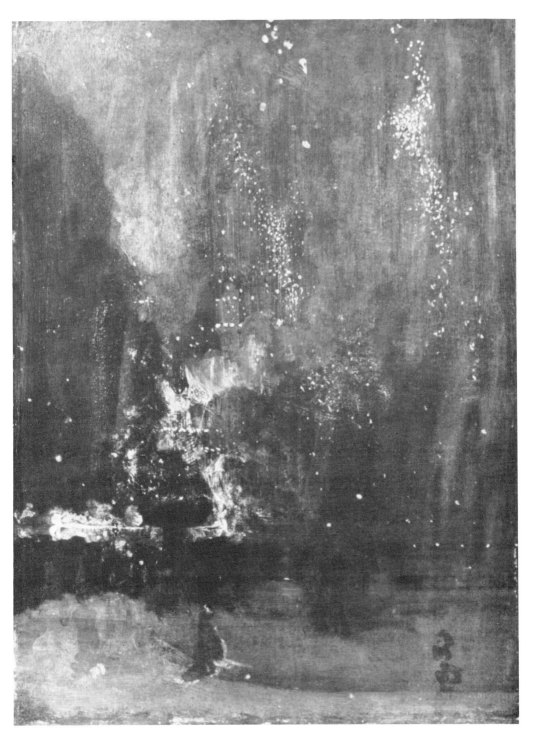

James A. M. Whistler, *Nocturne in Black and Gold: The Falling Rocket* (1875). Courtesy of the Detroit Institute of Arts.

17

The water-garden paintings, once so beautifully installed in the Orangerie, are a model of the cosmic ocean-womb; they surround the viewer, placing him or her at the center – the emergence or submergence point – of the womb of the sea, whose surface streams with myriad lilies through which the dynamic force of creation rises from the unfathomable abyss of potentiality. The viewer is re-embraced by a sense of the eternality of the original moment, happening now and always, as basis for the subsistence of all passing phenomena. As Monet said: "Il faut beaucoup travailler pour arriver à rendre ce que je cherche: l'instantanéité [It is hard to express what I am seeking: the instantaneous]."[12] He expressed the desire "to see the world through the eyes of a man born blind who has suddenly gained his sight: as a pattern of nameless color patches." This is equivalent to seeing as a newborn might see, or as the birth of the world might be seen, without conceptual categories yet overlaid on primary sense-data.

A late water-garden monochrome found in Monet's studio after his death is titled *Nirvana jaune*. In his old age he was influenced by Buddhism, where symbolism similar to his is found in abundance. Amida Buddha, for example, sits on a lotus on the water, nursing beings toward that realization as of "a man born blind who had suddenly gained his sight." The latest of the water-garden paintings (ironically after considerable loss of color vision in the artist's eyesight) are almost completely monochromatic veils of yellow or blue, reposing in peaceful unity while shimmering with creative dynamism. When the artist died, returning at last "through the lily pad" into the primal sea, his studio was filled with such paintings, obsessively repeated literally hundreds of times in various monochromatic hues.

At the beginning of the twentieth century the limited monochromaticism of the Impressionists and neo-Impressionists was still in force. Picasso's "blue paintings," for example, involve the aesthetic of close-valued figure and ground. Around 1910, in Cubism, Futurism, and Fauvism, this tendency joined hands with a growing attention to the two-dimensionality of the surface, as in Matisse's *Red Room* (1909) (with its Whistleresque sub-title, *Harmonie Rouge*), *The Red Studio* (1911), and *The Blue Window* (1911), in all of which the uni-colored ground asserts itself as a two-dimensionality directly conflicting with the implied three-dimensionality of the represented space. Early Cubist works like Picasso's *The Girl from Arles* (1912) simultaneously frac-

ture the commonsense "things" into semi-atomic planes and melt them into a more or less uniform ground color, edges melting into the flat surface as Turner's ships melted into the sea. *Green Still Life* (1914) represents Picasso's furthest advance toward monochromy, which was, of course, not to remain his most characteristic style. In the same years, Luigi Russolo (*Solidified Fog*, 1912) and other Italian Futurists were engaged in similar experiments in close-valued hues and tones. But it was in the works of the Russian artists Kasimir Malevich and Alexander Rodchenko that the two great threads of the twentieth-century monochrome – the metaphysical and the materialist – were defined.

Malevich's Suprematism was influenced by the early works of P. D. Ouspensky, *Tertium Organum* and *A New Model of the Universe*, which appeared when Malevich was about thirty and solidified his mystical "fourth-dimensional" approach to the canvas. Ouspensky, a mathematician, mystic, and syncretic thinker, attempted, in *Tertium Organum*, to synthesize

Henri Matisse, *The Red Studio* (1911). Courtesy of the Museum of Modern Art.

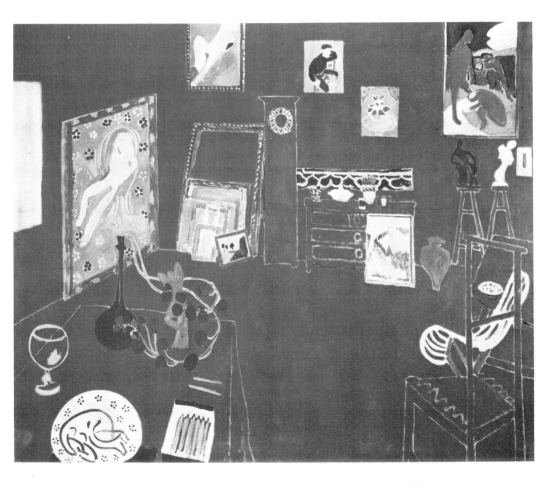

the legacy of Kant with the discoveries of modern physics (the four-dimensional space-time continuum), with liberal doses of Hindu mysticism, Plotinus, Böhme, Spinoza, and Burke thrown in. His work is extremely path-oriented and foresees the development of a race of "supermen" who will correspond, for our age and place, to the great yogis of the East, or the Inner Schools of the occultists. The essence of the Superman, as set forth in the *Tertium Organum,* is that he will have expanded his perceptual receptivity beyond the limits set by Kant; specifically, he will have gained the ability to perceive four-dimensionality whole, and thus all events in the three-dimensional world will be transparently, child-ishly, simple to him. Ouspensky's diagrams and descriptions of four-dimensionality lie behind many of the geometric abstractions of Malevich, and Malevich's "non-objectivity" is in part an attempt to penetrate, by way of art, into the four-dimensional awareness discussed by Ouspensky, who wrote of his intuitions of the fourth dimension: "Everything becomes alive! There is nothing dead or inanimate. I feel the beating of the pulse of life. *I 'see' Infinity* [italics added]. Then everything vanishes. . . ."[13]

With a possibly exaggerated regard for the "path" quali-ties of art, for its ability to effect (or to be the field for) personal transformation, Malevich at times speaks as if his *Suprematist Compositions* are the fulfillment of Ouspensky's preliminary "experiments," the palpable means to expand our receptivity toward Supermanhood. Of the *White on White* paintings, for example, he wrote: "I have broken the bound-ary of color and come out into white. . . . I have beaten the lining of the colored sky. . . . The free white sea, infinity, lies before you."[14] The white painting, like Van Gogh's blue ground, is a gateway into infinity, into a reality beyond all form. So sure was he that a new age of fourth-dimensional awareness was about to dawn that Malevich referred to these works as the ultimate paintings, the last two-dimensional artworks.

By discarding the concepts and forms of ordinary con-sciousness, Malevich wrote, "art reaches a desert where nothing can be perceived but feeling."[15] This "desert" is "pure" feeling, the substrate of consciousness, from which all the surface forms of personality, affectivity, and discur-sive thought have been erased; as the yogi attains the state of pure consciousness by *citta-vrtti nirodha* (Patanjali, *Yoga Su-tras,* 1), "the cessation of surface fluctuations in the mind," so the painter will attain to the visual analogue of pure

consciousness by erasing the surface fluctuations of line and color from the painting. The stripped canvas is an analogue of the opened mind. This desert beyond form, yet filled with pure consciousness, echoes the words of Meister Eckhart, who described his mystical experiences as taking place in a desert beyond form yet fuller than any form – a Nothing more existent than any Something. Path-oriented like the mystics, Malevich saw his art as a way to escape the relativity of the everyday world, which it annihilates by a kind of sympathetic magic in which the representation is taken to control the thing represented: represent the world as blank and it is voided:

The ascent to the heights of non-objective art [Malevich wrote] is arduous and painful . . . but it is nevertheless rewarding. The familiar recedes further and further into the background.
 The contours of the objective world fade more and more and so it goes, step by step, until finally the world becomes lost to sight.[16]

This turn away from the world of form can be seen in part as a kind of terrified and revulsed reaction against World War I, and the desert beyond form as an unintended description of a Europe lying in ruins. The sublime is an enthusiasm that seems connected with the aftermaths of great and devastating wars; it was prominent immediately after the Napoleonic Wars, World War I, and World War II. It may be, again, a sign of a disillusionment with the accomplishments of civilization that Malevich denounced artistic technique, conventionally perceived beauty, and all art bound to form, as futile and vulgar.

 Extremely reductivist works such as *Black Square* (1915) and *White on White* (1918) did not, of course, remain Malevich's most characteristic expressions. He became a pioneer of a more complexly aestheticized geometrical abstraction quite as much as of the empty or "deserted" painting. Yet his geometrical abstractions also often point in this direction: the *Suprematist Compositions* (1916) "expressing the feeling of fading away," as Malevich wrote of them, show black forms, geometrical like the Ideas of Plato, fading off into the white ground,[17] and the *Suprematist Composition Conveying a Feeling of Universal Space* (1916) and *Suprematist Composition Conveying a Feeling of a Mystic "Wave" from Outer Space* (1917) are almost completely white monochromes.[18]

 The monochrome tendency was expressed in a different mood by Malevich's contemporary Rodchenko, also of course in the post–World War I milieu. His *Black on Black* (1918),

Pure Red Color, Pure Blue Color, and *Pure Yellow Color* (all 1921) were less metaphysical than materialist in intention; they transformed the painting from an illusionistic field representing the deep space of infinity to a plainly stated material object with sculptural overtones. Rodchenko, like Malevich, called these the "last paintings," but with a different intention; he hoped to terminate with these works the tradition of idealist abstract art, the art of the sublime, and unmask the enormous lack of realism in Malevich's metaphysical pretensions at the same time. This approach to the meaning of the monochrome painting was one that would re-emerge only much later in the tradition. In fact, both the metaphysical and the materialist monochromes went on hold for a generation after these seminal articulations.

The reductionist tendency which rose to prominence in European art in the World War I era was short-lived; in the 1920s and still more the 1930s, when the Great Depression returned people's attention to concrete realities, painting tended away from emptiness and toward technique and formal complexity again. There is a lag of three decades before the full force of Malevich's and Rodchenko's legacies was felt.

Kasimir Malevich, *Black Square* (1915). The State Russian Museum of St. Petersburg.

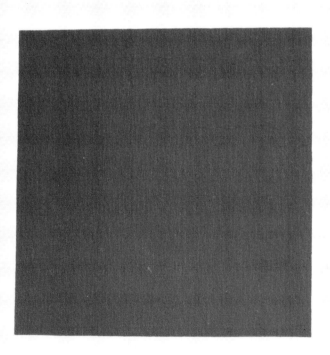

Kasimir Malevich, *White on
White* (1918). Courtesy of
the Museum of Modern
Art.

Still, there were some monochrome paintings in this period.
Joan Miró made a remarkable painting in 1925 (called *Paint-
ing*), almost entirely blue with a tiny dot in the upper-
left-hand corner. A certain turbulence in the brush work
around the center has led some to interpret the work as a
hidden landscape. Others have seen this painting and other
Miros of the period which, though not monochrome, yet
give overpowering emphasis to the ground, in mystical
terms.[19]

In the same year Miró painted *Birth of the World,* an em-
phatic brown ground with disconnectedly floating geomet-
rical "Ideas," suggesting the primal void and the first
emanation of the Ideal forms from it. The subject of creation
– and the linked subject of destruction or world-end – is
intimately connected to the monochrome, which depicts the
blank before or after the world and its history; its various
modes hover around this transition point between form and
non-form, some slightly on one side, some on the other.

Subsequent to 1925, Miró's work, in tune with the times,
veered away from the monochrome; his decades of bio-
morphic abstractions followed. But later in life he returned

23

to the subject of cosmic creation and the monochrome field. *The Birth of Day I* (1964) is a modulated field of blue-green with only the most incipient internal distinctions; it shows the fecund surface of potentiality in its first surging or breathing impulses toward birth. *Painting for a Temple I* (1962) is an orange near-monochrome with two small black dots floating in the upper left corner (more or less where the spot appeared in *Painting, 1925*).

In the 1930s various painters, influenced both by Malevich and Miró and by the vaguer "monochrome tendency" which, since their work, was "in the air," painted in near-monochrome styles. Ben Nicholson began making his *White Reliefs* in the late 1930s, and Tobey's *White Writing,* in the mood of Chinese "grass-style" calligraphy, first appeared in 1935, after the artist's stay in a Zen monastery in Japan. Both styles stem from the desire to bridge the separation between figure and ground – between Many and One, or particular and universal – yet without sacrificing the figure entirely, without plunging headlong into the desert or void of the empty canvas.

Joan Miró, *Painting for a Temple I* (1962). Galerie Maeght, Paris.

Many painters in this period stepped back from Malevich's "desert" and developed the implications of his more moderate geometrical abstractions. This generalization roughly covers the Polish followers of Malevich, the De Stijl painters, and some of the Bauhaus painters. Mondrian in the 1940s painted pure monochromes and hung them in various patterns in his studio – but did not exhibit them as completed pictures. His less monistic style, Pythagorean-Platonic (rather than Parmenidean) in its implications of a multiplicity of mathematical-geometrical underpinnings of reality, sometimes approaches monochrome white (e.g., *Composition avec jaune,* 1938). But always the black rectilinear divisions crisscross the field like Plato's geometrical abstractions attempting to enchain the divisionless Parmenidean One. Walter Dexel and Lázló Moholy-Nagy were also close to monochrome at times in the 1930s, though always shying away from complete emptiness. Bart van der Leek made compositions 90 percent monochrome but with minimal geometrical abstraction in this period,[20] as did Carl Buchheister,[21] Friedrich Vordernberge,[22] and, in France, Georges Vantongerloo,[23] and Jean Gorin.[24]

In terms of the Platonic metaphysics which not-so-distantly underlies much abstract art (virtually all geometrical abstraction), these paintings with minimal geometry on a near-monochrome ground are visual analogues of the phase right after the absolute has yielded up the first principles of being. In Plato's later works and in the extant reports of his lectures this moment is described: the formless and attributeless ground yields up first the basic principles of geometry and mathematics; then, from varying combinations of these, the world of "things" is produced, first the highest genera, then the lesser, till finally, at the bottom of the ontological hierarchy, the commonsense world of particulars appears. Malevich's geometrical abstractions on nearly empty grounds, like those of Mondrian and others, represent this early stage of ontological unfolding, closer to the absolute void than to the commonsense realm of particulars, yet hesitating to face it directly. This is an intermediate stage between realistic representational painting, which affirms the realm of particulars, and monochrome painting, which affirms the ultimate void. Malevich's call for an art beyond form and technique, an art of the void or the absolute, was taken up less by his immediate successors than by their successors. In the aftermath of World War II the desert beyond form once again became a leading theme of painting.

The exact beginning of this movement is hard to pinpoint. Yves Klein first exhibited monochromes publicly in London in 1950 (though not in an art gallery) – but says that he made his first one-color pictures three years earlier. Robert Rauschenberg exhibited his white monochromes for the first time in 1951 – the earliest exhibition of pure monochromes in an art gallery – but says that he made them two years earlier. Ad Reinhardt exhibited his red and blue monochromes for the first time in 1953 – but says that he started to make them in 1951. Clyfford Still's *Untitled, 1948/9*[25] is an almost pure brown-black monochrome with two tiny streaks of red and one of blue. Robert Motherwell's *The Homely Protestant* (1947–48) is an almost completely brown monochrome with half a dozen red streaks. Sam Francis's *White* and *White Green Earth* (both 1951) are near-white monochromes with lozenge-like modulations of the ground. Barnett Newman's *Galaxy* (1949) is a red-violet near-monochrome with two close-valued stripes: in 1951 he made an all-white painting, and the famous *Day One* (1951–52) is a nearly pure pink monochrome. Ellsworth Kelly's *Study for Twenty-five Panels: Two Yellows* (1952) is a square monochrome with internal division into twenty-five smaller square monochromes. From 1950 on the pace accelerated. By 1955 Jasper Johns had monochromed the American flag. By 1958 Joseph Albers' *Homages to the Square* were approaching monochrome, as were some of Mark Rothko's floating rectangle compositions. By the 1960s and 1970s the monochrome tendency had spread into all types of painting and become a pervasive element of the mainstream vocabulary.

It was Klein above all who gave conceptual definition and verbal formulation to the monochrome in the post–World War II period. Like Malevich he saw it as an aspect or a sign of a spiritual path and attempted to embody its principle – "the monochrome spirit," as he put it – in his life.[26] Like Malevich, Mondrian, and others,[27] Klein had been deeply influenced by an occult tradition of spirituality which preserved the Neo-Platonic obsession with the One. In Klein's case the One–Many theme appeared in a Rosicrucian formulation.[28] In this tradition (as in Neo-Platonism) essential unity and apparent plurality are mediated by an emanational theology: the universe emanates out of primal unity in seven stages. The last and "lowest" of these is the corporeal plane, on which human life is currently conducted. Here the boundaries of the Many are rigidified by material form and its conditions such as gravity and unilocality. This debased

age, in Klein's view, was about to give way to an age of immateriality and levitation in which humans would have special powers, like the Ouspenskyan Supermen whom Malevich anticipated in the supposedly imminent fourth-dimensional age. Klein wrote:

We will become aerial men, we will know the force of upward attraction, toward space, toward the void and the totality at one and the same time; when the forces of terrestrial attraction have been dominated in this way we will literally levitate to total physical and spiritual liberty.[29]

For Klein, as for Van Gogh, blue was the color of infinity, in Klein's case because of its connection with the sky, the site of the levitated humanity of the next age. He called his blue monochromes "portraits" of the sky – which he claimed to have signed, in an act of levitation, on its other side –

Yves Klein, *IKB Monochrome* (1961). Courtesy of the Menil Collection.

and in general addressed the empty sky as a pure spiritual condition. His 1957 show of eleven identical blue mono-chromes was called *L'Epoca blu,* and was Klein's formal announcement of the new age of art; blue had become for him (as for Goethe and as in much traditional iconography) the symbol for the absolute – the empty infinitely extended sky of his "aerial" kingdom.

> Through color [he wrote] I experience a feeling of complete iden-tification with space, I am truly free.
> If a color is no longer pure, the drama may take on disquieting overtones. . . .
> As soon as there are two colors in a painting, combat begins; the permanent spectacle of this battle of two colors may give the onlooker a subtle psychological and emotional pleasure, that is nonetheless morbid from a purely human, philosophical point of view.[30]

There are similar formulations in Buddhist literature, which holds that the healthy or enlightened mind is like pure space or, as some texts have it, like the open sky. This open and spacious mind, with no internal division based on opinion or ego-projection, is one with the Dharma, or Transcendent Truth. As soon as the first division appears in it, neurosis rules. As the Tibetan Buddhist Milarepa said:

> The mind is omnipresent like space . . .
>
> . . . the mind, like the sky, is pure . . .
>
> It was fine when I contemplated the sky!
> But I felt uneasy when I thought of clouds . . .
> Therefore rest right in the sphere of the sky!
>
> A wise man knows how to practice
> The space-like meditation.
> In all he does by day
> He attaches himself to nothing . . .[31]

Milarepa balances his sky and clouds imagery with a parallel imagery of sea and waves, which recalls the monistic impli-cations of Turner's late paintings:

> It was fine when I contemplated the sky!
> But I felt uneasy when I thought of clouds . . .
> It was fine when I contemplated the great ocean!
> But I felt uneasy when I thought of waves . . .[32]

Klein's worship of the sky (and specifically the far, empty sky, beyond atmospheric phenomena, what he called the "other side" of the sky – the sky as pure undivided space) is another imagery for worship of the one foundation rather

than the many transient forms which rest upon it. His monism or absolutism is thus more abstract and radical than that of Turner and Monet and the mother-oriented mythologies. It represents the absolute rather as above and beyond all forms than as below and underlying them. Thus, Klein's celebration of pure monochromatic color and his attempt to take its nature into himself – adopting the sobriquet "Yves the Monochrome" – express his desire to attain to a transcendent condition of non-differentiated consciousness (what Malevich called "pure feeling") to which all differentiation (all line or form) is mere accident – a principle more austere than that of the nourishing and mothering One of the sea-womb. The space-like mind has become like Mallarmé's blank page which, containing nothing, contains everything. As prime matter holds all things in a state of potentiality, so, Klein felt, the monochrome painting holds all things in a state of "pictorial sensitivity." When beholding the ground without figures – the blank monochromed canvas – one is looking at infinite and original omnipresent Sky-like mind. The empty canvas is free, absolute, transcendent; the filled canvas is imprisoned, relative, tortured by limitations.

From this ethical-psychological stance Klein posited a dichotomy between color, which represents the wholeness and universality of space and of space-like mind, and line, or drawing, which represents neurotic fragmentation into a realm of discordant particulars; color fills space, line divides it:

Color, in nature and man, is saturated with the cosmic sensitivity, a sensitivity without recesses. . . . For me, color is sensitivity materialized.

It is saturated with the all just as everything is that's indefinable, formless, limitless sensitivity. It is, indeed, the abstract space matter.

Line may be infinite . . . but it lacks the ability to fill the immeasurable all. . . .[33]

As unmodulated color = space = Sky = infinity = cosmic sensitivity = omnipresent mind = the absolute = the immeasurable all, so, in a negative and "disquieting" equation, line = obstruction = world = limitation = insensitivity = neurotic personality = the relative = the measurable finite particular. Thus Klein saw not only art history but life itself as a "battle between line and color," and proclaimed himself, in his artistic knight-errantry, the "Champion of Color" against line, of unity and openness against discord and division. By relating to pure color, as the alchemist related to his symbols of Prime Matter, one is to be restored to one's

original nature before the onset of dualistic fixation, mythically, to Eden: "By saturating myself with the eternal limitless sensitivity of space I return to Eden. . . ."

The "monochrome spirit," then, was an urge to seek Sky-like mind, which constitutes the return to Eden, and to relate directly to the absolute; if an artist's life was not based on this premise, then his paintings could not be "true" monochromes embodying the "monochrome spirit." Seeing artistic imperatives as deeply ethical, Klein said that Rauschenberg's white paintings, for example, looked like monochromes but did not have the monochrome spirit.[34] Monochrome painting meant art as a spiritual path of the most direct kind, far more direct than the old religious art of painting gods and angels: here one painted only the "blue deep" (as Gaston Bachelard called it) from which all gods and angels arose (or descended) or were temporarily and ambiguously constituted apparitionally as clouds which cannot disturb the distant blue emptiness of the sky. Alongside his mystical monochromes Klein heralded the empty sky and the purity and unity of space in a variety of altogether immaterial works – "zones of immaterial pictorial sensibility" – which portray space as the Prime Matter, or realm of potentiality from which transient forms arise and into which they dissolve again in time. In the Malevichian–Kleinian tradition the "immaterial" work is closely linked with the monochrome, which, as the "last" material artwork, makes way for it and heralds its advent.

Klein's charismatic influence spread the monochrome spirit widely in the next generation of European art. The attraction of this world-renouncing ideology can hardly be divorced from its historical position in the aftermath of a world war. In the war-torn nations of Europe, even some older artists, such as Lucio Fontana, felt the attraction of Eden and responded. Between 1957 and 1959 Fontana produced works in slashed paper, and from 1959 to 1969 the hundreds of slashed monochrome canvases (usually in white, but often pink, gold, green, grey, etc.) for which he is most famous. Their monochromaticism is as essential to these works as their semi-sculptural cutting – indeed, the cuts and slashes are in a sense simply reinforcements of the monochrome idea, reaching through the surface as an acting out of the idea of attaining pure space, higher dimensionality, immateriality, and so on.

Fontana was rooted in Futurism and, through Futurism, in Constructivism and Malevich; he was influenced by Klein

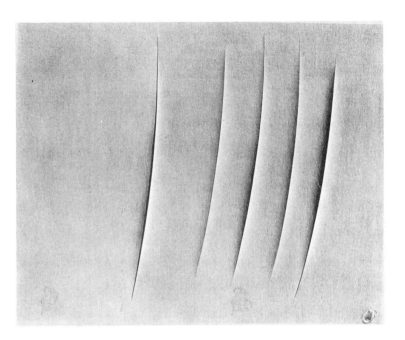

Lucio Fontana, *Expectation*
(1960). Ludwig Collection,
Cologne.

and influenced him in turn. He was part of an international Malevichian avant-garde of the 1950s and 1960s which rejected the values of the School of Paris, attempting to define Malevich's ideas of "higher space" through painting, environment, aerial art, and light art.

In 1927 Malevich had written, "The artist (the painter) is no longer bound to the canvas (the picture plane) and can transfer his compositions from canvas to space."[35] Fontana's art is an embodiment of this principle. In 1965 he wrote:

As a painter, while working on one of my perforated canvases, I do not want to make a painting: I want to open up space, create a new dimension for art, tie in with the cosmos as it endlessly expands beyond the confining plane of the picture.[36]

"Creat[ing] a new dimension" is an obvious Malevichian/ Ouspenskyan echo, and the aim of "[tying] in with the cosmos" suggests the path-oriented approach with its resonances of sympathetic magic, that is, the belief that changes in art represent changes in ontology: as art creates a new dimension so life will be elevated to new dimensions of power and awareness.

In another sense, the often violently slashed and gouged openings seem to represent a violent explosive breaking of the limits of the mind, opening it endlessly in all directions as it were (the fourth dimension, according to Ouspensky,

must be at right angles to all our known dimensions, and thus must open as it were in all directions).

Thus the fourth dimension is born [says Fontana], volume is now truly contained in space in all its directions.[37]

. . . the discovery of the cosmos is a new dimension, it is the infinite, so I make a hole in this canvas . . . and I have created an infinite dimension. . . . That is precisely the idea, it is a new dimension corresponding with the cosmos.[38]

The hole then is not intended as a destructive gesture, but as a channel or bridge between the relative and the absolute, between something and nothing (Fontana describes the holes as "a bridge thrown toward nothingness"), between the finite space of the canvas surface and the infinite space "beyond" the canvas.

Still, no less than Malevich's desert beyond form and Klein's empty sky, Fontana's invitations to infinity to assert itself implicitly involve the annihilation of the world of forms and individuals; they seem to reflect the horror of world-devastating war as well as the onset of nuclear endgame weaponry. It cannot be ignored that the emptiness these artists invoke is one with the end of the world. Ultimately the monochrome painting is a picture or emblem of the end of the world, or the moment after. In Hindu Tantric art the monochrome is especially sacred to Shiva, the god of the end of the world, whom Oppenheimer invoked at the first atomic explosion, which occurred shortly before Fontana's slashed surfaces and other beginning-and-end-of-the-world art such as Pollock's *The Deep* and Newman's *Day Before One*. As Fontana wrote:

Once man has been able to convince himself that he is nothing, absolutely nothing, nothing but pure spirit, then he will no longer be blinded by material ambitions . . . then man becomes like God, he becomes pure spirit. There you have the end of the world and man's release from matter. . . .

Thus, art has the potential to actualize not only higher-dimensional awareness, but also the destruction of the world and of art itself. The madness of this (With this painting I destroy the universe) derives from the Hegelian view of history, with its predication of an end of history in a condition of complete spirituality – a view which is paralleled in the various occult traditions with their prophecies of imminent new ages metaphysically beyond the corporeal.

Klein's influence was especially strong in Italy and Germany, the European nations most devastated by the war. In

Germany the young artists who called themselves the "Zero
Group" (again with hidden implications of the end of the
world) felt Klein's influence intensely. From 1957 until after
Klein's death in 1962, Otto Piene, Heinz Mack, and others
of this group spoke of "liberation" through color, of the
"spiritual sensitivity of the surface," and so forth. In 1958
the group presented an exhibition of paintings showing the
monochrome tendency – "The Red Painting" – accompa-
nied by the first issue of their magazine, *Zero*. Piene says of
this period, "Yves Klein had perhaps been the real motor in
provoking a Zero movement. . . . His influence . . . came
from his personal genius and his universal attitude toward
purification."[39] Writing in 1964, Piene sees that the "individ-
ual tendency" of the Zero artists "had only a loose connec-
tion with his [Klein's] ambitions." But this was not so clear
at the beginning, when, in *Zero*, no. 1 (April 1957), the Zero
artists speak as Klein epigons, writing of "purifications of
color," "purifications by color," and so forth. At the time,
these artists were into monochrome styles with sculptural
variations of the surface by perforation and imprint, show-
ing the influences of both Klein and Fontana; but it was
already evident by the time of *Zero*, no. 2, "Vibrations"
(October 1958), that these artists by "individual tendency"
had more in common with the *Yellow Manifesto* of Vasarely
(1955) than the Blue Revolution of Klein; more in common
with the Spanish group Equipo 57 (founded in 1957 to study
the interaction of motion and vision) than with the School of
Nice. Already the influence of Klein was giving way to the
influence of Tinguely and Fontana and of the writings of
Moholy-Nagy, leading toward a science-and-technology-
worshipping three-dimensional non-sculptural art with ki-
netic elements.

The title *Zero* (long sought for, according to Piene) indi-
cated "a zone of silence and of pure possibilities for a new
beginning"[40] (again not unlike Mallarmé's blank page). In
the first issue this silencing for a new beginning was ex-
pressed through the theory of the monochrome. It resided in
"The purification of color . . . the peaceful conquest of the
soul by means of calm serene sensibilisation."[41] Behind the
echo of Klein is an older echo, of the semi-Tantric teaching
of Goethe in the *Farbenlehre*, that exposure to an unmodu-
lated color pacifies and universalizes the soul.

Mack, in his article in *Zero*, no. 1 ("The New Dynamic
Structure"), starts out by echoing Klein ("If I set one color
in contrast to another, I may possibly intensify the first, but

at the same time I am restricting its freedom . . ."[42] but soon shows a Vasarely-like bent for optical motion rather than Kleinian illimitable emptiness:

. . . it is possible to bring one color into play so that it becomes completely self-sufficient. We can achieve such intensity of color vibration through a continuum of deviations from an ideal monochrome, or through a continuum of graduated value of the same.[43]

For Klein the ideal had been to set color free from manipulation. Mack sees minor chromatic manipulation as a way to set color free rather than as a type of color-bondage. This revision amounts to a partial rejection of the monochrome idea as defined by Klein, which now is seen as too antivisual. Mack draws the monochrome spirit down from the heights of the noumenal and re-involves it in phenomena – but with a mystical vibratory relationship to them:

Purity of light . . . takes hold of all men with its continuous flow of rhythmic current between painting and observer; this current under certain formal conditions, becomes a forceful pulsebeat, total vibration. . . .

He concludes with another nod to Klein and, beyond Klein, Malevich (and the Tantric thinkers of India): "Color [is] a manifestation of spirit. . . ."

Mack and Piene set up their idea of "vibration" as a middle position between figure–ground "paralysis" and the more or less static monochrome. Mack dismisses "the tumult of polychromy" and Piene defends vibration as "the activity of the nuance, which outlaws contrast, shames tragedy, and dismisses drama."[44] This amounts to a claim that the "disquieting overtones" which "enter the drama," according to Klein, when any line or second color is added to the pure monochrome, do *not* arise in the "activity of the nuance" which makes for vibration; in this type of work we are, as it were, somewhere in between the figure and the ground, on a vibrational bridge between the One and the Many – avoiding the schizophrenia or alienation of the figure–ground painting while also avoiding the world-rejecting autism of the pure monochrome.

B. Aubertin, a French artist connected with the Zero Group, published in *Dynamo* (1960) an interesting statement on the monochrome in which he attempts to establish it as a school in the art historical sense in which Cubism was a "school," and one of comparable importance. His statement shows the climaxing force of monochromism around 1960 and its intense appeal to painters who had been struggling to push and

pull and otherwise manipulate their colors; the mono-
chrome's rejection of technique, which had been emphasized
by both Malevich and Klein, offered a sense of liberation
from academic constraints which is comparable to that felt
by French painters when Impressionism liberated them from
Neo-classicism:

Color [Aubertin wrote] has two values – an absolute value (pure
tone) and a relative value (obtained by physically mixing the pig-
ments with one another and by optical mixing – placing pure
colors side by side).

 As soon as several colors meet on a canvas, they lose their
absolute value (pure tone) and acquire a relative one. . . . Mono-
chrome painting preserves absolute value for each color.

 The aim of color is totally realized in monochrome painting.
The fascinating fullness of color is tangible only in monochrome
painting. Here, deprived of its intermediary function, color finally
exists. Radiating through space, it imposes its magic. . . . Thus
color adds an ontological expression to its physical property.

Color's "ontological" aspect means that it is not only a
quality, but an embodiment of the substrate of pure being,
and that it can exercise the force of pure being, beneath or
beyond all qualities. This is a restatement of the idea ex-
pressed by Malevich, Klein, and others: the monochrome,
as a "gateway to infinity," draws one into it and out of
oneself simultaneously; it exerts a purifying attraction toward
unity and away from the separated-ego point of view which
is represented by line, drawing, and the figure. The absolute
space of pure consciousness prior to all images is projected
onto the unbroken monochrome surface, and that surface
then, charged, as it were, with the energy of this projection,
is able to open a channel into the absolute space beneath the
surface or image-mind of the viewer. This power, which
Malevich called "pure feeling" and Klein "immaterial picto-
rial sensibility," Aubertin calls "pictorial reality":

When pictorial reality is present in an invention, we are dealing
with a pure autonomous creation. . . . The monochrome painter
addresses himself to pure imagination. It is within the power of
imagination to provoke a feeling of ecstasy in the spectator. . . .
Complete control of it is demanded by the monochrome painter.

The painting, by awakening awareness of the absolute space
within the self, engulfs the viewer, as it were, from within;
functioning as the trigger of awareness of a greater Self, it
engulfs the smaller self of the viewer: "The painting no
longer merely presents itself to the spectator – it engulfs
him." Finally the monochrome absorbs into its grandly sim-

ple "solution" of art history both the old illusionistic paint-
ing of depth and the action painting: the action of the painter
on the material (like the action of the priest or white magi-
cian while transforming profane substances to divine) leaves
the formless but all-important "pictorial reality" palpably on
the canvas, ready to exert its purifying magnetism upon the
viewer:

> The color material must . . . be worked with exceptional force in
> order to produce a radiance and an intensity that, while giving it
> quality, establish a pictorial presence.
> The painter's gestures, his technique, and the fact that he con-
> stantly reworks his canvases give his pictorial reality an uncon-
> trolled freedom. The free action of the knife, the brush, and the
> hand on the canvas . . . counts for the most in the expression of a
> unique quality whose nature is pictorial reality. . . .
> . . . the life of the painted surface is conditioned by the presence
> in it of the pictorial reality, introduced through a particular mate-
> rial and by means of a qualitative manual execution in which
> sensuality and sensibility rise to the surface.[45]

Aubertin's formless but palpably present and spiritually cru-
cial "pictorial reality," like Klein's "immaterial pictorial sen-
sitivity," goes back to Hellenistic-Roman alchemical ideas
and Aristotle's Prime Matter. It relates to the Vedantic con-
cept of *akasha,* the Buddhist term *shunyata,* and the Cabalistic
Zim-Zum, the creative space produced by the "contraction
of god." This type of idea occurs regularly with the
metaphysical monochrome. The materialist monochrome
involves another attitude, one which, first expressed by
Rodchenko, reappeared ambiguously in the career of Piero
Manzoni.

In 1957 Manzoni, then 24 years old, saw Klein's show of
identical blue monochromes in Milan. A few months later
he signed the *Manifesto Against Style,* which was also signed
by Klein and which marked a turning away from the School
of Paris with its emphasis on technique and beauty and was
a defining document of the Malevichian avant-garde as op-
posed to the Matissean. In the fall of that year Manzoni
produced his first gessoed canvas rectangles, calling them –
in a conceptual one-upping of Klein's "monochromes" –
"achromes." In the remaining four years of his life he pro-
duced achromes in a variety of materials and with a variety
of non-painterly techniques (such as stitching, rumpling, and
creasing) adding definition to the surfaces. In addition, re-
calling Klein's dichotomy between line and color, but re-
versing his championship of color, Manzoni began produc-

Piero Manzoni, *Achrome*
(1958–59). Private collec-
tion.

ing the long, sometimes kilometers long, rolled-up lines
which suggest the linear infinity of the world of form as a
balance to the quasi-theological dogma of formless spatial
infinity posited by the Kleinian monochromes.

In several brief writings Manzoni articulated the idea of
the monochrome without the traditional "path" orientation,
though often ambiguously echoing Klein's messianic-Edenic
discourse. The echoes of Klein's absorption of traditional
spiritual disciplines coexist ironically with an understated
espousal of a Marxist materialistic view. At moments Man-
zoni sounds religious or inspirational: "Why shouldn't this
surface be freed? Why not seek to discover the unlimited
meaning of total space, of pure and absolute light?" This
language balances ambiguously between history and spiritu-
ality. Seen within history it is more of the end-of-the-world
discourse characteristic of the post-war monochromists. Dis-
covering pure and absolute light is talk of heaven, and the
surface which might as well be cleared is not only the human
soul but also the face of ravaged Europe, the slate of history
which might be voided by the will against form. Elsewhere
Manzoni echoes with ironic ambiguity the anti-form art-
discourse of infinity: "Infinity is rigorously monochrome,
or, better still, it has no colour."[46] Manzoni's reductionism
is that of Marxist materialism, not that of spiritual absolut-
ism. His use of dinner rolls as sculptural elements in
achromes, his exhibition of his excrement in answer to Klein's

use of gold, his map-works, his exhibition of old shoes – in these and other details of his work there is an attempt to redirect attention to the material necessities of life in society without involving self-important displays of virtue and purity:

> Art for Manzoni is not in fact a means of resolving the problematic nature of the individual in flight from the everyday into an escape towards the universal, the immaterial, the magic of the primary. It is the declaration of an individuality that has been lived out in a real time and space, and with a concrete and unmanipulated body.[47]

The "monochrome adventure" (as Klein called it) is brought from the other side of the sky down to earth; the monochrome spirit is to be held identical with the physical surface, not a special, spiritual presence within it. Manzoni is transitional between the metaphysical monochromists, with whom he shares a passion for the "freedom" of "infinity," and the formalist monochromists of the 1970s and after, with whom he shares an insistence on the ordinary physicality of the plane.

These artists – Klein, Fontana, Manzoni, and the Zero Group – were, if not a "school," at least a "movement"; they shared not only the monochrome style, but a kind of monochrome vision: a world transformed into "higher space" by the conjoined art and science of the immaterial infinite. Science sent its cosmonauts into space; art will now make of each of us a cosmonaut into his or her own inner spaces, delving below the level of personality (drawing) and undergoing a transformation into a more whole and unified being (undifferentiated color), one whose inner space is unified with cosmic space in a living vibration. Whether or not they literally expected their art (or any art) to transform human consciousness on a wide scale and lead society into a purified utopia, they expressed themselves this way. For them, as for various Asian schools, painting was allied with the spiritual and occult traditions and disciplines; it was also, in a more Western mood, allied with what they regarded as the inner meaning of modern science: higher-dimensional unity and evolutionary path-orientation. For them painting and the other arts were to become parts of a new culture of unity, forming, with science and religion, a bridge to a new evolutionary age.

On the American scene in the post-war period the mystical view of the monochrome as the medium of a transforming voyage into deepest inner space was equally prevalent –

but in a more alienated mood, without the Europeans' messianic-utopian faith in art as an effective instrument for social change. In the 1940s those painters whom Harold Rosenberg was later to call "the theological sector of Abstract Expressionism" turned radically away from Cubist and Geometric formalism and toward a content-dominated art which attempted to express the permanent spiritual foundations of human life. In the early and middle 1940s this urge was expressed in the Jungian- and surrealist-influenced work of the "mythmakers." In the late 1940s, after the war, the mythic schema of archetypal forms floating on a ground of consciousness gave way to a direct seeking of the absolute beyond form, and thus to monochrome and near-monochrome styles.

The earliest datable American metaphysical monochromes (or near-monochromes) were made by Clyfford Still, who in 1948–49 (before Klein's private London exhibition of 1950) painted a group of almost-all-black canvases.[48] At the same time he opened his palette to other (mostly earth) colors, and established his mature or "classical" format of open holistic expanses of one color or close-valued hues and shades, with ragged flame-like edges and intrusions of contrasting colors at the lower corners, usually the lower right, which, rather than nullifying the overall monochromatic effect, heighten it by pointing it out. Seminal works of this type include *1948-F, 1951 Yellow* (an almost completely yellow near-monochrome), and *1951-N* (a near-monochrome in close shades of red). The holistic and expanding monism of these works is not contradicted by their perceptible areas, which, as one author has said, "are not separable forms against a background but function as zones of a holistic field."[49]

Literary influences which Still was aware of working out in his art included Pseudo-Longinus's *On the Sublime* and the works of Blake, especially *The Marriage of Heaven and Hell* with its attempt to re-unify a humanity fallen into dualistic inner divisions (Klein's "disquieting overtones"). The paintings have been appropriately described as "symbolic," provoking "sensations of exaltation and liberation," "universal," "transcendent," creating "visual metaphors for the sublime."[50] The artist himself referred to his work as "the genesis of a liberating absolute."[51] And indeed it was, for American artists, a genesis, a beginning of a daring exploration of the monochrome idea – the idea of an *absolute* painting, a painting which goes beyond sensual relativism (figure–ground relationship) toward an expression of the whole-cloth of

being – which for Still as for Klein was to be described primarily by the word "freedom." To Klein it was the internal divisions of the ground which seemed authoritarian limitations and insults to freedom; to Still, it was not the internal line so much as the framing rectangle that was a denial of holism and freedom:

> To be stopped by the frame's edge was intolerable; a Euclidean prison, it had to be annihilated, its authoritarian implications repudiated without dissolving one's individual integrity and idea in material and mannerism.[52]

He sought a surface with implications of infinite expansion beyond the frame. The rectangle is, after all, a shape, and all shape is a limitation of open space – in a sense an insult to it. Klein chose to deal with this problem conceptually, calling his blue monochromes "portraits," through a studio window, of the night sky; thus, the rectangle is not implicated in the surface itself, nor does it surround it. We are looking *through* the rectangle at a boundless space behind it. Still arrived at a different, more visual, solution. Snaky lines (as in *1943-A*) enter the rectangle from outside, uniting it with the whole continuum of being; intrusive color fields begin at the lower corners and lead not into the rectangle but out of it, into other areas implied but not seen.

When Still made his breakthrough, Barnett Newman was also on the verge of breaking out of the quasi-figurative "mythmaker" style and into the sublime of pure color. In the "Euclid" paintings of 1947–48 the continuous ground is broken by one or two vertical stripes (Newman would later call them "zips") which, like Still's glimpses of contrast in the corners, accentuate rather than contradict the basically monistic ground. The crucial work *Onement 1* (1948) shows the mature plan of a vertical stripe on an unbroken and unmodulated ground. *Galaxy* (1949) has two stripes, both simply near shades of the ground. In 1950 and after Newman moved closer to pure monochromy, making the zips close-valued to the ground or moving them to the edges of the canvas, leaving the monochrome expanse not broken but framed by them, and often producing such paintings in pairs: *The Voice* (1950) and *The Name II* (1950) are both white paintings with off-white zips; *Day Before One* (1951) and *Day One* (1951–52) are a complementary pair (orange and blue) with only the most minimal edge stripes; *Vir Heroicus Sublimis* (1951) and *Cathedra* (1951) are eighteen-foot canvases, red and blue respectively, incorporating hidden squares which

are in themselves lesser monochromes framed by the zips; *Eve* (1950) and *Queen of the Night* (1951) have only one side zip each; *Prometheus Bound* (1952) has a bottom stripe only; *Primordial Light* (1954), side stripes; *L'Errance* (1954), a single stripe which is set near the edge and does not qualify the monochrome statement significantly. From 1948 until his death in 1970 Newman made variations on these types, always hovering near the heart of monochromatic absolutism, as in the "stretched" red (as he called it) of *Who's Afraid of Red Yellow and Blue III* (1967), the half-dozen white near-monochromes in the *Stations of the Cross,* and the side-striped monochromes *Be II* (1961, 1964), *Noon Light* (1961), and others. The monochrome tendency in one particular gradation of intensity is the central theme of Newman's mature work.

Like Still, Newman felt the importance of the Pseudo-Longinian work *On the Sublime.* In 1948 he wrote of the conflict in art between the quest for beauty (which is an aspect of form) and the quest for sublimity (which is "beyond" form, even the destroyer of form).[53] He resolved the conflict for himself (and for a generation of painters after him) by a radical repudiation of form and beauty in favor of an art in which "form can be formless" – that is, a rejection of the figure–ground relationship in favor of the ground alone, asserting that the One, not the Many, is the proper goal of art as of mysticism. The historical reference of this idea in the immediate post-war period is clear enough:

Modern art, caught without a sublime content, [is] unable to move away from the Renaissance imagery of figures and objects except by distortions (Cubism, etc.) or by *denying it completely for an empty world.* [Italics added]

Newman's "empty world" echoes yet again Malevich's "desert beyond form," Eckhardt's emptiness fuller than any form, and so on. Newman wrote, "We are re-asserting . . . man's natural desire to express his relation to the Absolute."

The precise scenario which he selected to reveal "man's . . . relation to the absolute" was the moment of creation, or cosmogony – the mythological first moment, when absolute emptiness yields up the first suggestion of relative forms. His titles, which he described as "metaphors" of "the emotional content" of the paintings, hover persistently around this farthest reach of the human imagination: *The Beginning* (1946), *The Command* (1946), *Genetic Moment* (1947), *Abraham* (1949), *By Two's* (1949), *Covenant* (1949), *Galaxy* (1949),

Eve (1950), *Day One* (1951–52), *Day Before One* (1951), *Adam* (1951), *Primordial Light* (1954), *Shining Forth* (1961), and so on. Still other titles show an awareness that the Creation is a mythological analogue to the philosophical concept of the ground of being which at every moment is creating and sustaining the universe: *Moment* (1946), *Be I* (1949), *Here I* (1950), *Be II* (1961–64), *Not There – Here* (1962), *Now I* (1965), *Now II* (1967). Still other titles show that Newman's is an art that tries to become a yoga, a path to union or a symbol of a path to union: the *Onement* series (1948 and after), *The Promise* (1949), *The Way I* (1951), *The Way II* (1969), *The Gate* (1954), *The Stations of the Cross* (1958–66). Through the art of the sublime (the infinite, the absolute), Newman said, the artist performs "an act of defiance against man's fall and an assertion that he return to the Adam of the Garden of Eden."[54]

Newman's subject, in other words, was not, like Klein's, the absolute in itself, but, more like Malevich's, the absolute at the borderline of the relative, the transition point between absolute and relative, through which each flows into the other. His titles and statements indicate that for Newman this transition point was conceived in Cabalistic terms found in the Luriac creation myth, especially *Zim-Zum*. In the process of *Zim-Zum,* god contracts himself so as to leave room, as it were, for the universe to flow into – the universe which will be distinguishable from him, yet within him. The space produced by god's contraction is, as one scholar put it, "a primal space full of formless hylic forces."[55] It is the ground before figures have arisen on it. This concept is analogous to ideas such as Prime Matter, potentiality, plenum-void, Malevich's "desert filled with pure feeling," and Klein's Rosicrucian-based "immaterial zones of pictorial sensitivity." The zip paintings, and also Newman's synagogue design, are meant to embody the principle of *Zim-Zum* – of continual uninterrupted flow from and to god, the zip emerging from the ground only to plunge into it at once (or simultaneously), and so on. His interest in the First Moment was a mythic translation of his interest in the NOW – the first moment ever repeating itself in the ongoing mystery of Being.

After Klein, Ad Reinhardt is the artist whose work most uncompromisingly and persistently embodies the monochrome idea. The many-colored rectangles of his paintings of the 1940s settled finally, in 1953 and 1954, into red and blue monochromes, or near-monochromes with distinctions

Barnett Newman, *Stations of the Cross, First Station* (1958). Courtesy of the National Gallery of Art, Washington, D. C.

Ad Reinhardt, *Abstract Painting* (1960–61). Courtesy of the Museum of Modern Art.

of tonality; in 1955 the red and blue gave way to black, which was to remain, in different shades, the only pigment Reinhardt used till the end of his life. By 1960 the black monochromes had developed the distinctive inner geometry based on the traditional four-square mandala of the Orient. He, above all the painters whom we have considered, has become the symbol of ultimate reductionism. Echoing earlier remarks made by Malevich, Rodchenko, Mondrian, and Klein, he said, "I am simply making the last paintings which can ever be made."

Reinhardt too felt that he was working out in his art the impetus of certain literary sources; these included Buddhist texts and, especially, the classical painting manuals of the Chinese and Japanese, with their foundations in Ch'an or Zen Buddhism, which he often echoes in his own writings. His gradual chromatic reductionism itself is to some extent based on the records of this non-Western tradition. The Japanese painter Kubota, for example, "often declared he hoped to live until he might feel justified in discarding color and employing *sumi* (black) alone for any and all effects in painting."[56] In this tradition art was based on the idea of

shunyata, "emptiness," and its relation to the painterly treat-
ment of space.

In Buddhist thought, "emptiness" is the creative principle
which makes room for things to happen in – and at the same
time the extinguishing principle, the black hole through which
all would-be entities pass away. Often symbolized by space
or the clear sky, it is related to the Cabalistic *Zim-Zum,* to
Klein's "immaterial zones," to the alchemists' Prime Matter,
and so on. One author writes:

Space was not to them [Chinese painters of the T'ang and Sung
dynasties] a cubic volume that could be geometrically constructed,
it was something illimitable and incalculable which might be to
some extent suggested by the relation of forms and tonal values
but which always extended beyond every material indication and
carried a suggestion of the infinite. . . .
 . . . When fully developed as in the compositions of the Ch'an
painters, where the forms often are reduced to a minimum in
proportion to the surrounding emptiness, the enveloping space
becomes like an echo or a reflection of the Great Void, which is
the very essence of the painter's intuitive mind.[57]

In terms of Western art history in the twentieth century, the
idea of illimitable space as a symbol of the Great Void which
is the essence (non-essence) of self points directly and un-
equivocally toward the monochrome, the featureless or nearly
featureless painting which apotheosizes empty space.

"Complete realization is like unchanging space," says a
Tibetan Maha-ati text. A scholar comments on the Buddhist
doctrine involved, in language that could be a comment on
the monochrome painting:

What we see and immediately experience is nothing determinate
or definite which any adjective referring to a specific quality can
designate. It is an utter openness which nevertheless is emotionally
moving and aesthetically vivid, even more so than anything else.[58]

In the Buddhist literature the ideal of "vivid" emptiness is
described negatively, as is the One in the negative theology
of Plotinus. The *Astasahasrika Prajnaparamita* says, "Space
has not come nor gone, is not made or unmade, nor effected;
it has not stood up, does not last, nor endure; it is neither
produced nor stopped."[59]

Reinhardt's various writings on the monochrome style in
painting are rooted in this tradition of discourse; they express
his recognition of the parallel between the reductivism ex-
pressed around him by formalist critics and the metaphysical
reductivism of emptiness. When he writes in a certain vein

45

he seems to be expressing an extreme formalist, art-for-art's-sake, anti-contentualist view, while in fact he is imitating the style of the Ch'an and Zen books on painting:

Art is separated from everything else, is related to nothing, and so is one thing only, only itself.[60]

The one thing to say about art is its breathlessness, lifelessness, deathlessness, contentlessness, formlessness, spacelessness, and timelessness. This is always the end of art.[61]

This is art at the zero point, evolving out of illusionism to flatness and then through blue and red and gold flatness to white flatness and finally to black:

Only blankness [can be serious art, only] complete awareness. . . . Only the artist as artist . . . vacant and spiritual, empty and marvelous. . . .

Only in this way is there no grasping or clinging to anything. Only a standard form can be imageless, formless. There is no other way to get rid of all qualities and substances. Finally there is nothing in the purest art to pin down or point out. Nothing is attached to anything.

And so on: again the monochrome as an icon of the absolute, of the annihilation of form:

. . . no sketching, no drawing, no line or outline, no forms, no figure, no foreground and background, no volume or mass, no cylinder, sphere, cone, cube, etc., no push or pull, no shape or substance, no design, no colors, no white, no light, no chiaroscuro, no space, no space divisions within the painting, no time, no size or scale, no movement, no object, no subject, no matter, no symbols, no images, no signs. . . .

He concludes, "The fine artist should have a fine mind, free of all passions, ill will, and delusion."[62] Passion, ill will, and delusion are known in Buddhism as the three "roots of evil" and are a formula as readily recognizable to a Buddhist as, say, the Lord's prayer to a Christian. For the act of painting, Reinhardt gives the elimination of the three roots of evil in the personality priority over every other requirement. The pure painting can rise only from a purified mind – a mind without internal divisions, like the open sky. Painting which is not a reflection of this openness of mind is no painting at all. As the artist's inner world is cleared of the "disquieting overtones" of passion, ill will, and delusion, his work must inevitably veer toward the absolute monochrome, the "last painting," which Reinhardt called "the pure icon."

Mark Rothko's work evolved from a somewhat tentative social realism in the 1930s to the Mythmaker style of the

1940s and, in late 1949 and early 1950, stabilized in his mature pattern of fuzzy-edged rectangles floating ambiguously upon (or behind? or inside?) a more or less contrasting surround. The viewer's sense of which area was figure and which was ground was ambiguous and shifting. Throughout the 1950s these works emphasized earth colors – magnetic oranges, yellows, reds – and toward the end of the decade the monochrome tendency became more and more clear; along with a slow darkening of the palette, the floating rectangles became ever closer in hue and shade to the surround; this tendency culminated in the late 1960s in the vast "plum" monochromes of the Rothko Chapel (1971) and their companion near-monochrome black-on-brown triptychs. The Chapel group is Rothko's culminating work; it is also, arguably, the last great monument of Modernism and the abstract sublime. It is clearly in the monochrome tradition: seven of the canvases are pure monochromes with internal brush turbulence, especially around the centers, and seven are near-monochromes.

Mark Rothko, Rothko Chapel, interior view, northwest, north, and northeast wall paintings (1965–6). Courtesy of the Rothko Chapel; photograph by Hickey-Robertson.

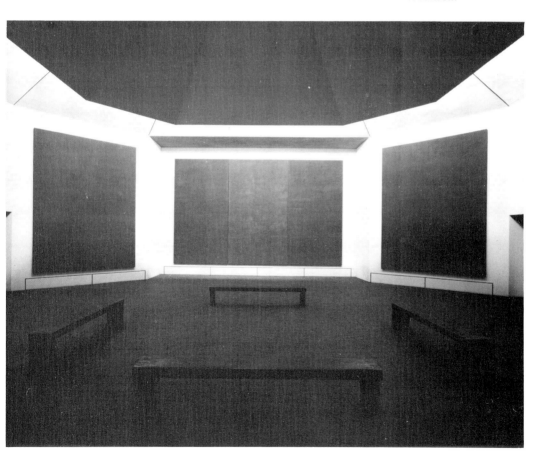

Rothko was a seeker in the vague and confrontational way of existentialism rather than along any path defined by previous passage: humanity unknowable in its lack of essence facing canvas unknowable in its plunge toward infinity. In his most revealing published statement,[63] about a year before arriving at his mature style and format, it is more his diction, his choice of words, than the sense of his statements, which reveals the inner meaning of art for him: within two pages the adjective "transcendental" occurs twice, the verb "transcend" once; there are phrases like "the transcendent realm," "the urgency for transcendent experience," "the artist's . . . ability to produce miracles," "Pictures must be miraculous," "the solitary figure," "solitude," "human incommunicability." From this foundation – an oppressive sense of silence and solitude, an undefined or unguided urge toward transcendence and freedom – arose his increasingly holistic paintings. The concerns of his art were with transcendence of the limited individual self, and with the infinite as goal of such transcendence. "I don't paint to express myself," he once said, "but to express my not-self."[64] Again, "I try to express both the finite and the infinite."[65] In describing the chapel paintings to a visitor to his studio in the late 1960s Rothko said that "he was trying to suggest – state rather – the infinity of death by a single monochromatic color."[66] The chapel group is a surrounding matrix like Monet's *Nymphéas* when they were in the Orangerie, but relating more to death than to birth, to reimmersion in the One rather than emergence from it. The somber statement about the melting away of the world of form surrounds the viewer, pointing to both his mortality and his afterlife. The death-dark monochrome is the symbol of the door beyond doors – the gateway to infinity. It is a launching pad or ascension point to the beyond – a chamber, uterine in shape and bloody in color, suggesting both death and an ambiguous rebirth after death, as by sympathetic magic.

One critic has written that Rothko was seeking "a universal principle," "an ultimate sign," "an absolute art"; "his purged paintings affirmed the purged ego. . . . Each work was an evidence of the mind's approximation to zero. . . ." His painting was "a ritual of self-purification."[67] And another: he aspired to "a pantheistic content"; "The passivity and impersonality of Rothko's brush and reductive design . . . suggest a desire on his part that the viewer vacate the active self."[68] A third: his art was "a quest presented . . . in terms of the void The logical result would be a blank

canvas . . . that would be full, an absence that would be rich."[69]

In the early 1940s Robert Motherwell's work showed the influence of Miró, Cubism, and geometrical abstraction; this development culminated in 1948, when the first of the *Elegies to the Spanish Republic* appeared. In the same year Motherwell painted a brown near-monochrome with half a dozen red streaks, *The Homely Protestant* (1947–48). These two works contained the seeds of his art for the next three decades. At first the direction indicated by the *Elegy* took hold, leading to the famous compositions of black splotches and splatters on lighter grounds (with a brief reversion to near-monochrome, in a format much like Still's, in *Iberia #2* and other works of 1958). A new format, near-monochrome with outlined "window" near the top center of the rectangle, sometimes with elements of contrasting color inside the "window," appeared with *Open No. 35* and *Open No. 38* (both 1968) (foreshadowed by *In Black and Pink with Number 4*, 1966). Subsequently Motherwell extended this format into a variety of color schemes in a decade of consistently near-monochrome works.

In 1948 and again in 1951, Motherwell published statements in the tradition of mystical abstraction. As in Malevich's formulation, the pursuit of pure feeling is held to lead away from the world of form toward an emptiness which is experienced as mystical:

One of the most striking aspects of abstract art's appearance is her nakedness, an art stripped bare. How many rejections on the part of her artists! Whole worlds – the world of objects, the world of power and propaganda, the world of anecdotes, the world of fetishes and ancestor worship. . . .

What new kind of mystique is this, one might ask. For make no mistake, abstract art is a form of mysticism.[70]

The mysticism of abstract art lies in its effectiveness as a path to union: ". . . one's art is one's effort to wed oneself to the universe, to unify oneself through union."[71] Art which, through stripping off the transient forms of selfhood, unites us with the cosmos is sublime art. The sublime is defined in terms often used to describe mystical experience: it is silent, it transcends the personal, it comes unannounced and unsolicited to those who are ready for it and cannot be induced by those who are not ready:

. . . painting becomes Sublime when the artist transcends his personal anguish, when he projects in the midst of a shrieking world

an expression of living and its end that is silent and ordered. . . . In the metaphysical sense, it cannot be a question of intent, one experiences the Sublime or not, according to one's fate and character.[72]

In 1950 Sam Francis arrived at his first version of the monochrome, an all-over monochromatic pattern of "lozenges" or "corpuscles" or "billows of smoke" with a lighter ground showing through here and there, especially at the edges, to activate and frame the amorphous but vibrant center (e.g., *Opposites,* 1950; *Black,* 1950; *White Painting,* 1950; *White Painting No. 4,* 1950–51; *Red and Pink,* 1951; *White Green Earth,* 1951; *Saint Honoré,* 1952; *Blue-Black,* 1952; *Big Red,* 1953; *Saturated Blue,* 1953). This style dominated his work from c. 1950–55, giving way to a more or less biomorphic style (with lots of white space showing), which lasted till around 1965. In 1960, however, this style began undergoing an evolution toward the monochrome – the second approach to the monochrome in the oeuvre. The figurative incident was pushed more and more toward the edges, leaving an increasingly dominant monochrome white space in the center, an empty space which asserted itself more and more as the subject of the paintings (e.g., *Untitled* [*Blue Balls*], 1960; *Blue Ball Composition,* 1960–61). By 1963 this assertive central white expanse was pushing painterly incident off the edges of the canvas (e.g., *Untitled,* 1963; *Open Composition,* 1964; *Iris,* 1965). By 1966 (e.g., *Mako,* several *Untitleds*) the format was an all-white monochrome with internal frame along the edges. By 1972, the process turned in the other direction again: the framing elements moved back toward the center, asserting themselves not as frame but as drawing on the ground (e.g., *Untitled No. 16,* 1972; *One Ocean, One Cup,* 1974) and in some cases filling it completely (e.g., *Polar Red,* 1975). In short, this artist's oeuvre shows a repeated turn toward the monochrome absolute, punctuated by renewed excursions into the realm of form until a need for renewal at the blank source becomes dominant again.

Francis's work has been influenced by his familiarity with Eastern thought (especially Zen), Jungianism, and various occult traditions, including alchemy. His two monochrome periods suggest a changing and deepening perception of, and relationship to, concepts such as voidness, energy, pure space, and the union of these three.

Whiteness comes to dominate his work as early as *The Whiteness of the Whale* (1957). (The title is a quotation from

the "whiteness chapter" of *Moby-Dick,* where Melville says that whiteness "shadows forth the heartless voids and immensities of the universe.") In the paintings of this period the painted forms explode in the whiteness, in a mood influenced by the Chinese "flung ink" style, like fragile organisms barely emerging from the void and still surrounded by it, momentarily to be engulfed by it again. Sir Herbert Read saw the effect as a bubbling evolutionary soup, "the color and turmoil of primordial substance," in other words, creation. The white void from which creative force emerges is experienced as a vast silence in which the color incidents are brief sounds. In the almost all-white paintings of the 1960s silence asserts itself as the center of all sound, more basic than sound, more all-embracing and ultimate. Whiteness, said Francis, is "ringing silence . . . an endless, ultimate point at the end of your life." White is the void, infinity; color is energy coagulating into finite streams and flashing across the face of the void to disappear at once into it again. "Silence and arrest," Francis has said, "equal ecstasy," and the question is where ecstasy resides, in the eye or in the mind.

The eye perceives many differences among the various styles of metaphysical monochromes mentioned here – the scabrous impasto of Still's paint surfaces in contrast to the thin wash of Rothko's; the expanding flatness of Newman's as opposed to the contracting gleam of Reinhardt's; the subtle activation of Klein's blue as against the matter-of-fact presence of Manzoni's achromes; and so on. But beneath these various surface differences the works share the role of milestones along the road of the Romantic quest, insignia of the inner travail of rejecting phenomenal multiplicity and attempting to gaze into the Grail of primal oneness, where Sir Thomas Malory's Galahad saw the individual break open into the infinite. Throughout the twentieth century the broad one-color field has functioned both as a symbol for the ground of being and as an invitation to be united with that ground. The monochrome painting may be the only important religious icon produced in the twentieth century: the expanse of a single color mounted at altar level and gazed at by the faithful in a silence as of worship or transcendent intimation.

The intensity of both cosmogonic and eschatological focus in the post–World War II metaphysical monochrome was the last gasp of the Romantic ideology of art as (in words used by Rothko) "an adventure into an unknown world, which can be explored only by those willing to take risks."[73]

Thereafter the monochrome would be practiced for different motives and with different attitudes. For painters who reached maturity after the monochrome style had already been established as one of the dominant modes of Modernist abstraction, the metaphysical and mystical utterances of their predecessors in the 1950s and early 1960s lacked novelty and danger. For them the monochrome was no longer an adventure into the unknown but an inherited situation, an art historical fact which had to be taken into account even if only for formalist reasons.

In the 1970s the monochrome spread, as an indubitable fact, like a snowfall, into all areas of the Fine Arts. Several new uses took over the form: the formalist use of it as an inherited design challenge to be met; the materialist use of it as a critique of the tradition of sublime or idealist art; the conceptualist use of it as a bridge between painting and concept. These three monochrome modes were related: the materialist monochrome merged with the formalist monochrome to the extent that both emphasized physical presence, and with the conceptualist monochrome in that both emphasized critical potential; the conceptualist and formalist monochromes, finally, merged in the austerity of their decisions. All three shared a sublime reductivism – understanding radical irony as one of the modes of the sublime. Their differences were primarily in styles of discourse.

Younger artists who practiced the formalist mode talked not about a color that opens into infinity, but about a color that holds the surface, declaring its flat physicality; not about ecstasy and the absolute, but about surface and edge. The cult of space had been replaced by the dogma of flatness. The idea of a monochrome surface expressing infinite three-dimensional extension behind the canvas came to be seen as a residuum of the illusionistic depth of representational painting. Although this attitude was already present at least as early as Jasper Johns's *White Flag* (1955), the real turning point was around 1960. The statements by the Zero Group artists mark the end of the alchemical phase of the monochrome, with its belief that the monochrome was at least a symbol for the absolute and at most a special container of it, and the beginning of a less idealistic, more factual or physical approach to the one-color field.

But there was a hidden problematics to this distinction that was not recognized at the time. The formalist ideology that dominated in the 1960s came from the same roots which produced the Romantic ideology of art. They shared certain

assumptions at an unacknowledged level. Both incorporated the Kantian view of art as disinterested and autonomous. Both involved a mystical reverence for color as opposed to the traditional valuation of drawing, and both derived satisfaction from reducing the number of their elements.

Formalist work such as color field painting was based, not necessarily articulately, on Kant's doctrines of disinterest and autonomy. The artists saw their work as self-sufficient or non-relational – simply itself. At the heart of this feeling was the conviction that their work did not relate to concepts and metaphysics. What they did not see is that this non-relationality is in itself a transcendentalist metaphysical idea, and the same one, beneath the surface, that the metaphysical monochrome was based on. It is the belief that artwork relates to the absolute that makes it appear non-relational in terms of the world of concepts and experiences. The claim to disinterest and autonomy is based, whether outspokenly or tacitly, on the assumption that art was concerned with the beyond rather than the here below. What had changed was more a style of discourse than an underlying belief system.

The case of Robert Rauschenberg illustrates the transition. In 1949 he made *White Painting with Numbers* and in the next two or three years exhibited a variety of all-white paintings: a white canvas four feet square, a set of four white squares arranged in a larger square, a set of three upright white rectangles, and a set of seven upright white rectangles. When

Robert Rauschenberg, *White Painting (Seven Panels)* (1951). Private collection. Courtesy of the artist.

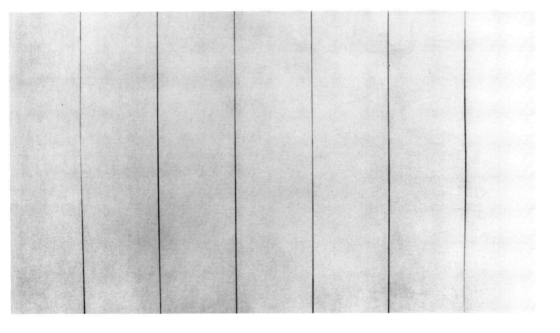

he exhibited white paintings in 1951, Rauschenberg provided them with an explanatory statement in the metaphysical tradition of the sacred fullness-emptiness:

They are large white (one white as one God) canvases organized and selected with the experience of time and presented with the innocence of a virgin. Dealing with the suspense and excitement and body of an organic silence, the restriction and freedom of absence, the plastic fullness of nothing, the point where a circle begins and ends.[74]

"The plastic fullness of nothing" is equivalent to Mallarmé's blank sheet which, containing nothing, contains everything, or the Cabala's "primal space filled with formless hylic forces." Rauschenberg speaks, in this statement, in the intoxication with the sublime that was so prevalent around 1950. In 1968 he described these pictures very differently. Instructing that they should be hung to catch viewers' shadows, he declared, "The white paintings were open compositions by responding to the activity within their reach."[75] No longer pointing to the beyond, the white paintings are reinterpreted as sites for a concrete interaction between art and everyday life. Rauschenberg, like Manzoni, was transitional between the metaphysical monochrome of the 1950s and the formalist, materialist, and conceptualist monochromes that followed.

In the 1960s and 1970s the influence of the metaphysical monochrome entered every other mode of art. In formalist and Minimalist painting it is found in Frank Stella's Black Paintings, in Jules Olitski's veils of color, Jo Baer's edge-striped white canvases, Brice Marden's impenetrably physical color surfaces, Robert Ryman's subtly differentiated white paintings, Robert Mangold's void expanses with minimal geometry and oddly shaped empty frames, Blinky Palermo's decorative arrays of bright monochromes, Imi Knoebel's systemic series of identical white pictures, and so on. In these years Rauschenberg's serial sequence of identical white monochromes hung together to make a larger horizontal rectangle became a recurring format, seen in Knoebel's work, in Gerhard Richter's sets of identical *Grey Paintings* (1975), and in the sets of identical grey paintings made by Alan Charlton since around 1967.

These artists, while repudiating much of the metaphysical equipment of the elaborate artists' statements of the 1950s and earlier, still unconsciously echoed them. Marden, for example, like many artists of his generation, continued in the 1970s to invoke nonspecific or undifferentiated feeling –

echoing Malevich and behind him Kant. "I believe," he has said of his own work, "these are highly emotional paintings not to be admired for any technical or intellectual reason but to be felt."[76] The essentially transcendental nature of supposedly undifferentiated feeling – which is what Malevich meant by "pure" feeling – is not overtly acknowledged. When the discourse of mysticism is hinted by artists born (say) after 1930 or 1935, it is the mute mysticism of the formalist. What Aubertin called "the life of the painted surface," with its "ontological" force, the surface seen as a palpitating membrane of creation, enters the toned-down discourse of the 1970s more mutely. Marden, for example again, has said, "As a painter I believe in the indisputability of The Plane." This is not exactly the mysticism of the metaphysician, who believes he perceives the infinite in The Plane, but neither is it clearly beyond it; it is the mysticism of the Minimalist or materialist, who hopes to relate to the object simply as object, but has not shaken off a residual mystical reverence for the cosmogonic surface – or its discourse.

The simplicity of the monochrome, its ability to be more or less fully described in words, pushed it into the realm of conceptual art, too. The British artist Bob Law declared in the early 1970s that his black monochromes were "the transition from pictures on the wall to conceptual art in the head."[77] In fact, the monochrome has from its beginning asserted a critique of previous types of painting – of their incorporation of drawing and their apotheosis of technique – and it was natural to engage the monochrome idea in Conceptualism's relentless critique of painting in the late 1960s and the 1970s. Both Klein's and Manzoni's oeuvres featured Conceptualist irony. Klein's exhibition of literally invisible "paintings" (the "zones of immaterial pictorial sensitivity") foreshadowed many Conceptual works that carried the inflated idea of the "last painting" ad absurdum.

In the 1960s and 1970s language invaded the visual arts. In 1967 Daniel Buren and others hung paintings in an inaccessible room in a Paris museum and distributed a leaflet verbally describing them in detail. The immaterial art which the metaphysical monochrome had been held to presage was proving, ironically, not to be the immateriality of a higher spiritual dimension but of critical conceptualism, not to involve levitation so much as parody. In 1969 Tom Marioni held an exhibition entitled "Invisible Painting and Sculpture" in Richmond, California. In 1967–68 Mel Ramsden exhibited a black monochrome with a text saying that the black

was not its color but its concealment. Robert Barry stood in front of would-be viewers and telepathically communicated his painting's appearance to them. John Baldessari's *Work with Only One Property* (1966–67), made to the artist's specifications by a sign painter, parodied the thin line between monochromy and Conceptualism.

In the 1970s and 1980s the monochrome idea extended into virtually every branch of the Fine Arts. It entered performance art in the blood and red paint surfaces of Hermann Nitsch; it graced the outdoor city in Maura Sheehan's monochrome treatments of parking lots, transitional spaces, and abandoned buildings; it nodded to space-light art in the scrimmed spaces of Robert Irwin and the indefinite light zones of Doug Wheeler; it penetrated sculpture in Allan McCollum's arrays of framed rectangles painted all over with one color.

From an adventure into the unknown the monochrome idea has become a staple of the contemporary art vocabulary. Its metaphysical seriousness is not entirely gone but is localized in terms of social reality. Monochromes of the Great Void can still be made, for example, in California, by an artist like Eric Orr. But in New York and Europe the "monochrome spirit" is overlaid with layer upon layer of ironic and critical distance. Its metaphysical seriousness peers out through these revisionist distorting lenses.

The absolutely simple field of color, with its appeal to "pure" feeling, has become an intricate iconographic manifold that can be entered from any direction and adapted to any purpose. As an element of sheer design it may live for another couple of decades – perhaps past the end of its century. But as a major conquest, like the discovery of a continent or a galaxy, in the adventure of art, it lies in the past, exhausted and wrung dry of meaning. It is the banner on the grave of the mad ambition of Modernist abstraction.

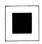

THE OPPOSITE OF EMPTINESS

Lately, a number of major exhibitions have investigated the roots of abstraction. Each has tended to emphasize a particular relationship, exploring the bridge between abstraction and some other subject. The eruption of primitive styles in European art around the turn of the century has been offered as one key to the historical continuity between preabstract and abstract Western art. The utopian promise of the industrial revolution, and especially of machinery, has been proposed as another, and the influence of revolutionary political doctrine as yet another. Though all these exhibitions, each with its scholar or cabal of scholars, its stunning documentation, and its visual argument, tend to magnify their own threads, together they make it obvious that the roots and meanings of abstraction are far more varied and complex, and far more involved in changing circumstance, than any explanation of abstraction based on the idea of the search for pure form could allow.

Recently, a show called "The Spiritual in Art: Abstract Painting, 1890–1985" set out to demonstrate that much significant Western abstract painting developed not as a strict consequence of art-historical evolution, but with influences from various occult and hermetic traditions. The spiritual traditions that curator Maurice Tuchman and his collaborators consider are those of alchemy, Rosicrucianism, theosophy and its variants, the tarot, Tantrism, the Cabala, ideas of the fourth dimension, Egyptian or pseudo-Egyptian mysteries, esoteric Christianity (especially the work of Jakob Böhme), and more. They are mostly not parts of established religions but heretical offshoots of them. Tantrism, which regards itself as the true essence of Hinduism, is illegal in India in certain of the practices recommended in its classical texts. Cabalism, which regards itself as the secret tradition

57

of Judaism, has been frowned upon in many Jewish contexts. Böhme was forbidden to publish by Lutheran authorities. Of the Western traditions here, most go back to the ancient school known as Neoplatonism. They tend to emphasize the concept of the underlying oneness of all things, and hence to blur traditional distinctions between good and evil, pure and impure, and so on. This is why these esoteric traditions, as they are called, are inimical to the mainstream religious traditions, which usually rely on such distinctions to set off themselves and their congregations against the rest of the world.

To relate abstraction to the esoteric traditions is significantly to open up the inherited doctrines about it. The most influential nineteenth- and twentieth-century formulations of the premises of art history were made under the sway of the Hegelian idea of history as an evolutionary process in which nature would gradually and inevitably be converted into pure spirit. There is a distinct parallel between this idea and the occult or esoteric idea that at the end of a long evolutionary process the Many will return to the One. The general attitude toward the two bodies of texts, however, has been very different. While Hegelianism emphasizes the evolution of the national state, the spiritual traditions are generally regarded as softer, more tender- than tough-minded, and more concerned with the inner development of the individual personality than with stark political realities. Though the two traditions, in other words, share a certain structure of thought, they seem to imply different stances toward life. Perhaps the central difference is the question of cyclicity. In the classical Modernist tradition shaped by Hegel and his successors, abstraction stands for the advance of history, and history conceals within itself the onetime structure of Christian millennialism. The spiritual traditions, in contrast, often teach an infinite cyclicity of emanation and return, which seems a less urgent and authoritarian framework.

Recent studies of the history of occultism in the nineteenth and twentieth centuries, however, have pointed to its implication in state excesses quite as much as Hegelianism's.[1] Occult ideas about utopian new ages fed directly into both German and Italian fascism in the early part of this century. Many, perhaps most, of the major Nazi figures, including Adolph Hitler, felt they were working out occult prophecies similar to those of Theosophy. Spiritualist ideas of humans evolving into gods or supermen underlay fascist programs of eugenics. Ideas of supreme spiritual masters led to a con-

tempt for democratic institutions. And so on. Though the occult systems are often regarded as relatively benign, or at any rate harmless personal preoccupations, their ways of thought in fact seem deeply implicated in the most dangerous political events of this century. The connection of these traditions with the development of twentieth-century abstract art, then, raises somewhat disturbing questions about the relationship between art and power, art's willingness to be coopted into a political consensus, and the like.

For centuries, the esoteric traditions have produced visual devices for education or contemplation. Symbolically or diagrammatically, these have often portrayed a series of stages through which multiplicity is held to emanate from and return to oneness, which is regarded as the foundation on which every particular phenomenon has its being. Often through an iconography of geometric shapes (which looks much like certain Modern abstract art), these works mediate between the One and the Many, between changing experiences and an unchanging metaphysical ground. The mainstream, established religions, of course, also offer abstract or semiabstract visual encapsulations of their doctrines, but with a linear and dualistic emphasis (except in the cases of Hinduism and Buddhism, where different considerations apply). In the European tradition, the seventeenth century was the heyday of the esoteric cosmogram. Rosicrucians, alchemists, and mystics such as Robert Fludd, Böhme, Henry Cornelius Agrippa, Heinrich Khunrath, Athanasius Kircher, and Michael Maier specialized in abstract or semiabstract compositions, often strikingly beautiful, which were preserved in their books, such as Fludd's *Utriusque cosmi* (History of both worlds, 1617), Maier's *Atalanta fugiens* (Atlanta fleeing, 1618), Khunrath's *Amphitheatrum sapientiae aeternae* (Amphitheater of eternal wisdom, 1609), and Kircher's *Mundi subterranei* (Lower worlds, 1678). In the nineteenth and twentieth centuries, occultists such as Madame Blavatsky, Annie Besant, Charles Leadbeater, and Max Heindel continued or revived this tradition.

"The Spiritual in Art" sets out to establish a relationship between such books – both their teachings and their images – and the twentieth-century tradition of abstract art. The idea that these books had a formative influence on abstract art, however, requires a number of qualifications, which can be found in more or less detail in the catalogue essays. Piet Mondrian read and looked at the works of Blavatsky (from whom he once said he learned everything), Besant, and

Leadbeater because of a passionate interest in their contents – virtually a religious conversion – but he did not proceed to invent abstract art solely on the model of their occult images and cosmograms. Beyond their formal influences, what these books offered, it seems to me, was a general proof and promise. Abstract art was arising anyway, out of its variety of causes, but at the moment when it was arising Mondrian saw in books about theosophy, and others in other sources, the proof that it could be saturated with content, that it could be a deep and far-reaching mode of communication, a visual means to express both an esthetic sense and a vision of reality – to unite, as Mondrian said, art and philosophy.

Hermetic, alchemic, and cabalistic cosmograms are symbolic representations of philosophical and spiritual ideas, visual encapsulations of world processes. What the emphasis on abstraction as pure form prevented us from seeing for so long is that much of twentieth-century abstract painting is not strictly abstract – like the cosmograms, it involves symbolic representations of ideas about reality, with varying degrees of visual mediation. For long periods, this type of evidence has been unacknowledged, circumvented, or brushed aside, since from a formalist point of view such strong outside content is an obstacle to the idea of pure, autonomous form. It renders hollow the insistence that abstraction refers only to itself.

There was a time when the idea of an abstract model that denied influences of ambient conditions, references, and circumstances conveyed a sense of liberation and transcendent possibility, and thus exerted a wide appeal. From a post-Modern vantage, however, that denial seems an inherent and fatal flaw. To isolate one chain of causality, such as the causality of sequences of visual forms, from the causal web as a whole is to ignore the linkage of social and psychological forces. It is to posit an immaculate conception, a zone in which the meanings of the world miraculously cease to function. This is really no less a religious belief than are the mystical traditions that it pretends to reject. It is a religion in disguise, masquerading in secular clothing. When religious beliefs are elevated into principles of history they can exert a frightening, irrational power, blinding whole populaces to what history is really unfolding. The Hegelian-based belief in pure form guided by transcendent spirit, for example, eventually came to serve a dominance-oriented view of history. This view in turn, clouding the Western mind with a

belief that certain forms held supremacy over the future, fed an age of terrible wars. Of course, the occult traditions are equally susceptible to abuse when, as does happen, they shift from the periphery to the mainstream of cultural history. Then, their usual emphasis on inner personal development can be generalized and externalized into a model of historical development quite as dangerous in its claims on the future as the Hegelian one. Kasimir Malevich, seemingly combining the Hegelian myth of history with the concept of entering the fourth dimension, felt that he was making the final art-works; Mondrian, from his point of view of theosophy, felt the same about his work and that of the other Neoplasticists; and Yves Klein, from his Rosicrucian point of view, made the same claim for his own work. All these cases show a similar ego inflation and a similar willingness to foreclose the future. And, as Tuchman points out in the catalogue for "The Spiritual in Art," Karl von Reichenbach's theory of "Odic force" was used by some of the Nazis to justify their claims over everybody else's future as well as their own. The point is that though the esoteric traditions have generally functioned benignly in history, they cannot be regarded as inherently and necessarily benign. Their benignity results in part, as it were, from their underdog position.

A center of the exhibition is the focus on the works of four pioneer abstractionists who were clearly and con-sciously influenced by various occult traditions: Wassily Kandinsky, Frantisek Kupka, Malevich, and Mondrian. Ex-amples of these artists' work are supplemented by catalogue essays which develop the show's argument primarily in terms of their biographies and their statements of intention. One reads that "Kandinsky's paintings were very much a product of his close reading of theosophical and anthroposophical writings by Helena P. Blavatsky and Rudolf Steiner"; that Kupka "was apprenticed as a youth to . . . a spiritualist who led a secret society," and that his "visionary experiences were translated into visual form in his painting"; that "Mon-drian joined Amsterdam's Theosophical Society in 1909," and "invented an abstract visual language to represent these concepts"; and that Malevich consciously "fused his interest in [P. D. Ouspensky's concept of] the fourth dimension with occult, numerological notions" in Suprematism, which was "intended to represent the concept of a body passing from ordinary three-dimensional space into the fourth di-mension."

The fact that the occult traditions in general involve a

mysticism of space, of the fullness of emptiness (the idea that all things come out of it and return to it), has made them easy to confuse with the formalist insistence on pure form and its desired emptiness of all external content, as displayed by Clement Greenberg's writings on Mondrian and Kandinsky. According to Greenberg, these artists derived "their chief inspiration from the medium they work[ed] in," and from a "pure preoccupation with the invention and arrangement of spaces, surfaces, shapes, colors, etc., to the exclusion of whatever is not necessarily implicated in these factors."[2] Mondrian and Kandinsky are drastically misrepresented by such remarks, which address half the story at best. In fact, many abstract painters were misrepresented by what became a solipsistic genre of critical discourse about the supposedly formalist intentions and boundaries of abstract art.

Throughout the period covered by the exhibition, the period between 1890 and 1985, the intention of abstract art involved a spiritual iconography as well as aesthetic aspects. The wide-ranging essays in the catalogue discuss many of the artists in the show, and others as well, and here one reads in more or less detail of Jean Arp's concern with representing the thought of Böhme, of Jackson Pollock's explorations of Amerindian and Jungian cosmograms, of the influence of Cabalistic concepts on Barnett Newman's work, of Marcel Duchamp's conversion of the symbolism of alchemy to his own purposes, of the influence of Böhme and Paracelsus on what Marsden Hartley called his "cosmic Cubism," of Oskar Fischinger's adoption of Buddhist, alchemic, and theosophical elements, of Eric Orr's selection of forms and materials from Egyptian burial cults and shamanic rites, and of much more.

Some inclusions in the exhibition, such as those of Ellsworth Kelly and Jasper Johns, seem somewhat forced, making the exclusions appear all the more unfortunate – especially the underrepresentation of women, with only 8 out of nearly 100 artists female, and only 1 of the 8 still living. (The show also seems at times to be tipping its hat to artists from California and New Mexico, some of them quite minor, inviting the unfortunate suggestion that it is merely another expression of the land of cults and fads.) Perhaps Tuchman felt that he had liberally remembered women artists by the show's fascination with a virtually unknown Swedish artist, Hilma af Klint, whose works are displayed in a room by themselves. Af Klint is used as a kind of paradigm or test

case of the relationship between abstract images and occult or visionary thought. Born in Sweden in 1862, she was a professional portrait-and-landscape painter and one of the founders of a spiritualist group which centered on her abilities as a medium. Her two professions merged in the 1890s in a series of "automatic drawings," which developed in about 1906 and after into oil paintings and watercolors. These works offer a distinct addition to the history of abstract art, as well as to the diagrams of spiritualist works. Yet according to the catalogue essay on her, by Ake Fant, af Klint seems to have known nothing of abstract art (which indeed was largely inchoate in 1906). Somewhat unclearly, Fant's essay seems to imply that the archetypal or innate nature of both the esoteric traditions' diagrams and Modern abstract painting is demonstrated by af Klint's intuitive arrival at their look. It seems, however, that much of her painting can more or less be accounted for by her apparent familiarity with such work going back to the Neoplatonism and Cabalism of the Renaissance and thence to the Neoplatonism and mystery cults of the Roman Empire, the philosophical cosmograms of Plato and the Pythagoreans, the works of Babylonian astronomers and cartographers, Sumerian cylinder-seal engravings, Egyptian hieroglyphic rebuses, and the abstract iconographies on Paleolithic cavern walls. This is a linkage with the past of a kind that Modernism and post-Modernism desperately need in order to keep their own insights and achievements in perspective.

It is ironic that around the cutoff date of this exhibition, 1985, two tendencies deeply germane to it began to make themselves felt. It was in 1985 that neoabstraction began to hyper-realize the tradition of the abstract sublime, rendering it an admitted parody of itself. This work emphasizes the draining of content from abstract art by the formalist cult of pure form. Ostentatiously unspiritual, it presents itself as the empty simulacrum of abstract art, the corpse of the faith in pure form. It makes the antispiritual into a cultic style that is a mockery of the history of abstract art and of the meaning it once had. Its emptiness is the demonstration of the art-annihilating or art-devouring solipsism of formalist doctrine. And while the claim of this work to be a model, unreal, is ostensibly post-Modern in meaning, and is based on post-Structuralist ideas of the death of the real, it echoes, in its implications of the end of the authenticity of art, a tone of apocalyptic absolutism familiar from classical Modernism.

At about the same time that neoabstraction was appear-

ing, self-conscious linkages to non-mainstream or esoteric traditions such as those in Tuchman's show began to flurry again. Above all, the word "alchemic," in its third or fourth resurgence in our century, began to appear in almost as many sentences in the art press as the word "appropriation." In the last couple of years various symposia and exhibitions, including the Venice Biennale of 1986, have focused on the theme of alchemy as if it offered a kind of regenerative force for the present. Certain artists have for decades been producing works, with or without the word "alchemy" attached to them, that now can be seen as authentic and deep images of transformation. But in the face of the suddenly spreading wave of interest in alchemy, and of the inevitable works aimed at that interest, one braces oneself for another stream of empty simulacra of the real thing. Unfortunately, neoabstraction wraps up our century, and wraps up abstract art, in a neat package, as if both were closed and ended, while neoalchemic work, so to call it, heralds a new age in which the problems of the past will supposedly magically disappear. Neither is the case.

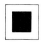

GREY GEESE DESCENDING

The Art of Agnes Martin

AGNES Martin's characteristic art began to appear at a moment when the tradition of the abstract sublime, while still alive in the canvases of Barnett Newman, Mark Rothko, and others, was on the verge of giving way to Minimalism. Her works of the period 1960–67 show a rigor or reductionism in scale and proportion that is more Minimalist than Sublime; sublime abstractionists like Newman preserved size and ratio as elements of personal expressiveness. Martin's pictures, on the contrary, are almost always square and of predictable size – the paintings typically 6 feet by 6, the drawings 9 inches by 9. The incident within the frame reflects this format in rectilinearity and parallelism, usually involving parallel lines and grids – though one can find examples in this early period of triangles or circles floating in rows and columns parallel to the edges of the support. This internal format dominated by the grid hovers ambiguously between the sublime and the minimal and can be seen as incarnating the one reductionist program or the other. It hovers, one might say somewhat grossly, between Mondrian and LeWitt.

So relentlessly do these works address the grid that it acquires an air of content, which seems to accumulate in a series of thin filmy layers of elusive intention. Sometimes the rectangles of the grid aren't empty – for example, they may contain a dot made by the head of a nail that has been driven through the surface – but usually the rectangles coalescing into an allover grid are empty, like graph paper before anything has been drawn on it. In the early 1960s the grounds on which the grids were drawn could be colored; from 1964 to 1967 they were off-white. Again, in the early 1960s the grids often had blank borders around them; toward 1967 they began to extend out to the edges. The lines are

drawn now in pencil, now in black or colored ink, watercolor, or oil or acrylic paint. Sometimes they are sharp and clear, sometimes they skim the surface of the support, skipping from height to height; sometimes they are broken. In many cases the gridwork tends to disappear as one backs away from the picture, leaving the impression of a hovering ground or a subtly activated field.

Beginning in 1967, at the climax of a period of masterful output, Martin basically stopped making art for a period that ultimately lasted six years. Because of their moment in art history, the works that preceded this pause were inevitably received as belonging to Minimalist art, and were compared to and exhibited with the works of other artists who had been termed Minimalists. This association was in fact somewhat insensitive to what is going on in Martin's work.

Martin was born in 1912, the same year in which Jackson Pollock was born, a year before Ad Reinhardt was born, seven years after the birth of Newman and a few years before that of Robert Motherwell. She is, in other words, a contemporary of the Abstract Expressionist generation rather than of the Minimalist generation that came after. Her all-over compositions are a development of Pollock's; she might be described as having redirected Pollock's mazes of lines into grids. Mark Tobey's overall distributions of serial elements are also pertinent. The extreme reductiveness of Martin's images relates to the directions that Newman, Reinhardt, and others pursued, as does her aesthetic vocabulary, her use of a hard edge and a geometric format, and her evolution to an almost complete exclusion of nonrectilinear elements. Her dependence on an "image" or format repeated over and over again echoes the works of Rothko, Newman, Clyfford Still, Motherwell, and others – though it goes beyond them somewhat in its invariance of size and ratio.

While Minimalism developed partly out of Abstract Expressionism – Reinhardt actually called his later work "minimal" – it rejected the Abstract Expressionist emphasis on touch, subjectivity, and romantic notions of selfhood. Formally, Martin's work exhibits many of the Abstract Expressionist elements that passed into Minimalism – overall composition, repetition of structural motif, hard edge, and so on – but it emphasizes touch, and, above all, it is saturated with the expression of feeling and emotion that the Minimalists formally abjured, a feeling much like that of the sublime. The comparison of Martin's art to Minimalism was

Agnes Martin, *Untitled #4*
(1977). The Australian Na-
tional Gallery. Courtesy of
the Pace Gallery.

rooted in a certain similarity of look, but look alone is an
insufficient criterion for such judgments. It is true that the
grid is a major theme in both Minimalism and Martin's
work, but the grid has played more than one role in art
history.

In graph paper, a grid of squares occupies a rectangular field;
Martin usually uses a grid of rectangles on a square field.
The rectangle, as she herself has suggested,[1] drains out the
stabilizing or rigidifying power of the square, introducing
comparatively unstable and flowing elements into it. This
interplay between the fixed and the changing is one way of
locating the underlying tension that pervades and unifies her
work in its ideas, as the grid patterns and lines unify it
optically. *Untitled* (1960)[2] contains five rows and ten columns
of elements and breaks down to the simple ratio 1:2. *Words*
(1961) has the same ratio, combining elements in relations
between four and eight. *Blue Flower* (1962) contains 33 rows
and 33 columns of elements. *Pale Grey* (1966) contains 66
rows of elements and 44 columns of them, while *Untitled*
(1966)[3] exactly reverses this, containing 66 columns and 44
rows; both these works have the ratio 2:3, which appears in

other works as well, such as *Untitled* (1967).[4] *Whispering* (1963) has 15 columns and 20 rows of elements, incorporating the ratio 3:4. This ratio is also found in *Untitled* (1961),[5] but in reverse – 44 down and 33 across. When asked about decisions having to do with how many elements would be included in a given work, Martin answers that her interest is more in scale, in an architectural sense, than in arithmetic. Yet the works tend to cluster around the simple ratios 1:2, 2:3, and 3:4, which have long been viewed as creative and dynamic. Experimenting with divisions of stretched string, Pythagoras found that in music these ratios make up the three so-called perfect intervals; he and his followers defined the harmony of the spheres through such ratios. Martin's arrival at numbers like 33 and 66 recalls other architectonic structurings with cosmic implications, such as that of Dante's *Divine Comedy,* each of the three parts of which has 33 cantos, with an extra one added to make 100 the number of totality.

Various factors, including the loss of her loft when the building was torn down, caused Martin to leave the New York art world in 1967. The six-year space before she started making art was not totally a gap or silence, since it was in these years that Martin began to write a series of personal notebook reflections and lecture notes, some of which would ultimately be published, in her own handwriting, in catalogues of her exhibitions. A collection of them is now in the University of Pennsylvania's Institute of Contemporary Art, Philadelphia, in a public archive, to be consulted by students of Martin's work. They are dated from 1972 to 1976, and thus accompanied the artist's transition back into making art, which began in 1973, with a series of prints, followed by the return to painting in 1974. Sometimes these writings echo the discourse of Martin's older Abstract Expressionist peers. Newman, for example, wrote that art should evoke a "memory of the emotion of an experienced moment of total reality."[7] Martin has similarly written, "The function of art work is . . . the renewal of memories of moments of perfection."[8] Indeed, Martin's approach to the grid has parallels to Newman's zips, which have been connected with the Cabalistic term *Zim-Zum* — a kind of emptiness understood as the source of creativity.[9] The square format of Martin's works tends negatively toward the sublime by avoiding both the suggestion of landscape that the horizontal rectangle brings

with it and the suggestion of the figure borne by the vertical rectangle.

More often Martin's writings seem to me to recall passages or intentions of classical Taoist texts – a body of literature with which Martin has lived closely. Without suggesting that this reference point exhausts, or even specifies, the content of her work, I nevertheless find it unavoidably recurring in connection with it – especially in connection with Martin's use of the grid.

In art practice the grid has had a common function in the transferral of images from one scale or place to another; the original image is gridded, and a grid of the same number of elements, but not usually the same size, is drawn onto the receiving surface. Finally each square or rectangle of the gridded original is transferred separately to the corresponding space of the new grid. The gridded surface, then, functions as a kind of ontological ground, a membrane from which forms emerge into the light, a threshold where energy passes from formlessness to form. So what is a grid standing empty, like graph paper on which nothing has yet been drawn?

In the *Tao Te Ching,* or *Book of the Tao* (which has been variously dated between the sixth and the third centuries B.C.), attributed to the philosopher Lao Tzu, there is a passage about art. If the people, Lao Tzu says, "find life too plain and unadorned, / Then let them have accessories; / Give them Simplicity to look at, the Uncarved Block to hold."[10] In Taoist terminology the "Uncarved Block" is a state of potential being that coexists with the many concrete actualizations of being. It contains, in its uncarved state, countless potential forms, its infinity being compromised and constricted by any particular carving of it into actuality.[11] In this context we might reconsider Martin's grid. It is like the block from which no particular form has yet been carved. It contains within its potentiality all possible forms. It waits. Activated and tingling, the grid is the place of infinite creativity, the ground to which we must return for "the renewal of memories of moments of perfection." When Martin's grids disappear as one backs away from the painting, they disappear, as it were, into the otherwise formless ground, where they reside always in a kind of latency, giving the ground an appearance of floating vibrancy, of light-filled potentiality, of invisible but active force. Thus the grids are intensifications of the meaning that the ground itself has in

art. They show the ground hyperactivated for the appearance of the figure, the image, yet still empty, suspended at the moment of hyperactivation just before forms appear, and before infinity is compromised. The empty grid, then, is like the uncarved block, and in Taoist painting theory the uncarved block equals the mountain. In a similar way Martin's open grids suggest both the openness of the New Mexico sky and earth in which she lives and also the mountains which hover in its emptiness. Her grid is like the substructure of a landscape in which a mountain rises cloaked in mist.

Martin's work thus involves the dichotomy between an ordered system – the grid – and a particular event within that system – the personal feeling of the lines, which proceed over the surface with a heartbreaking delicacy of touch. She has expressed this dichotomy through a discussion of the difference between unchanging and changing things. Changing things Martin calls the "exhaustibles," unchanging things the "inexhaustibles."[12] This dichotomy has occupied a lot of twentieth-century art, but most relevant here is the tradition of the abstract sublime, from Kasimir Malevich's *Black Square* (ca. 1915), to Yves Klein's blue monochromes, to Pollock's *The Deep* (1953).

In the 14 years since 1973 Martin has regularly exhibited new work that shows a strong continuity with her work of the earlier period. "I've always painted the same theme," she says.[13] These works maintain the size and shape of the earlier ones – paintings mostly 6 feet square, drawings and watercolors usually 9 inches by 9. But the reductiveness of the grids has often undergone further reduction. The vertical lines of the grid have disappeared from many paintings, leaving a series of horizontal stripes; from a few the horizontal elements have disappeared, leaving vertical stripes. At the same time color has both changed and remained the same. Sometimes, as in many of the works of 1964–67, there is no color, but only the most delicate of pencil lines dividing an off-white ground. Elsewhere the coloring of the pre-1964 works returns, and there are also works with color both more subtle and more powerful. Martin here is the ultimate colorist of the highly tinted, or whitened, hue – peaches of different intensities, blues of different intensities, yellows.

In Martin's later work the horizontal line often triumphs within the square format. She chooses to discuss it all in terms of feelings and emotions, "the subtlest feelings that

everyone has . . . feelings that people are hardly aware of having,"[14] to quote the artist. When told by a viewer once that no geese are to be seen in a work of 1985 entitled *Grey Geese Descending,* she replied, "I painted the emotions we have when we feel gray geese descending." "Descent" implies a downward flow from the heights to the depths. And the triumph of the horizontal in the later work might be seen as the triumph of receptiveness over assertiveness. The more recent paintings, by virtue of the reduction of the lines, and the avoidance of the clash or tension of the horizontals and verticals, and also through their complementary addition of an extremely sensitive and powerful colorism, have become less available to an overlay of discourse, more out there simply as a stimulus to feelings, more sensual and optical. In a statement of 1972, near the end of her six-year layoff, Martin wrote, "My interest is in experience that is wordless and silent, and in the fact that this experience can be expressed for me in art work which is also wordless and silent."[15]

The new work, in fact, is even more abstracted from reference. In a text of 1976, Martin wrote about abstraction – or about what she calls the "abstract response," which is "the response that we make in our minds free from our concrete environment. . . . We know that it is infinite, dimensionless, without form and void. But it is not nothing because when we give our minds to it we are blissfully aware."[16] Her shift from the grid works to the softly glowing stripe works is a shift that takes one even closer to this place. These paintings, even more than the grid paintings, with their inevitably somewhat hard rigor, are instruments to induce awareness of subtle feelings, to point one lightly toward them. In this respect her works relate to many tantric paintings, which also use veillike grids or stacks of horizontal parallel lines as meditation objects to focus the mind on itself.

"I would like my work," Martin writes, "to be recognized as being in the classic tradition. . . . Classical art can not possibly be eclectic."[17] Martin's writings contain several indications of what she means by "classical." In one place, an image of a Sung dynasty vessel is accompanied by the words "really cool," "classic," "unearthly."[18] Another page compares two T'ang dynasty vases, with the notation, "The pot on the right because of its suggestion of a nature form is not as classical as the one on the left. It is held down to earth."[19] Elsewhere Martin appreciates Chinese ceramists on

the ground that, looking at their work, one can see all the elements they rejected, their continual awareness, that is, of emptiness as the ground of form.[20] In a key inclusion in her notebooks she refers to Buddhist terminology that describes reality as made up of three levels: the *Nirmanakaya,* the changing everyday world; the *Dharmakaya,* the unchanging absolute; and the so-called transformation realm, *Sambhoga-kaya,* which lies between them. It is in this middle realm, where change and the unchanging somehow merge, that Martin locates the "classic."[21] In this intermediate realm between the absolute and the relative, one cannot get away from either the universal or the particular, either the idea of perfection or everyday reality. "I hope I have made it clear," writes Martin, "that the work is *about* perfection as we are aware of it in our minds but that the paintings are very far from being perfect – completely removed in fact – even as we ourselves are."[22] And she says, "If any perfection is indicated in the work it is recognized by the artist as truly miraculous."[23] Yet classical art "is like a memory of perfection."[24] And as Martin's art suggests, in order to attain to the art of the memory of perfection we must return from figure to ground, from rigid differentiation to open potentiality. We must go back, as Lao Tzu puts it, into the Uncarved Block, or, as Martin writes, to that rewarding state when "our most tenacious prejudices are overcome. Our most tightly gripped resistances come under the knife."[25] All judgments, all "knowledge," must be abandoned:

You may as well give up judging your actions. If it is the unconditioned life that you want you do not know what you should do or what you should have done. We will just have to let everything go. Everything we know and everything everyone else knows is conditioned.[26]

And, being conditioned, it must be let go. This relates to what Martin means by her reference to "unearthy," or by "freedom from the cares of this world." We must, in other words, empty our grids. In this view the grid, when full of images or ideas, comes to signify a manipulative way to see life, a system of formulas and categories that order experience artificially. The empty grid signifies freedom, no "resistance or notions," no "thinking, planning, scheming."[27] In short, all the disquieting overtones of the psychic drama take their leave. During moments of such awareness we have intimations of the state of "free and easy wandering" described by Chuang Tzu.[28] (Martin quotes this phrase in her notebooks.)[29] We "quietly come, quietly go."[30]

Martin's art expresses by its reductiveness the idea of loss
of habit, and by its quietness and unassumingness the quality
of humility that is the opposite of what she calls "Pride the
Dragon." Her work is a message about the "free and easy"
path that a suitably sensitive viewer recognizes in the pic-
tures, thereby increasing his or her own storehouse of sensi-
tivity. A poem by Martin could be quoted as a closing
description of her work:[31]

> I can see humility
> Delicate and white
> It is satisfying
> Just by itself . . .
>
> Humility, the beautiful daughter
> She cannot do either right or wrong
> She does not do anything
> All of her ways are empty
> Infinitely light and delicate
> She treads an even path.
> Sweet, smiling, uninterrupted, free.

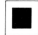

ABSENCE MADE VISIBLE

Robert Ryman's "Realist" Painting

Y 1957, when he was in his later 20s, Robert Ryman had established a distinctive signature mode for his paintings: he limited his format primarily to the square and his palette almost exclusively to white (though the natural color of the supports and, after 1976, of the supports' fasteners provided counterpoint to the white, and though the whites themselves varied). This self-limitation was a kind of thing that was done in the heyday of Greenbergian theory, when Ad Reinhardt, for example, limited his palette to black, Franz Kline to black and white, and so on. But the decision remains remarkable, as does the fact that Ryman has worked within these limits for more than thirty years, evidently feeling them as expansive and infinitely renewable.

Some critics have supposed that there was no change or development in his work during that time.[1] Others see a "slow evolution."[2] Whether one views it as a kind of progress or not, it is undeniable that there has been great variety in the work; its elements pass through an unending series of nuanced changes and recombinations, with a variety of paints (oil, acrylic, enamel, gouache, and more) being applied through a variety of brushstrokes or styles of touch (from Johnsian allover texturing to house-painting brushes drawn once across the surface, and from one direction to another, horizontal, vertical, diagonal) onto a variety of surfaces (from paper to cardboard to fiberglass to aluminum to steel, whether mat or polished) in a variety of sizes (from 7 inches square to 24 by 8 feet) hung by a variety of conspicuous devices (from bolts to elaborate flanges to metal ribbons to wooden pegs and foam blocks) in a variety of relationships to the wall (directly on the wall, partly on and partly off it, close to it, a few inches from it, freestanding several feet away

from it, horizontally perpendicular to it, or variously placed in relation to wall lines, door lines, windows, and so on). The work deals with light, too, in a variety of ways, an endless flow of flat-to-sparkling nuances, characteristically unfolding with an uncanny precision and clarity.

Ryman's public career developed fairly slowly – his first one-person show came only in 1967, ten years after he had focused his approach. By around 1970, however, there was interest in his work in both America and Europe, and since then both critics and public have agreed on the historic weight of his oeuvre. Writers in particular have responded well to Ryman; indeed one is struck by the high level of discourse the work has drawn out of the culture around it. But one is also struck by a contradictoriness in this discourse. Having unfolded over three decades with little if any fundamental change in its premises, Ryman's oeuvre has encountered a number of critical climates, and its reception has been adjusted to each in turn.

The work has often been discussed as if it were unambiguously Minimal art. Some have said, for example, that it has no metaphor in it, no reference to anything outside itself, no narrative, no symbolism, no metaphysical implication – nothing but physical presence.[3] This was of course a standard claim of Minimal artists, and Ryman himself tends to talk like a Minimalist: sometimes he will make a remark like "The painting is exactly what you see,"[4] which would seem to say much the same as Frank Stella's famous credo, "What you see is what you get." Both statements can be taken to imply that conventional representation and metaphysical abstraction equally refer to matters outside the physical boundaries of the painting, and thus must be rejected through insistence on the primacy of the painting's presence. In the 1960s such remarks involved a rejection of Abstract Expressionism's macho spiritual bombast for a down-to-earth, and still somewhat macho, materialist austerity. They were refreshingly blunt: We're not going to lay any trips on you, the artists seemed to be saying. Like Carl Andre's affectation of workman's overalls, these matter-of-fact statements suggested that at least on some level the artist did not think he was doing anything special, anything out of touch with real, or ordinary, life.

The Minimalist position is sometimes regarded as the ultimate expression of Clement Greenberg's belief that the painter should eliminate from his or her work anything that

75

Robert Ryman, *Untitled*
(1961). Private collection.
Courtesy of the Pace Gal-
lery.

does not belong exclusively to the medium of painting. Thus
narrative, being literature, is eliminated; drama and tragedy,
being theater, are eliminated; representation, being photog-
raphy, is eliminated; and so on. But many of the artists for
whose work this theory was devised did not accept it at all.
Both Barnett Newman and Mark Rothko, for example, had
specific interest in content: the sublime and the tragic respec-
tively. Ironically, it was their successors in the Minimalist
generation, which little interested Greenberg, who really
accepted his theory and worked on its premises.

Greenberg wanted the painting to employ only nonrepre-
sentational color and a two-dimensional surface. Though the
purism of his theory was tacitly based on spiritual attitudes,
he seems to have intended something more materialist by it.[5]
Michael Fried took the materialism of Greenberg's theory
further – introducing elements traditionally regarded as non-
aesthetic, such as the canvas support bars, for example, as
part of the painterly and critical enterprises[6] – and the Mini-
malist generation drove it fully into the open. Thus
for Ryman the essentials of painting finally are: a two-
dimensional surface, preferably a neutral square; paint, all of

one color so that composition, though still residually present, is greatly diminished; and a support structure for the surface, which is frankly acknowledged through visible hanging devices. Ryman's use of hanging devices as compositional elements surpasses Fried in its acknowledgment of the painting as a physical reality rather than a pictorial illusion. I do not know how Greenberg feels about this extreme form of his doctrine, but it does seem a legitimate outcome of his thought.

Ryman's work clearly has much in common with Minimalism, but he does not call himself a Minimalist. His own preference is for the word "Realism." In an important statement, he first sets his approach off against representation and abstraction, both of which he says follow an "inward aesthetic": both, that is, posit imaginary worlds separated from the real space around the picture by the frame, which always invites the viewer inward, into the work.[7] Next Ryman posits a third, "Realist" type of painting (also, he says, called "Concrete," "Absolute," and "Non-objective" painting in the past). The "Realist" painting "uses all of the devices that are used by abstraction and representation . . . [except one]. The only element that is not used is the picture . . . and since there's no picture, there's no story. And there's no myth. And, there is no illusion, above all." This, then, is what the formula "The painting is exactly what you see" means: without illusion, the painting is "what you see" and nothing else. It is completely honest in its physical and material presence, which involves no tricks, puns, or hidden agendas. The painting is called "Realist" because it is simply and directly a real object, referring to nothing outside itself, stating nothing but its own identity.

Furthermore, since the painting is not a picture of anything but is a real object occupying its space as any real object does, and since, again like a real object, it has no frame to set it off from real space, "there is an interaction between the painting and the wall plane." Accordingly, Ryman refers to his "Realism" as an "outward aesthetic," in contrast to the "inward aesthetic" of both abstraction and representation: the real object asks the viewer not to enter into it but to experience its outward presence as a plain physical object in real space, interacting "with the wall plane, and even to a certain extent with the room itself."

Nothing here really distinguishes Ryman's work from Minimalism. It is interesting, though, that in constructing a tradition for "Realism" Ryman mentions not the Minimalist

school but the early Modernist Piet Mondrian, who remarked that his work struggled to be "free of the tragic."[8] Ryman also singles out Rothko for "his use of the painting as an object in itself."[9] The artist himself, then, seems to identify most closely with artists outside his Minimalist peer group, artists whose works are known to have been metaphysically laden. And the terms of his "Realism" argument might suggest a number of other classical Modernists: critics often mention Kasimir Malevich, for example, in connection with Ryman, though most of Malevich's works are either representational or abstractly metaphysical. Piero Manzoni may be closer to the mark, at least in his "Achromes" (1957–63): Manzoni wrote, "What I want to do is to create a completely white surface (yes, quite colorless, neutral) that is in no way related to any artistic phenomenon or element outside the surface itself. It is not the white of a polar landscape, or of some beautiful and evocative material, or a feeling, a symbol, or anything else; it is a white surface that is nothing but a white surface. . . . Or better still, it is there and that's all."[10] Manzoni's emphasis on the surface – rather than on the whole support system, with stretcher bars and hanging brackets – is less relentlessly materialist than Ryman's approach, yet still seems ideologically close. The major difference, perhaps, is that Manzoni's materialism seems to have been rooted in European revolutionary thought – of the type that embraces both anarchism and Marxism, say – and Ryman's seems to stand alone, without any such generalized matrix.

Critics also link Ryman's work with the post-Minimalist artists sometimes, in the 1970s, called "analytic painters."[11] This group was made up mostly of Europeans – Alan Charlton, for example – though Americans such as Robert Mangold, Brice Marden, Agnes Martin, and Dorothea Rockburne have also been included. The products of these artists' "program of minute attention to material, format, color, line and texture" were exhibited under titles like "Painting about Painting" and "Painting without Pictures."[12] A Dutch exhibition of such work in 1975 used the title "Fundamental Painting," which the curator encapsulated in terms very like Ryman's own: "Format: neutral, square, or close to it. . . . Scale: human, not sublime abstract, where you lose yourself in it. Color: one color. . . . Line: the edge, or a reference to the edge. . . . Texture: . . . determined by materials. Materials: various."[13] As in Ryman's "Realism" theory, the painter,

having abandoned pictorial values, is left with only the ma-
terials to explore.

To class Ryman as an "analytic painter" seems alluring, then, but for one question: is it adequate to discuss his work strictly in terms of painting, with whatever modifier? For once his materialism is acknowledged, it tends to move his art partway out of the category of painting and into that of sculpture. Ryman himself says that he doesn't "think of [his work] at all as sculpture,"[14] but at the time when his paintings were first taking their distinctive form, in the late 1950s and early 1960s, it was a primary artistic project to break down the distinction between painting and sculpture, or, better, to shift emphasis from the former to the latter. This arose from shifts in the perception of art's ethical priorities. In the era of high Modernism, with its hidden but overpowering metaphysical assumptions, painting's illusionism, even or perhaps particularly when abstract, seemed to give it an advantage over sculpture in attaining ethereal realms of meaning. In the 1960s and 1970s, however, illusion came to seem a distraction from real life, reflecting an irresponsible obliviousness to the duties of embodied social beings. (This was the period of painting's so-called "death.") A sculpture, on the other hand, even when representational, was a real object occupying the same space that the viewer occupied, the space of the body and of society. This seemed to give it the ethical advantage.

In defense of painting, or in deconstruction of painting, artists and critics pushed the medium toward sculpture. The process had begun even in what seemed painting's heyday. Greenberg himself had remarked that a stretched canvas without a mark on it could be a painting, though not a very good one;[15] but in fact many events have demonstrated that a stretched canvas, with or without a mark on it, can be a perfectly good sculpture. A canvas deliberately left blank would clearly seem to emphasize its own role as a three-dimensional object at the expense of its pictorial surface. The treatment of the painting as, in effect, a sculpture may have been what Robert Motherwell was referring to when he said of Stella's black canvases, "That is very interesting, but it is not painting."[16]

The shift from the illusionistic toward the sculptural presence of the painting was a key feature of the end of Modernism. Elements such as Jackson Pollock's hobbyhorse head affixed to a canvas, from 1948, and Lucio Fontana's punctured canvases of 1949 on, may be seen as foreshadowings.

Then, as early as 1957, Yves Klein mounted paintings away from the wall like free-standing sculptures and affixed three-dimensional found objects to them. Robert Rauschenberg and Manzoni also stuck objects to the surfaces of their works, and since then many others – Luciano Fabro, Richard Jackson, and Immants Tillers, to name a few at random – have used canvases in frankly sculptural ways, stacking them, strewing them about the floor, and so on. Surely Ryman belongs as much to this group as among the "analytic painters." His materialism is implicitly sculptural. In sculpture, material is of primary significance, whereas in painting it is usually irrelevant whether the artist has worked on, say, cotton or linen. Similarly, in sculpture any object such as a bracket or screw or peg is considered part of the work, while the means of hanging a painting are traditionally considered external necessities to be made as unobtrusive as possible. In these and other ways Ryman's objects are strangely more like sculptures than like paintings. It's true, of course, as Robert Storr observes, that "whatever the relative degree of physicality of the devices with which [Ryman] has experimented . . . it is paint and paint space . . . which beckons light and entraps it."[17] But many other artists – Marcel Broodthaers, Bertrand Lavier, and more – have demonstrated that paint can function easily within sculpture.

Even as Ryman's works act like paintings – even like paintings of "inward aesthetic" – by attracting the viewer to nuances of difference in the picture plane, their sculptural quality can be seen again in their openness to their environment. Many have commented on the way a Ryman painting transforms the space, becoming part of a new work that includes the lines and texture of the wall, the height of the ceiling, and so on. Of course this is true of any painting or indeed any object to a degree; the point is that it is true of Ryman's work to an extraordinary degree, to a degree, in fact, that somewhat contradicts the idea that it is painting at all. Painting, enclosed by the frame of the rectangle, sets itself off from the space it hangs in; sculpture participates in that space. Painting can include both a ground and a figure within the ground; sculpture is only a figure, making the space in which it is exhibited its ground. Ryman's works in this way act like sculptures, figures within the ground of the ambient space.

Despite an evident intention to strip matters down to a crystalline simplicity, both Stella's and Ryman's "what you

see" remarks open up much debate. It never has been all that clear where the act of seeing ends and the act of cognitive addition begins. On the one hand "what you see" might mean, as Minimalists are supposed to intend it to mean, a mere array of material substances and objects: wooden frame, stretched canvas, paint. But if this is all that is meant, then where is the aesthetic point? Are we to understand that "what you see" is somehow not only material but also aesthetic? If so, where does the aesthetic enter? Is a material presence always aesthetic? Is the wall as aesthetic as the painting upon it? These artists, in other words, have not explained why they bothered to make the painting at all, rather than simply pointing to the wall, which is already there and is already "exactly what you see."

It is worth considering what these statements would have meant in the pre-Minimalist mode of discourse from which they emerged. Greenberg's doctrine of the "purely optical" had somehow allowed for concepts such as Newman's "stretched red," in which "what you see" is supposedly nothing less than the sublime. The "purely optical," then, becomes a vehicle for all sorts of metaphysical content to be supplied by the viewer, who would likely know from verbal supplements, however, what the artist intended by a particular abstract field. In this context, to say that "the painting is exactly what you see" is merely to point to a blank that needs to be filled in. What the statement communicates powerfully, however, is the artist's reluctance to fill it in himself.

The grandly spiritual art discourse of the '50s had been rejected by the artists of the following generation as, essentially, outworn. In its place, artists like Ryman inserted a verbal blank. It is the unspecific nature of this blank that has allowed critics to place Ryman in so many different categories; and it has also allowed them to find more meanings in his work than the hardware-store-shelf style of materialism can encompass, from Donald Kuspit's discussion of "absolute art" and the metaphysical "zero of form" to Dan Cameron's celebration of Ryman's white as "the color of purity and revelation."[18] Contradicting both Ryman's own talk of "Realism" and the entire body of writing that stresses his materialism, both these authors attribute at least hints of mysticism to Ryman's work. And in fact it is not altogether clear that the artists of Ryman's generation completely rejected the spiritual type of discourse.

To say that the outer trappings of a way of thinking are outworn, or out of fashion, is not necessarily to feel that its

inner core is irrelevant. It is significant, I think, that while the 1960s artists rejected the earlier generation's way of talking, they kept much of its practice, such as the purist avoidance of representation and the interest in the monochrome field. And they didn't even totally give up the talk: Rauschenberg, for example, in 1951, described his white paintings as "one white as one god," echoing the tone of what Harold Rosenberg called the theological branch of Abstract Expressionism without any obvious irony. It was only later that he spoke of these works in down-to-earth social terms – as screens meant to show the viewers' shadows, implicating the work in the flow of everyday life. Which statement is truer of his intention in making the paintings, or of their cultural significance? Was the first description an insincere echo of the older artists then still dominant, or was the second an attempt to revise his position after the fashion had changed?

Similar questions can be raised about Ryman. In the context of related work of the late 1950s, it is not so clear that his work entirely lacks drama, narrativity, and the sublime. Indeed, in and of itself the work may suggest many things, sparking a train of associations that go far beyond the raw perception. I don't think Ryman can eliminate this aspect of his art merely by denying it. Seen in historical and cultural context, his work involves a double bind, carrying manifest associations that are then denied by the artist who, wittingly or not, contrived them in the first place.

It is true, of course, that there is an absence of overt narration in Ryman's painting. Still, no absence is simply an absence; absence is already a kind of narrative. Philosophers have formulated this idea in different ways. To Aristotle, absence was inherently dynamic, for always implicit in it was a potential presence. Others have held that absence is itself a positive presence, a perceptible thing. Certain Indian thinkers have spoken of a Prior Absence (the absence of something that has not yet appeared) and a Posterior Absence (the absence of something that was previously present) as metaphysically distinct entities.[19] In this sense the empty surface is not merely empty; it is either waiting for something to transpire upon it, which is one narrative, or recording the disappearance of something that has already transpired, which is another. Either approach involves a set of feelings – tragic, or elated, or anticipatory, or longing. The field on which events transpire, absence palpitates with their dynamism.

The clean slate also involves a narrative of its cleaning, implying reasons for doing so, purposes, and counterpurposes. Even "nonpainting" like Ryman's, for example, can be placed in the history of painting, where it tells a story of all the elements that have been removed from it – elements off the field for the moment, but still players. To shift the terms just a little: Doesn't purity imply a narrative of purification? Doesn't austerity imply a drama of struggle against superfluity? Doesn't a clean slate imply some crisis that has necessitated its cleaning?

For all his work's look of predetermination, Ryman's method is intuitive, in a process-oriented way that goes back to Action Painting. "When I begin," he remarks, "I'm never quite sure what the result is going to be. . . . I don't have a plan. . . . I have . . . a certain feeling of what I want."[20] This unfolding of the piece out of impulses encountered in the making of it, much as the paintings of Kline and Pollock unfolded, is another kind of drama implicit in Ryman's work. In this sense the once-revered "touch" of the intuitive painter is the event for which the ground hovers in expectancy. On the other hand, this drama has already been played out; it *is* the ground, rather than a figure transpiring upon it.

Kuspit and Cameron seem to mean something similar when they sense a mysticism clinging around Ryman's painting. Cameron has referred to the work's paradoxical combination of "inviolability with expectancy,"[21] an inviolability that suggests nothing can possibly transpire upon its surface except what is already there, and an expectancy that suggests a pregnant surface, a surface on which something is about to happen. This contradictory presence seems related to what Kuspit says about "absolute art" when he writes, "The point is to make it seem rich and full-bodied without undermining its numinous remoteness and bodilessness."[22] It is this aspect of the work, too, that creates the commonly recognized effect of giving a churchlike ambience to a room where a number of these works are shown at once.

It seems that the mysticism these critics have found in Ryman's work is actually there, but in a uniquely tempered form that does not really contradict the materialism that others have found in it. An Indian tantrist familiar with the monochromatic renderings of the absolute in that tradition might understand Ryman's paintings as representations of the pure sublime. But it is not pure sublime; it is a sublime experienced on the level of perception and deeply informed by the materialist ethos of Minimalism. Ryman's concern

with perception is such, in fact, that perception becomes something else: it functions in the work as a concrete universal. In effect, it is presented as an absolute. The work restores the simplicity of sense perception, yet invests it at the same time with grandeur and absoluteness. The peace of raw and simple perception comes to suggest a salvational force, as in Zen or *vipassana* meditation practice. The artist works as an empirical investigator of sense perception, yet in a kind of redemptionist aura. Thus, insofar as there is a contradiction in the discourse between the materialist and the mystical claims, I would agree, in a modified way, with both sides.

To a degree, the white of Ryman's paintings is a blank check to be filled in as this or that by each viewer, a Rorschach test to draw out and record different projections. Indeed, like the work of some other artists who have continued to pursue the same type of practice as the ages change around them, Ryman's art seems to take on different resonances of meaning in response to each new cultural atmosphere or pulse. It is open – conspicuously open, given its blankness and its unframed accessibility – to any unintended hieroglyphic that a viewer might wish to read into it.

Ryman has said that white carries no symbolic or referential quality for him at all.[23] His explanation of why he uses it is wonderfully down to earth: "It's to make it clearer that I use white; it's so that everything will be visible." I believe that this explanation is indeed all that is needed to understand the work on its own or its maker's terms, comporting perfectly with his "Realist" premises, in which everything down to the hanging brackets is to be honest and direct in its visibility, with no dark corners for obscure suggestions to lurk in. But white clearly has meanings beyond this intention – for example, in terms of the society around it.

On the same day on which Ryman made that remark to me about the clarity of white, the *New York Post* carried a brief story about the Grammy awards the night before. The singer Mariah Carey, whose father is African-American, "was sent a white stretch limo. Didn't like it. They had to recall the thing and send a black one."[24] A question comes to mind that Muhammad Ali asked some 20 or more years ago: "Why do you think they call it the White House?" Ryman's work, like that of any artist, is caught in its social situation. When one critic says that regardless of Ryman's denials, white still means "the absolute . . . light . . . the all inclu-

sive,"[25] how would such statements be felt in the nonwhite world? When another remarks that "no other colors can function without first taking [white] into account, seeking cooperation from, perhaps even paying homage to, the power of white,"[26] do we not hear a dying resonance of the age of white imperialism? When he continues that Ryman, in limiting himself to white, is "stripping the spectrum down to a pure, blinding essence," one can hear resonances of John Milton's paean to primal light in *Paradise Lost,* written in the mid-seventeenth century, in the first feverish budding of the colonial period: "Hail, holy Light, offspring of Heav'n first-born, / Or of th' Eternal Co-Eternal beam . . . / Bright effluence of bright essence increate." Milton means that white precedes other colors, and the Western tradition has long assumed the universal priority of whiteness in virtually every sense – social, metaphysical, ontological. Similarly in Ryman's work one can read a materialist metaphor to the effect that white gesso is the universal substratum that underlies all colors in all pictures. But there are troubling resonances. Perhaps as the Welsh poet Vernon Watkins wrote in his hymn to whiteness, "Music of Colors – White Blossom," "White must die black, to be born white again."[27]

Clearly Ryman's work is aimed primarily at an educated Western audience that has passed through initiations into the sublime, the monochrome, and the Minimal – primarily, that is, at a white audience. It is not going too far to say that Ryman is a tradition-bound and tradition-celebrating artist, meaning an artist whose work assumes that its audience is all of one tradition, and who is quite comfortable with this limitation. And indeed, even in this multiculturalist moment one mustn't lose sight of the fact that a Western artist has as much justification as another for indulging the idiosyncrasies and hermetic obsessions of his or her own tradition, however odd they might seem in a broader context.

But perhaps this social reading is too narrow. The physics of light and color are also said to attribute a certain primacy to white, asserting that white is the first color, the container of all others, and so on. And nonwhite cultures have also produced celebrations of this idea. The Egyptian *Book of the Dead,* for example, speaks of the transformed soul in the afterlife as having a body of light, feeding on light, and dwelling among the circumpolar stars as one of them – as, in other words, white light.[28] Similarly, the Tibetan *Book of the Dead* speaks of various lights that will appear to the soul

in the afterlife, and advises that it resist a "feeling of fondness for the dull smoke-coloured light" and take refuge instead in "the dazzling white light," the light of the "Mirror-like Wisdom," which is primal and will lead it to the ultimate afterlife location.[29] Both Egyptians and Tibetans, of course, are or were nonwhite peoples.[30]

Herman Melville, in *Moby-Dick,* devoted a whole remarkable chapter to the poetic and associative meanings of whiteness. I will refrain from adding to them. The point, in any case, is that though Ryman's work throws itself open to this kind of interpretation, these are questions in which he himself is essentially not involved. Within the artist's sense of his work, white functions not as a signifier but as a condition of visibility: an aid to the directness and simplicity of the raw sense datum, which is the same for all.

THE FIGURE AND WHAT
IT SAYS

Reflections on Iconography

ABSTRACT art, especially the art of the Sublime, was regarded for much of our century as the necessary and inevitable culmination of art history, to which all past art had been tending since prehistoric times. According to this view, representational art had gradually extended its mastery over visible nature till it was complete in the mid-nineteenth century, at which point the stage was set for abstract art, through which human mastery would be extended from nature to include the realms of the Sublime and the Absolute. By the mid-twentieth-century artists such as Ad Reinhardt and Yves Klein were convinced that they were making the last physical art works, after which art would dematerialize into pure Spirit. Not the least interesting thing about this belief system is how wrong events have shown it to be. Representation and the figure, far from being obsolete, survived the period of abstraction and reasserted themselves, about ten years ago, as something we still wanted or needed.

The ideology of abstract painting was limited in ways that would have distressed many of its great practitioners if they had been aware of them. The work of Kandinsky, Mondrian, Rothko, and others seemed to imply that human problems are spiritual more than material, that they are to be solved by finding a way to relate to the Sublime rather than by working with social and political realities. It is difficult for abstract painting practiced without irony, or without emphasis on materials rather than forms, to evince any other ideology than this. Even should the artist be a political activist, the formalism of the work would still be vulnerable to the criticism that it tends to lull others into apolitical aestheticism. In that situation art seems distressingly divorced from the realities of human life – even antagonistic to them. It was

a renewed concern for such realities, in the face of ecological and Cold War threats to them, that led to the temporary banishment of painting from approximately the mid-1960s to the late 1970s. In that period, as a corrective measure, Conceptual art attempted to shift the emphasis from the abstract and aesthetic to the concrete and cognitive; performance art stressed the ethical and social. Painting's long addiction to pure aestheticism and the abstract seemed to have wrung the life from it. It was for a decade or more declared dead. When this "death" turned out to have been only a temporary exile, painting returned gradually to the foreground in representational rather than abstract modes. But representation, at that juncture, was not regarded naively as involving an objective correlation. Rather, it was approached with indirection, subtlety, and a healthy lack of trust.

The word "representation" appears to mean "presenting again," as if something were presented once in nature, then represented, or presented again, in a picture; it implies a neutral transfer of information. But of course it is not that simple. What appears in the picture is not really the thing. The picture is flat; the thing is rounded. The picture is enclosed in a rectangle; the thing exists in the fullness of space. The picture is one size, the thing another. The picture has one past and future, the thing another. The picture has one value and purpose, the thing another, and so on. It should be noted, too, that a painted picture can attain a luminosity that is at most about a twentieth of that of an ordinary afternoon out of doors. A picture, in other words, is not a real "presenting again," but a symbolic one. The quality of "likeness" in a picture is established – to a degree that cannot precisely be specified – not by fact but by conventions which vary from culture to culture. These conventions of picture viewing – picture *reading* might be a better term – are ingrained in our subjectivity in childhood and permanently affect the way we see the world. For example, in Renaissance perspectival renderings the convention was to indicate the convergence of parallels only in the depth axis of a picture, unlike nature, where parallels converge in all directions. So deeply have we been drawn into our inherited representational conventions that when we stand out of doors and look at an urbanscape with architectural parallels extending in all directions, including upward, we tend to see convergence only in depth. The reality of pictures has gotten in between

us and the reality of the world. The reality of our pictures, one might say, *is* the visual reality of our world.

On the same principle as with perspectival convergences, the way we are accustomed to seeing humans represented in pictures will have a lot to say about what we feel ourselves to be. Our pictures, in other words, make us as much as we make them. Granted their power to affect our ideas of self-hood and of relationship, representations of human beings and of the world they live in are innately political; they necessarily embody social conditions and the ideologies implicit in them.

The fact that Paleolithic artists, for example, represented human males and females very differently suggests that the sexes' social roles were very different. Females – whether intended as goddesses or mortals – were represented by corpulent (pregnant?) figures whose diminutive hands were engaged in the maternal gesture of expressing milk from

Neil Jenney, *Woodman and Woodland* (1970). Courtesy of the Rivendell Collection.

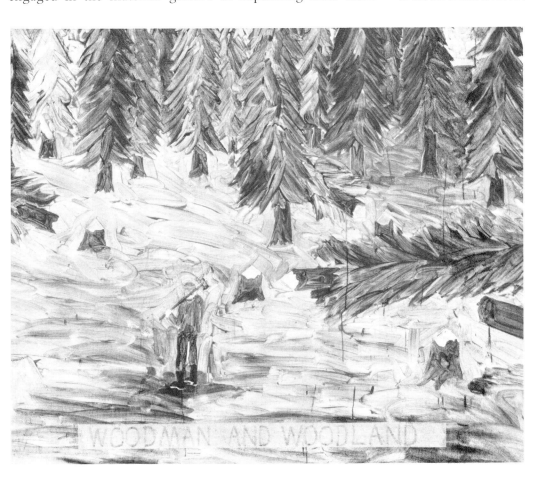

their breasts. Lacking faces almost completely, these figures did not represent separate egos so much as a generalized principle of fertility. Men also were represented as inchoate or unformed egos, tending to dissolve self-awareness into other-awareness. The Sorcerer of Trois Frères, for example, looks confusedly out at us with owl ears, feline tail, antelope horns, and so on. He is a part of the maelstrom of nature, one with the animal realm. In the rare cases when artists of this period drew human faces, they were so minimal and unformed as to suggest an ego that had hardly raised its head above the night of the unconscious.

In the early Bronze Age – the age when the first large-scale states arose in Egypt and Mesopotamia – the human figure emerged somewhat from the welter of natural species. A new emphasis on the face and eyes indicates more advanced ego development. The human figure asserted its difference from nature, and its will to control it, through increasingly orderly pictorial arrangements. The motif of symmetrical flanking placed the human figure, whether male or female, at the center of an orderly universe that emanated rank upon rank from the central figure. The figure – the hero – controls the universe with his presence by establishing and maintaining an order that reflects the human mind. This icon signifies the attempt to master the surrounding world, to tame it by Work, to remake it in an image of human effort and humanly imposed order.

In this period the human figure, whether intended as divine or mortal, was generally represented at a moment of climactic achievement. It was the monumental moment of the hero's taming of the world that was recorded again and again, and the hero was presented as if absolutely aware that all eyes were on him. The ideology underlying these representations – with their rigid centrality, their symmetrical ordering of the world around a central figure, and their assertion of the mastery of a dominant individual – is an ideology of monarchical control.

In archaic Greece both male and female representations developed new conventions and ideologies. Female icons had fixated, since the Paleolithic age, on the gesture of maternal breast-offering. This motif remained central to the representation of the human female for twenty thousand years. Then, in early Greek culture, the use of the hands changed: from offering the breasts they began to cover them. At the same time the facial expression became increasingly involved in reflection and choice. The male human at the

same time was represented completely naked, that is, stripped of external defining attributes, gazing out at the world with a curiosity and clarity of presence that no longer confused itself with nature.

Perhaps most striking, the figure was seen in a wholly new moment. Before, the figure was usually seen at moments of greatest mythic or historic tension; the Greeks introduced casualness. The vase painting by the Sosias painter showing Achilles bandaging Patroclus presents the heroes in a new humanistic orientation. They are not center stage, but off in the wings between heroic scenes. They are not posing for other people's attention, but caught as if by a candid camera at a moment when they are unaware of our gaze. They are not engaging in triumphant exploits, but are suffering and showing compassion. The ideology of emerging democracy saturates these figural representations as much as the ideology of monarchy had saturated those of the Bronze Age and the ideology of shamanism those of the Paleolithic.

In general the figural representations of any age are hidden expressions of the dominant ideology of that age. At the same time they reveal shared feelings and attitudes that may be virtually unconscious, or just emerging, in the social context. The clear outlines of Byzantine figures, for example, as well as their gold grounds and halos, speak of the doctrine of the individual eternal soul – the doctrine that the essence of a human is to remain eternally separate from others, eternally himself or herself. It is the opposite of the

Robert Longo, *White Riot I* (1982). Courtesy of the Rivendell Collection.

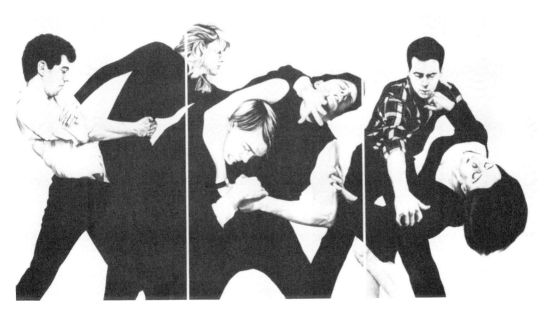

Paleolithic Sorcerer who is sinking at every moment into the primal swamp in which species mix and merge. The cultural meaning of medieval Christian art involves the fact that the figure exists in an unreal space while neither the figure nor the artist is aware of this fact. The disjunct and non-perspectival space of medieval art was out of historical sequence. Perspective had been a trait of Greco-Roman wall and panel painting, and again in the Renaissance became normal as a way of visualizing space. Yet in the Middle Ages it was, significantly, forgotten.

The use of perspective signals two things: first, that the subjective point of view is built into the picture, and second, that the subject clearly sees itself as outside the picture, as looking at a world which is separate from it and yet to which it is related through the act of seeing. In non-perspectival renderings the object is apt to keep its own integrity rather than be taken up into the distortions of subjectivity – as nowadays in axonometric renderings. Perspectival rendering is a mode of mastering nature through pictures, as much as was the Bronze Age hero-picture. The ego dominates the world by gazing at it and coopting it into its subjectivity, that is, into the distortions of a point of view. A world without perspective is not subject to human control. It has its own presence which it will not compromise for our subjectivity; it exists in its own ways that our seeing cannot divine. Something of the prescientific and prerational aspect of medieval European culture is reflected in its portrayal of the figure and its surrounding space.

In European painting since the Renaissance the figure–ground relationship has emerged as the central element expressing the relation of the ego to the surrounding world. When the ground asserts itself, rising up and enveloping the figure, the ego seems to be sinking into a sleeplike dissolution; when the figure asserts itself and stands out in sharp clarity from the ground, the ego seems to feel itself as a subject with its own integrity experiencing the world as an object clearly separate from it. The clear outlines of the figures in the work of Ingres or David contrast in this way with the ragged edges, beginning to open into the ground, of figures in Delacroix, or the figure's approach to the color of the ground in Whistler, and so on.

Modernist abstraction attempted to convert the ground into a non-illusionistic surface, to acknowledge the surface as a real physical presence, as opposed to the representational disguise of the surface as a window into space. It was be-

lieved that this tactic could empty all content from a painting, opening it to the ineffable absolute. But this was to a degree a mistaken belief. There was content in the flat surface that went beyond acknowledgment of its physicality. The abstract art of the flat surface was involved in a two-dimensional or schematic type of representation related to the reading of flow charts, graphs, mandalas, and Islamic cosmograms. A Jackson Pollock drip painting, for example, models reality as made up of perpetual flux, dissolution, and lack of fixed identity; a Mondrian, on the other hand, presents it as static, ordered, and clear. It was the misconceived belief that abstract art represented nothing that made it seem the final term in a semantic series. But this belief that it had no content was a means to hide its content as ideology. It became in time a repressive belief, denying the honest meanings in human life. After three generations of abstraction the figure climbed up out of the flat surface and again confronted the world around it.

Nicholas Africano, *Photographing* (1977). Courtesy of the Rivendell Collection.

Much of the meaning of recent figuration – much of what it had to come into being to express – is centered in its portrayal of space. In the work of Alex Katz and later of Neil Jenney and the New Image painters, the figure lies within a depthless plane which is still the acknowledged surface of late abstract painting. The figure is emerging from the ground, but the ground has not yet opened up to disclose an illusionistic space for it to move in. The figures either look mutely out at us as if lacking room to express themselves – like Katz's *Ada in Blue Housecoat* (1959) or Jenney's *Woodman and Woodland* (1970) – or they are so helplessly locked in shallow space that they are unaware of us watching, unaware, that is, that there is a larger world and a possibility of a freer space than their own. Robert Longo's *Corporate Wars* (1982) and *Untitled* (White Riot Series, 1982) involve the narrow space of tragedy and entrapment; the figures are fighting, in a sense, for the slight amount of available space behind the surface or within the low relief. In Nicholas Africano's *Photographing* (1977) and *Battered Woman Series* (1978), the figures seem even more desolately trapped. Usually seen in profile, they are unable to look out of the painting and express themselves to the outside world. Like Achilles and Patroclus in the Greek painting, they are unaware of our looking at them, caught in their own world of private suffering. Yet the tone is darker; the shallow space has become less a space for intimacy than a symbol for human captivity, for society as a nightmare, inescapable because there is no place else to go.

Georg Baselitz, who was painting in a mode roughly figurative before the recent wave of neo-figuration put his work in a stylish context, brings space in even more tightly around the figure, in the form of the heavily textured and oppressively present ground. The surface of the picture plane is worked in layer upon layer of paint, with marks of dragging everywhere suggesting violent discontinuities within it. It surrounds the figures like a palpable substance thicker than water. Space simultaneously oppresses the figure, giving it no direction to move in without encountering resistance, and constitutes the figure by pressing in around it and holding it together: the thing that holds the figure's selfhood together is also the thing that torments it. The figure's embeddedness in the ground signifies the intensity of human involvement in life and, as a correlate, the unavoidability of being trapped in the environment – whether historical or social – which presses in terrifyingly on all sides.

In other paintings of the last decade space did open up –
but with odd disharmonies. In Anselm Kiefer's work, for
example, vast spaces open out from the canvas – often per-
spectively rendered spaces that recall Renaissance assertions
of ego clarity and confidence – but usually without human
figures in them at all. There is a disunion between the figure
and its world. Either – as in the works of Katz, Jenney,
Africano, and others – the figure has no world to move in,
or – as in Kiefer's – there is a world but no figure willing to
inhabit it: the figure is sensed lurking outside the frame,
evidently afraid to occupy the space offered – afraid of the
future that might unfold within it. Roger Brown's work, in
which vast spaces are shown with tiny people running about
in them, often fleeing from a disaster, is part of this disunion,
as is April Gornik's empty ritual scene, *Two Fires* (1983).
The upside-down presentation of the figures in Baselitz's
recent work serves both to abstract them, obscuring them as
figures and embedding them more deeply in the surface as
paint, and to add specific human content – of confusion,
relativity, lack of sure footing. Baselitz's *Flügel (Finger-mal-
erei)* (1972–73) is figuration at the very edge of abstraction.
The figure is almost not a figure; it has no structure to hold
it together. Usually Baselitz's figures are compressed to-
gether by the thickness of surrounding space to keep them
from disintegrating. Here the wing is like a thing barely
materialized out of torn patches of color. It suggests an

Anselm Kiefer, *To the Un-
known Painter* (1983).
Courtesy of the Rivendell
Collection.

inability to fly or a bird torn apart in flight, or a bird located just outside the frame, of which we are glimpsing, off to one side, a single stroke of a wing beat.

Fragmentation of the figure is another basic element of the new figuration, alongside its entrapment within inadequate spaces. Jannis Kounellis's broken classical heads, *Untitled* (1980), seem to declare the wholeness of the self irrevocably gone. The fragments of selfhood lie on a shelf, waiting to be put together again as in an archeologist's shed, but there are not enough of them. Tony Cragg's *David* (1984) combines fragments of modern urban detritus in a reference to the loss, in contemporary art, of the wholeness that the figure had in both Renaissance and Greco-Roman times. The reference includes suggestions of the decentering of the self in late industrial society and of the attempt to hold it tenuously together by the memory of classical selfhood. Julian Schnabel's work also involves broken classical fragments, incomplete classical statues, and references to archeological sites in the accumulations of broken ceramic ware like potsherds. Susan Rothenberg's incomplete people and animals in *Upside down and sideways* (1979–80) and *One Armed Float* (1981–82) evoke the fragmentation of the self and – its artistic correlate – the impossibility of representing a thing in its fullness. David Salle's layered images suggest a semiotic model of selfhood as a temporary situation created by the imposition of transparent code-bearing overlays on one another.

The disunion at the heart of much recent figuration is the center of its profound meaning. A return to the figure usually signifies a new moment of humanism, a new need to redefine or readjust the human self-image for a type of activity or a sense of the world that it has not had before. But much of the new figurative work is a negative or renunciatory figuration, expressing deep misgivings about the situation of being human in the late twentieth century. This is partly because of the pressures of history: because of World War II – which has left a deep mark on the idea of humanity everywhere, though more consciously in Europe than in America – and because of World War III. Kiefer and Clemente represent two opposing responses to the pressure of history.

Kiefer presents materials from German myth and history in an atmosphere of *Götterdämmerung,* or Twilight of the Gods. The subject is the Nazi holocaust and the work is an attempt to face it and exorcise it at the same time. This can hardly be done in any humanistic frame of mind. Hence

Tony Cragg, *David* (1984). Courtesy of the Rivendell Collection.

Kiefer's meanings are never precise; something remains open in the message of the paintings which suggests the uncontrollability of things. The stage is set, but there is no way of setting what will transpire on it. *Urd, Werdandi, Skuld* (1980) shows three figures, barely recognizable as such, wrapped like corpses or mummies and burning like logs, whom the title identifies as the three Norns of Old Germanic mythology – figures which equate roughly with the three Fates of Greek myths. Kiefer also used the burning log to represent Brunhilde. What is keeping the fire going is the old Germanic myths; at the same time, they are burning themselves up.

Clemente represents an opposite approach to the problem of being a European artist after World War II: rather than relating to recent history his work tends to leap over it – as Renaissance art leaped over the Middle Ages to an older source – to a level of primal or archetypal imagery often involving ancient cultural settings. He mixes references to ancient, Renaissance, Indian, and expressionist work with references to alchemy, astrology, cabala, tarot, mythology and Roman Catholicism. He evades his Italian background by diffusing attention worldwide and escapes history by entering the occult. But in so doing he must acknowledge, as much as Kiefer does, the uncontrollable negation present in things. As opposed to history his works suggest cyclicity, a situation in which neither hope nor despair but acceptance is appropriate. In Hegelian terms this art attempts to escape the sphere of Work into the sphere of madness or nature. Clemente often reverts to the older traditions that combined human and animal elements – a man with horns, a fish speaking to a man, a naked man with birds on his shoulders. His central theme is fertility, but this is only the other side of the theme of aggression, which is its negative correlate. Generation, birth, death, sacrifice, and regeneration combine and recombine while never assuming a semantically fixed form. There are hints of narrative but they are never resolved. In *Sole Cadente* (1981), a naked woman is being kissed by a donkey in front of a huge setting sun. The sun just over the ocean – almost mingling in it – is the scene for cosmic beginnings and endings; it is the place where the cycles reverse and turn into each other. A first or last kiss or generative act is being performed between a totemic animal (the donkey classically represented lust) and a humanoid goddess. The donkey's position is both that of a flayed skin – the donkey's death – and that of the "displayed female"

icon signifying sexual intercourse and birth giving. *This Side Up* (1980) is a self-portrait in which the artist presents himself naked and without a penis. His heart is outlined on his chest while behind him a book, which he seems to have just flung with his left hand, shows quasi-alchemical images of serpents and a crescent moon. With its right hand the figure points to himself, or perhaps to the revealed heart, in a

Francesco Clemente, *This Side Up* (1980). Courtesy of the Rivendell Collection.

gesture like Christ, an Ecce Homo gesture. His stomach is soft and vaguely feminine, as is his posture. Death and castration and sacrifice are celebrated in a space that is outside of history or that does not acknowledge it. These are the scenes that are not shown on Kiefer's readied stages, which are within history and hence cannot look at history's inevitable failure to truly tame and master nature, the very aspect of life that Clemente is celebrating.

In America also much of the new figurative painting has carried a weight of weariness with the figure and its activities – its humanness. Eric Fischl's work is about sexual repression in society – a theme which, like Clemente's fertility theme, has violence as its other side. In *Digging Children* (1982), he portrays children playing on a beach as a kind of savage ritual, bringing repressed sexual material to the surface. The children seem to be preparing to bury someone or something just sacrificed. The title suggests not only that the children are digging, but also that the viewer may be voyeuristically digging their little upturned asses; they are, in other words, treated like catamites.

The critical edge of the new figuration frequently involves evocations of specific cultural codes with open acknowledgment of their ideologies, explicitly rejecting the naive idea of a neutral representation. Fischl's pictures often involve references to filmic camera angles which bring with them a momentary sense of watching a film and hence of the semiotics of film. His scenes sometimes look like 1950s or 1960s Hollywood suburbia, yet his content lays bare the psychosexual repression that underlay that period of the Hollywood classical cinema. He shows on the surface what they most tried to hide, what, in effect, they brought to the surface all the more by their conspicuous attempts at hiding. Thus Fischl's work functions as a kind of social criticism with references beyond the world of painterly aesthetics.

Richard Bosman's work relates still more openly to popular semiotics. Often his images come from gangster comic books and the related semiotics of boys' novels and film noir. He brings out into the open the ideological presence that naive representation attempts to hide. *Tracks* (1984) is a comic book–like image of a man following a track in the snow with a gun in his hand. What is most disturbing about the figure is that it hides its meaning in the semiotic of the comic book and the genre film; it cannot be grasped directly but only through some prepackaged code. Its selfhood and its will have been coopted by social packaging. Acts of vio-

lence, the picture suggests, are robotically performed by minds in the sway of mass media. Ed Paschke's figures, as in *Tropanique* (1983), have been virtually recreated by mass media, above all by the distortions of TV, which have turned them into something barely recognizable as human. Steven Campbell's kilted wanderer stumbles through a black comedy in which the human condition is a pratfall in a children's book.

Much of this work expresses the burden of the past less than anxiety and concern for the future. Judging from the context provided by the rest of Jonathan Borofsky's work,

Eric Fischl, *Pizza Eater* (1982). Private collection. Courtesy of the Mary Boone Gallery.

for example, *Green Space Painting with Chattering Man at 2,841,789* (1983) involves the threat of apocalypse. The chattering man is gazing into the vortex of the end, the nothingness of nuclear annihilation. He chatters on, blindly subject to language and thought, saying nothing meaningful in the face of his imminent end. Robert Morris's *Untitled* (1984) directly portrays the firestorm of nuclear holocaust. Jedd Garet's figures in *The Last Couple* (1980) and *Flaming Colossus* (1980) survive featurelessly into a nuclear sunset world of civilization's endgame. Jean-Michel Basquiat's primitivist figures with chaotic overlays of half-understood language suggest a savage-like state of post-literacy and post-civilization. The most recent representations of humanity share something with those featureless and undefined earliest ones of all, those from the Paleolithic age.

At this close of a millennium our critical awareness of the relativity of modes of representation has created a new and more useful type of representation. Naive representation – representation that is believed to objectively represent reality – is a kind of dream or hypnosis or wishful thinking. The post-Modern form of representation is not to attempt to represent things in the world but to represent modes or styles of representation: the film, the comic book, the classical painting, the advertising mode. This process constitutes a review of the various dreams of what humanity is, with constant awareness of their dreamlike status. As representation has become self-critical, its ability to shadow forth the problems of the society around it has deepened. There is something like an end of the age – end of the world? – inventory to this parade of the various dreams of ourselves that have historically passed as ourselves. Recent representational painting has revealed not only the shifting status of representational modes or points of view, but also a deep anxiety about human nature and the future of the shared human project of civilization. Human identity is the ultimate subject of all representation, and, at the moment, that subject matter is an empty place around which the various dreamlike approaches to reality cluster. The art of our time has offered us, in place of the simple pictures and definitions of the past, a meta-picture involving multiple models that constantly shift and balance and, to a degree, negate one another. There may be a picture of the future here, but it is at present still a picture that is shaped by negation – a picture that cannot yet be directly seen.

THE CASE OF JULIAN SCHNABEL

Painting, Modernism, and Post-Modernism in His Oeuvre

IN the nineteenth century, history was viewed as a more or less linear progression toward a goal that was loosely defined yet awesomely impressive. The philosopher Hegel formulated this goal somewhat mythically as the self-realization of universal Spirit, which was to be accomplished through history and would also constitute the end of history, through attainment of the perfect state. This process, it was believed, would not unfold entirely spontaneously. It needed human assistance, and this is why Hegel called history "Work." Will was the essence of getting the Work done. To put history over the top, certain human leaders of special importance ("world-historical individuals") would have to exercise Will with a focus and intensity that go far beyond the ordinary, that are, precisely, heroic. What is necessary for such an exercise is an heroic selfhood crystalline in integrity while rugged enough to enforce its designs on the world. Napoleon was the great example and Beethoven's *Heroic Symphony* the affidavit.

Responding to the socio-political macrocosm around it, the art world redefined itself in terms of heroic selfhood, the Work of history, and the Goal. A metaphysical, crypto-religious way of talking about art became common. Hegel himself, for example, said that great art was the embodiment of the absolute; it already contained in some way the goal that history in general was driving towards. That this was a contradiction in terms (if it is embodied, it is no longer the absolute) did not trouble anyone at the beginning of the Romantic era. A. W. Schlegel who, along with his brother Friedrich, first defined Romantic art, described beauty as "a symbolical representation of the infinite." Hegel's friend and colleague Schelling brought the contradiction back into the open, saying that art was the resolution of an infinite conflict

in a finite object. More importantly, Schelling proposed a revision of priorities that would have tremendous influence. Kant had said that the aesthetic, ethical, and cognitive faculties were equal and separate. Hegel agreed more or less when he said that art, religion, and philosophy were three equal channels to Spirit. Schelling, however, said that the aesthetic faculty was the highest, the most innately spiritual and transcendent, and this was to be a characteristic belief of the Romantic era. Hegel had emphasized the nation state as the means of advancing Spirit. Yet the elevation of art above all other human affairs almost forced the conclusion that art, not statecraft, is the activity most suitable for attaining the goal of history. This idea was intensely appealing to artists, poets, and their admirers. It found expression in Percy Bysshe Shelley's famous claim that poets are the unacknowledged legislators of mankind. Though politics and the state might be the mainstream, the hidden avant-garde that led them onward was made up of visionary poets with their eyes fixed on the beyond. For the Fine Arts, Hegel's student Karl Schnaase formulated a parallel doctrine that remained, however hidden, a part of the foundation of Modernist art theory and of the exalted Modernist view of the artist's role. Loosely expressed, the doctrine was that the destiny of art is nothing less than to be a force that forges ahead of the rest of society and leads or drags history towards the moment when all nature will be reabsorbed into Spirit. The universal culmination, then, was not really to be attained through the efforts of statesmen, though in terms of exoteric history it may seem so; the pathway to its attainment was first to be explored by the efforts of artists, who alone work with the highest human faculty and whose productions actually contain reflections or microcosms of the absolute. The poet by placing one word beside another, the painter by placing one colour beside another, could effect ontological changes. In the specialized cult of the arts that grew in proportion as the authority of Christianity declined, these were the new world-historical individuals. That Napoleonic Will that would lead history to its culmination would be, therefore, not military or political will conquering and unifying nations, but aesthetic will engaged in the solution of formal problems through intuitions of the Unspeakable. The truest hero would be not a soldier, or leader of masses, but an artist bold in his lonely quest for the absolute. I say "his" because one consequence of this doctrine was the continued exclusion of women, whom our inherited tradition does not warrant as heroes,

from serious consideration in the art-making activity. In the Romantic ideology, if an artist is not a hero exploring the transcendent unknown, then his or her work is not engaged in the sublime quest which it is the highest destiny of art to fulfill.

It was just the moment, or century, for such a myth to take hold. Darwinism and the Industrial Revolution seemed to prove that a linear, upward directionality, an actual force of progress, was inherent in both nature and culture. A general decline in the influence of established religion over the preceding century had created a climate in which spiritual intensity was available to be channeled into other activities. The religio-spiritual approach to poetry and the arts, as Matthew Arnold noted, buffered the shock of de-Christianization. The development of industrial states left in its wake countless alienated individuals for whom such a private way to feel more important than the leaders of those states, at least in one's own mind (like Goethe's Werther transcendently enchanted by the literary hoax of the Ossian poems), offered the most intense gratification.

In painting, the mid-nineteenth-century realisms fostered an inspiring addendum, one which is also basic to the myth of Western art history. According to this myth, articulated by Roger Fry and others, art since the Stone Age has striven for the objective representation of nature. This was its first great project. Around the time of Giotto this quest became increasingly focused and remained so for four hundred years. A major milestone was the development of perspectival rendering in the Renaissance (somewhat aggressively ignoring the evidence that it had already been used by Greek and Roman painters, lost in the Middle Ages, and regained from rediscovered classical sources in the Florence of Alberti and Brunelleschi). With that event, the myth goes, the objective rendering of the external world first became possible; over the following centuries modes of representation worked steadily towards complete objectivity, which was attained at last with the mid-nineteenth-century realisms and early Impressionism. At that moment art, having mastered the representation of nature, was driven, by the inner directive of its historical destiny, to transcend it. Having mastered nature art must enter Spirit directly. The stage, in other words, was set for abstract art, which would extend the mastery of representation from physical nature to the sublime and the absolute. This was the grand and sacred vocation of abstract art, nothing less than the attainment of pure

Spirit and the culmination of history. It was this that lent such fervour to formalist pronouncements, and such breathless excitement to the work of artists who, like Jackson Pollock, for example, were regarded as "world-historical," as altering by their work the whole history of the world.

Of course, a heavy dose of Christian millennialism was hidden in this myth; the restoration of Eden can be sensed in the end of history, the second coming of the Messiah in the role of the hero, and so on. In the continuing decline of Christian authority and the increasing alienation of the individual from the ever larger, technological state, this doctrine exercised a powerful sway. A central current of twentieth-century art developed under its spell. Kasimir Malevich and Wassily Kandinsky believed all or most of it at some level of their personalities, as did Piet Mondrian, Lucio Fontana, Yves Klein, Barnett Newman, Mark Rothko, Jackson Pollock, and countless other Modernists of transcendental inclination. Formalist criticism, which always involved a religious kind of feeling, assumed it for the most part, though it sometimes remained unspoken. The myth strode among us like a veritable god, a god built, of course, in our image and answering to our sense of self-importance. It said that we were free to bring history to heel before our dream of Eden. By mid-century its enchantment was so intense that artists such as Yves Klein and Ad Reinhardt could believe that they were making the last, or next to last, artworks, the works that would herald and precede the final absorption of nature into Spirit. The incredible psychological pressure of this Messianic/prophetic role is one of the sources of the extremity of anxiety that characterizes so much twentieth-century art and the lives of so many artists committed to the Work, and is the principal source of our obsession with the artist's person.

The delusion was deeply out of touch with other important currents of twentieth-century thought, like a holy relic lying in an automobile showroom. Since the eighteenth century there had been another aspect of Modernism, not transcendentalist but sceptical, positivistic, and critical in thrust, which had been undermining mythic claims about the self and history. From David Hume to Jacques Lacan the self fell prey to various dissections and analyses. Marx broke it down into by-products of impersonal socio-economic conditions. For Darwin it was the result of biological forces. Freud saw it as a bag of disconnected and warring energies, none with much personality. For behaviourists it was a machine to be

programmed. Structuralism and post-Structuralism saw it as a more or less random group of superimposed codes. Yet still, in the theology of formalist Modernism, the myth of the world-historical individual survived, and so great was the spell of the heroic myth that much of the ambient culture, encountering it for the most part only in movies like *Lust for Life,* was grudgingly impressed and let it be.

The influence of this myth peaked in the 1950s, when the immanence of pure Spirit seemed palpable in the charged air of Abstract Expressionism. The crises of the 1960s forced a revision. As so many attempted to be "world-historical," to lay their hands directly on history and bend it to their will, but failed, the myth lost credibility. What is called the transition to post-Modernism occurred at the moment when significant numbers of people realized with surprise that they no longer could believe in the inherent force of progress, the exalted mission of history, and the inevitability of its accomplishment. Those critical forces that had already been present came to the fore, and were now called post-Modernism.

This major change in cultural attitude emerged in phases; in the opening or transitional phase, which might better be called anti-Modern, every major element of the Modernist myth was reversed. The belief in progress came to seem a dangerous superstition that had led, through blind faith in the value of technological advance, to a century of global wars and the development of endgame weaponry that was truly sublime in Edmund Burke's sense of dark, vast, terrifying, infinite, and annihilating. The idea that evolution involves a direction and that history has a particular shape inherent in it came to look like wish-projections. The idea that art is the primary means of access to spiritual advancement came to feel like a mystification that served a variety of purposes, not only buffering the shock of de-Christianization but also, more sinisterly, eliminating art as a force for social change. Seen in this way post-Modernism is an attempted corrective to the myth of Modernism, which by its apotheosis of human Will had led practically to the ruin of the world and the discrediting of the whole project of civilization.

What we have not seen so clearly is that the term post-Modern itself involves an element of wishful thinking. It implies a new age, whereas history suggests that what we are calling post-Modernism is probably only an oscillation in a process that has been going on in the West since the faith–reason controversy in the twelfth century. This

process, which underlies much of the peculiar dynamic of Western culture, is a constant wrestling between the Judeo-Christian and Greco-Roman limbs of our heritage, one of which always has the upper hand. These are the forces reflected, respectively, in the conflicting transcendentalist and critical urges of our culture. What we have called post-Modernism may be only a temporary ascendancy of the critical over the transcendentalist mood. There is no telling how long this end of the oscillation will last, but it may not be very long.

Around 1980 signs of a resurgence of Modernism became so prominent that they could not be ignored. In the art world this resurgence centred around so-called neo-Expressionist painting, which was received as the polar opposite of post-Modern appropriational art, and around Schnabel in particular. The extraordinary intensity of feeling about him as an individual, or rather about his conspicuous career success, derives from an exaggerated sense that his celebrity actually endangers history, or anyway that it is an expression of a real danger to history, by reestablishing the notions of Will and artistic heroism that we so recently escaped from.

In the brief age of the ascendancy of conceptual art, of course, the death of painting was widely proclaimed. Painting brought with it the whole ethical burden of Modernism and its failure. To paint was to be regressive. Yet painting did not go away. Our culture showed a profound and intense need for it, perhaps in part because the problematics of our culture had articulated themselves visually through painting for at least five centuries and it is therefore in painting that they can be immediately confronted. Still, the function of painting changed. Post-Modern painting evolved types of works whose motives were very far from those of Pollock or Picasso. In America and Great Britain particularly, painting came to be practised with a conceptual deconstructive force that revealed itself in various ways, including quoting and simulation, the prominent incorporation of verbal elements and, less frequently, elements of performance very different from action painting as performance, and the inclusion of a variety of contents that signified social involvement and a critical stance towards classical modernists' myths such as the heroic self. But Schnabel's work, like that of certain European artists today, demonstrates something like an old-style enthusiasm for painting. His first New York show, in 1979, was perceived as instrumental in what was called,

apocalyptically, like the Second Coming, "The Return of Painting," that is, of painting that wished to continue the Modernist line instead of deconstructing it. The post-Modern dread of, and rage at, Modernism singled him out as the new champion of the old-style self and its disasters. As Modernism resurged, he was seen as an enemy of women artists, of conceptual artists in whatever form, of critical rather than visionary art, and so on. His personal career interacted violently with the struggle between two views of history, as he was tossed about by the waves of the moment.

Prominent among those waves was the shifting of the market. Since transcendental Modernism was more saleable than deconstructive post-Modernism, the resurgence of Modernism was seen by some as brought about not by artistic but by market forces. The market success of Schnabel and others suggested they were childishly complicit, that is, that they were being used and going along with it. Meanwhile what was taking place under the guise of their self-expression was the forced return of the feeling of isolated heroism, of heroism not dependent on the web of events but transcendently confident in its ability to make events dependent on the hero's will. The dramatic suddenness of the neo-Expressionist flood, with Schnabel at the crest of the wave, lent it an air of heroic or Napoleonic conquest.

Yet this heroic air, many suspected, was itself faked. According to this view, the original Expressionists had indeed attained a totally direct unmediated apprehension of things, an eye that saw with the innocence of the child in romantic poetry, and so on. The neo-Expressionists of the 1980s, on the other hand, hopelessly corrupted by money and media, feigned ersatz simulations of the products of such childlike vision. To this way of thinking, neo-Expressionism seems an ultimate betrayal of art's claim to an innocent vision, an ultimate sellout of expression to pretence. Hidden in this view is the unconsidered assumption that a completely innocent expressiveness is a real possibility. One can sniff a trace of transcendentalist. Modernism in that assumption, a misty-eyed Utopianism masking a traditional Christian yearning for Eden. To postulate an unmediated direct apprehension is to postulate a consciousness just born an instant before, not yet imprinted with prejudices, associations, and a mixed bag of motives pulling in different directions. It is a variant of the myth of the hero who grew up in the forest and emerged from it a great singer because he had been talking with the birds throughout his childhood. The old

romantic myth of the innocence of the artist, of the artist's freedom from ordinary causality, is hidden here. But innocence, of course, is not required for expression, and may even preclude it (what could an innocent have to express?). A true innocent must not even have been exposed to the corrupting categories of language. When Kandinsky, Nolde, Kirchner, and others talked of pure, instinctive, immediate expressiveness they were, of course, fooling themselves. This is not to say that they did not enter states of intense concentration, but that such states are not primally innocent and are, furthermore, still available to an artist, or to anyone else, today.

Beyond the invocation of market forces, little has been written about how neo-Expressionism relates to its age. The answer is to be found not by looking angrily at photographs of young media-celebrated artists, but by looking analytically into their work. History expresses itself in the work, and the self reveals itself through the sense of history. In the last decade the subject of history has dominated much art, not just art history, or our own history, but the question of the whole nature of history: is it a force? a presence? a projection? a fantasy? a myth? a con game? What shape does it have (if any)? Where is it going (if anywhere)? What kind of hold does it have on us, really?

Abstract Expressionism displayed a related concern with self and history, but in a different mood. In that case, metaphysical approaches to time, and sublimist approaches to the idea of an ultimate origin, were the characteristic products. The heroic self was presented as attaining the sublime and being dissolved in it. As history, in the Modernist view, will end by transcending itself, so will the hero. It is the end of the hero's activity to have used self to such extreme purpose as finally to transcend it by an arrival or return to the absolute source of all selfhood. Pollock's *The Deep,* Newman's *Day One,* and countless other works of the era, celebrated this idea. These approaches have since been rendered archaic by the ascendancy of a more critical, less transcendentalist attitude. Artists have been processing instead, in visual and other modes, critical, questioning, doubting, or inquiring approaches to the theme of history. There is a rich range of positions available between the metaphysical version of history, which believes that it is a force with an inherent direction and meaning, and, at the other end of the spectrum, a purely critical or phenomenalistic view which holds simply that moments follow one another with no shape, direction,

or meaning to the process except those which we might project onto it. At one end of the spectrum we find artists like Kounellis, one of the great exponents of the subject of history, whose approach is primarily a classical Modernist one. He wants artistic and social commitment to the Modernist idea of progress. At the other end of the spectrum are the works of the appropriators, which openly confute the idea of the shape of history, reducing it to absurdity and attempting to neutralize or de-mystify our view of it. Schnabel's work falls in-between. It is an expression of a moment when one view of history is just giving way to another. His approach is neither that of an unreconstructed Modernist nor that of a detached post-Modernist. He represents a position that mingles elements of Modernism and post-Modernism – a position that seems, really, that of most of our culture. Spokesmen for one position or the other tend to present them as absolutes, giving the impression that one is either a Modernist or a post-Modernist and there is nothing in-between. There is a classical Modernist puritanism to this approach which invalidates it from the start as an instrument with which to measure post-Modernism. In fact, except for the crystalline utterances of spokesmen, the whole culture is strewn along that confused ground in between.

One of the characteristic motifs that recent art has used to portray relations between self and history is fragmentation. This motif is central to Schnabel's oeuvre, appearing most obviously in the so-called plate paintings. In these works a wooden ground is prepared by fixing broken ceramic ware to it with Bondo. Some shards lie convexly, some concavely, some stand out at an oblique or right angle. Paint and a variety of other materials are applied over this ground. Some critics have felt that the images that appear on these grounds are less important than the grounds themselves. It is in any case true that whatever image appears in these works must lie upon that ground, and that the ground is itself a signifier through which the image must be seen and understood. The ground contains the images not only physically but in their meaning.

The first significance of the crockery ground is its brokenness. It presents an underlying condition of brokenness as the screen onto which any and all images must be projected. This brokenness, while by no means identical to Pollock's allover drip ground, is related to it. After a period when awareness of their content was repressed, the drip grounds

have rightly been recognized as cosmograms signifying, roughly, the dissolution of all things into one another. They are metaphors for a state of ontological non-rigidity in which the identities of things are continually reprocessed through a single vast flowing continuum like Heraclitus' river. The individual identity of a part is submerged beneath the massive statement of the process as a whole. Schnabel's ground of broken shards comes from Pollock, but mediated by the discontinuous grounds of Rauschenberg's combines and collages, where separate entities momentarily form out of the flux of images, then break apart by its ambient surges and tugs. Schnabel's ground of shards is broken first, fluid second. Figures seen upon it are fragmented by the underlying brokenness of the ground of being. It is not a Modernist postulation of a whole and enduring selfhood that is presented in these works, but a feeling of fragmentation. The plate paintings are related, for instance, though with different feeling and tone, to Tony Cragg's use of fragments to build up decentred figures, or to Kounellis' use of fragments to suggest the brokenness of cultural norms in the late Modern world.

But the significance of Schnabel's ceramic-shard ground goes beyond fragmentation. Lay one of these paintings down on the ground, rather than hanging it on the wall, and it ceases to be a painting and becomes a sculptural representation of an archaeological site, particularly of Neolithic and Bronze Age sites which are characterized above all by the

Julian Schnabel, *The Mud in Mudanza* (1982). Collection of the artist. Courtesy of the Pace Gallery.

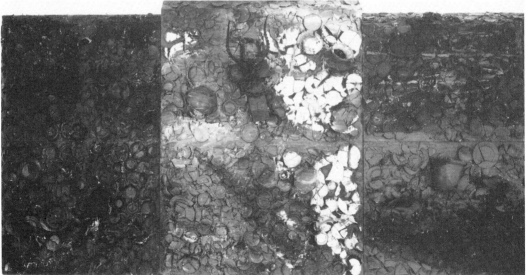

massing of broken ceramic shards sticking out of the ground
at all angles. *The Mud in Mudanza* (1982) most directly and
clearly conveys this content. The ground is itself an image.
It is the loam of history that lies there among the gaping
vessels that seem to come from another age. It is the dissolv-
ing and fertilizing ground of the past on which we raise our
brief constructions, which are equally to be broken down
into the death–and–life swamp of the archaeological rubbish
dump. The themes that surge and flow through the tumul-
tuous grounds are: history, the rise and fall of cultures, their
relativity, time as seedbed of both past and future, the feeling
of history flowing like a sewer, and so on. The fact that the
shards are not really from ancient ceramic wares (though in
some cases, like *The Mud in Mudanza,* they look that way)
but contemporary ones, usually brand new from the stores
and sometimes still bearing labels or price tags, focuses the
onslaught of ravaging time onto our own moment. It is our
own dream of history that is sinking into the broken scrap
heap of the past before our eyes. Images that appear on such
a screen are almost transparent. They seem to hover in front
of the ground, already broken, scattered, decentered. They
peer at us not as they were when they were themselves, but
as the broken relics of selves that could not hold together
through the storm of time, that were broken down in the
crucible of nature to be reprocessed into other things. This,
not heroic selfhood, is the basic ingredient of the iconogra-
phy of the plate paintings.

There is a certain thoroughness to the relentless way this
motif is worked out. *The Mud in Mudanza* presents the ground
not as a bearer of an image or signifier, but as an image or
signifier in itself. In *The Sea* (1981), the ground of broken
crockery becomes a metaphor of itself. Time is presented as
an ocean of ruins falling always from the past upon the
present; it is an oceanic process without internal order or
necessity, subject only to constant random reorderings like
the reordering of flotsam with each tide or, more precisely,
each wave. In the world's literature the sea is a traditional
metaphor for the ground of being. Here the aliveness of the
ground itself precedes any image upon it.

Despite imprecations of his images as disordered, mean-
ingless, and purely gestural, Schnabel presents an iconogra-
phy. It is not one that can be added up piece by piece, but
one that works by a sense of superimpositions, restatements,
or semantic overlays of a small group of closely related
concepts. The theme of the fragment redoubles itself through

these layerings. In *Blue Nude with Sword* (1979), fragmentary classical columns torn out of their architectural setting restate the motif of the rise and fall of civilizations. The theme of the fragment appears in three layers: the ground, the representation of classical ruins, and the fact that the imagery itself is a quotational pastiche of historical fragments. The nude warrior poised on the two columns like a living sculpture is a figure from Pollaiolo's *Battle of Naked Men*. The incense- or oil-burning column is copied from a paper coffee cup. The merging of high and low cultural elements from different eras acts out the randomness of cultural dichotomies and sequences. Human selfhood falls to the passage of time as the blood-red head falls to the ground. The swordsman's apparent heroism is mocked by his placement on a sculpture pedestal: heroism is presented as an artifice. His is not a free, personal exercise of will; it is the process of time and change working through him. It is the violence that drives history, or is history, that sends the bloody head to the ground beneath the swordsman's strike as beneath the scythe of time.

Ancient philosophy featured the concept of a fecund metaphysical Oneness, or infinity, which was often pictured as a constantly moving self-adjusting oceanic abyss from which figures are thrown up momentarily like waves on a surface, then sink back through the law of time, which always balances the One, never giving out without taking back. This concept has also had a powerful presence in classical Modernist painting; it underlies the metaphysical monochrome tradition and is often involved in the related cult of the ground or surface. Pollock's allover ground expresses something like this; it asserts the primacy of the ground over the figure, or dissolves the figure into the ground. The figure is located within a flux which denies fixed representation. In the classic drip paintings Pollock shows us the oceanic ground alone, no figure rising from it or sinking into it. In the later paintings with implications of figuration, the flux seems to halt briefly and unpredictably before dissolving again. Schnabel's works are also involved with this concept, in the ground, in the iconography of the figures, and in the relation between figure and ground. The decaying and fertile archaeological-site ground is like the ocean of time from which the blue nude leaps into being and into which his adversary, balancing, falls. Recurring images of broken classical statues, columns, and column capitals extend this archaeological theme through much of Schnabel's oeuvre.

There has of course been a surge of reprocessed classical imagery in recent art both in Europe and in America. The theme of the fragment dominates much of this work. One is reminded of the use of classical motifs as icons by Anton Raffael Mengs (1728–79) or of classical ruins by Giovanni Battista Piranesi (1720–78). There are interesting similarities and differences. In the eighteenth century, archaeology began to develop, and the art of the time reflected a growing fascination with it. In the twentieth century the motif is not about archaeology, the putting back together of fragments, but about deconstruction, about taking a culture apart or revealing it inwardly, as a ruin is laid bare to the eye. The eighteenth century was an age when democratic constitutions were written, always on the models of the Greeks and Romans. There was a sense of taking up the torch from the fallen civilization of the ancients. The need for the imagery of the classical ruin in our time, on the other hand, arises not from a sense of resuming where the Greeks left off, but from a sense that our own edifice may soon be a ruin. It is significant that both these are revolutionary ages when the future is like a deck of cards flung into the air. In the eighteenth century the advent of democracy and Romanticism was imminent; now the post-Modern vista stretches before us. The classical ruin is a kind of emblem, or negative emblem, of Modernism, prominent at its beginning and prominent again in this moment which has been heralded, perhaps prematurely, as its end. De Chirico used the motif of broken classical sculpture to express a haunting Romantic sense of a lost perfection which somehow was ourselves. Kounellis uses it more politically, to express both the loss of cultural and personal wholeness, and the historical task of building a new whole again out of the fragments. These two artists, both Modernists, see history as having a direction, as departing from a primal perfection and heading towards an ultimate one. The fragment is, for them, not the great reality; the reality is the whole that is implied by the fragment, the whole vessel of which it was once a part, and which the archaeologist seeks to put back together again. For Schnabel, on the other hand, the ocean of fragments, without being put back together again, is already a whole, is itself a place, or a condition, for living (there is no past state in particular to lament or any future state to bend one's effort to attaining).

The sense of time or history as an ocean filled with the fragments of the past and randomly laying them on the

beach of the present is duplicated at another level by the presence of quotational elements throughout the oeuvre. There are images borrowed from Pollaiolo, Caravaggio, Beckman, Goya, El Greco, Giotto, Courbet, Ingres, Rodchenko, and others. There is a level of classical Greek imagery and an increasing presence of medieval Christian imagery in paintings like *Vita* (1984) and *Veronica's Veil* (1984).

Modernist art for at least a generation has lacked overt Christian imagery. Around mid-century there was a general assumption, in line with the Modernist feeling that history moves inexorably onward, that this subject matter could not be painted anymore, though it could still enter into titles of works, such as Newman's *Stations of the Cross*. Schnabel's selection of this body of imagery is typically ambiguous. From a post-Modern point of view it is reasonable to revive any imagery from the past, and the fact that no one else revived this one is strangely telling about the hidden linkage between Christianity and Romanticism, which are bound by their devotion to the sublime, among other things. Christian iconography has not yet been reduced by post-Modern quotational parody; it is in a sense still too hot to handle in that way. In Schnabel's work the Christian imagery, like the relation with Pollock, seems to appear not with ironic distance so much as with a sense of personal continuity. The Christianity expressed in these works is of a pantheistic type, where the Christ presence is shown as a force pervading nature. The sacrament of communion is seen as a thing that is going on constantly through all of nature, even, consciously or not, through all of culture, which is viewed as a part of nature. In *Vita,* the Christ figure is portrayed as a universal female principle, and in *Veronica's Veil* the painter's canvas is presented as an analogue of the sacramental cloth. Schnabel's imagery is, finally, as quotational as that of the appropriators. His oeuvre as a whole is like the sea churning with fragments of the past, stirred up by the storm of the present. Nature is, similarly, a source of fragments and relics: the antlers, the affixed timbers, roots, branches, pieces of animal hide, and so on, that coexist with the fragments of cultural images.

The motif of fragmentation re-expresses itself in that of transparency and layering. Derived from the work of Picabia, this iconographic element has figured prominently in the new painting of the eighties, in both Europe (Sigmar Polke, Anselm Kiefer, and others) and America (Schnabel, David Salle, and others). Most commonly it is human im-

ages that are layered by these artists, iconographically sug-
gesting the multiplicity of modes of selfhood and the evanes-
cence of human existence. Human identity is seen as lacking
essence and coherence. Layered images from different ages
or provenances depict the arbitrariness of historical sequence;
each layer of the past is a transparency through which all
others can be seen. This is a post-Structuralist image that
sees a self as a layering of different codes, changing as they
shift their arrangement or as new ones are imprinted. In
Schnabel's oeuvre the layering of images has been especially
associated with the paintings on found grounds such as tar-
paulins.

Once used for covering trucks, these are surfaces that
already have a visual history before they are altered by the
artist. The ground of stained cloth, with its real history of
involvement in the world of labor, commerce, and the high-
way is, like the ground of shards, an analogue of the seedbed
of history, the sedimentation of shape upon shape like gen-
eration upon generation. The relativity of cultural and ethnic
norms suggests the propriety of combining any of them in
any way at all.

The so-called Mexican paintings were painted on tarpau-
lins previously used to cover the cargo beds of trucks in
Mexico. The found nature of the grounds of these works,
with their built-in archaeology of layered stains and tears,
actualizes what was metaphorical in Schnabel's earlier bro-
ken ceramic grounds, with their emphatically stated illusion
of foundness and archaeological depth. The Mexican tarpau-
lins bring their prior histories in the dark night of the world
into the sterilized gallery setting like an unshaven drunk
sleeping it off in a museum.

In these works the line between painting and conceptual
art, which has been a fine (if not invisible) one lately, is
crossed. Uncontemplated and undesigned, the darkened areas
of the canvas were not determined by the artist's aesthetic
sense but by the imponderables of weather and the road. The
holes are not Fontana-like penetrations into an aesthetic infi-
nite but mark the finiteness of a precise physical moment.
The images laid lightly and with restraint on the surfaces
resonate from underneath with the memory of the miles they
have covered on the Mexican highways. The reality of what
they did there, conveying real goods to real people, is at
once a critique of the sheltered activity of art and a claim, or
hope, about the reality, or nourishment, of what art brings.

Schnabel overlaid his own marks on those of chance and

nature here less as a unilateral action than as a collaborative interaction with the visible residue of the history of the ground, whose pre-existence exerted a guiding aesthetic presence. The gargoyle- and monster-like figures were coaxed up into the light by sketching in connections between marks already present, like an ink-blot test or a connect-the-dots puzzle. In the process the ground acted as an analogue of the unconscious, both of the artist and of the land, rendering up to the surface of consciousness, when stirred into motion by the artist's brush, images evocative at once of the Christian unconscious, hell, and of the pre-Christian religious imagery of Mexico, where they were painted.

Schnabel interacted with found grounds again in a series of works on Japanese theatrical flats, most of which had landscapes previously painted on them. Again the real, rather than the illusory, history of the ground should be seen as an essential part of the works. Long used as backdrops for Kabuki performances, they are imbued with a ritual and theatrical atmosphere as the tarpaulins are imbued with the atmosphere of night and the road.

This interaction involves more than the imagery of the backdrops, but extends to their prior function as well. The history of the Kabuki cloths as backdrops for ritual dramas parallels their use here as grounds for figures, and, even more, ritualizes and theatricalizes those figures which are presented before them. The image of the artist's daughter, for example, in *Stella and the Wooden Bird* (1986) – standing naked and crowned, daubed with a bloody red like a sacrificial figure from a fertility cult or a Grail myth – gazes earnestly out at the viewer from the ritualized ground like a player unaccountably trapped in a sacred and dangerous drama. As in Mahler's act of composing *Songs for the Deaths of Children,* the adult's foreknowledge of the coming death, not only of himself but of his offspring, plays against the pathos of the child's lack of such foreknowledge. Stella's direct look says more, in its gravity or sombreness, than it knows.

The Kabuki paintings were followed in 1987 by a series that involved a radical reduction of elements. Large, sometimes cross-shaped paintings on unprepared U.S. Army surplus tarpaulins, some of them exhibit a complete absence of pictorial imagery per se, and many of them observe a restriction to flat white paint applied in dilute and irregular one-coat addresses to the surface. In most of them linguistic elements (words, names, phrases) are the leading and often the only imagery. One of these is completely found, a small

banner reading "virtue" mounted on a large stretched tarpaulin. The heraldic loneliness of the little banner on the broad, ragged expanse is a picture of human ambition, or the dream of human values, in the midst of the uncompromising vastness of the cosmos. Most of the word paintings employ verbal elements adopted from William Gaddis' *The Recognitions,* a book which begins with a reference to the Stations of the Cross. So although there clearly is an element of homage intended – a homage of visual art to literature – still the relationship between the paintings and the book is not intimate, such that one would go to the book to seek avenues of interpretation for the paintings; rather, the text served as a mechanical limiting device, a somewhat arbitrary procedural rule like those commonly found in conceptual art. Gaddis' book, with its encyclopaedic presentation of the life-world and its far-reaching historical references, was a convenient microcosm from which to select an archaeology of literary fragments.

Schnabel has brought into the foreground in these paintings a quality of paint presence and paint handling that, although found in the earlier work here and there, was difficult to see beneath the assertive, tachistic, action-painterly look. This is the thin and mean way the paint lies on the dark canvases, the flat white often diluted to an anaemic semi-transparency and, in the light and inelegant way it hugs the rough surfaces, almost bonded with them. These are perhaps the most challenging – which is to say, the least ingratiating – of Schnabel's works. Their visual values fight to be seen through the conceptual awareness of verbal meaning, and they are in any case not, for the most part, the aesthetic qualities that have been associated with the artist's work in the past – almost, indeed, a negation of them. In works such as *Mutant King* and *Portrait of God* (both 1981), Schnabel had achieved a deliberate awkwardness of aesthetic expression that spoke more directly than an aesthetically polished gracefulness could at that late moment in the century's tradition. He had managed to get out of the framework of Modernist aesthetics into a negation of it which yet preserved something of its force and pictorial substance. The *Recognitions* paintings go even further.

The rejection of color and of non-linguistic imagery in general depleted the aesthetic arsenal. The stained and tattered tarpaulin supports with the crudely scrawled words on them lack even the charm of appearing to allude to graffiti. They have determinedly erased the qualities that originally

made the earlier work successful: its massive sculpted surfaces and imposing authoritarian confrontation with the viewer. Alongside the deliberate awkwardness of composition there appeared a deliberately unconvincing use of paint. The work suggested ambivalent feelings towards the Kantian aesthetic which underlay formalism and the New York School.

Finally, the critical issue about the so-called revival of Modernism that once overhung this work seems not to have been totally relevant. Schnabel's incorporation of elements from a variety of historical phases reflects the post-Modernist's tendency to see both the past and the self as shifting, interactive realities which make and remake one another constantly. The content of his work has more to do with the post-Modernist themes of fragmentation and decentering than with a revival of autistic Modernism. On the other hand, his desire to carry forward the expressiveness of Picasso or Pollock suggests a Modernist sense of continuity with mainstream art history. The ambiguity is not unusual. Most of our culture is presently involved in it.

Julian Schnabel, *Portrait of God* (1981). Collection of the artist. Courtesy of the Pace Gallery.

To allow the post-Modern rejection of Modernism to become an absolute is a contradiction in terms. The over-throw of the immediate past was an obsession of Modern-ism; post-Modernism cannot become obsessed with the overthrow of Modernism without becoming a repressed form of it. What is called for is not a new puritanism but a flexible continuum on which Modernism and post-Modernism may approach one another through a variety of compromises. A Buddhist parable speaks directly to this issue. It is said, in the Pali *suttas,* that the Buddha taught the unreality of the self. One day a visitor asked if not-self was a dogma with him. He replied, "I teach not-self because everyone I meet believes in self. If you believed in not-self, I would teach you the self."

THE WORK OF "GEORG BASELITZ"?

It is important to work with something that moves your spirit, and in order to move the spirit there must be content, you must create content. . . .

. . . All my contents should be referred to in quotation marks and with question marks after them.

Georg Baselitz[1]

ARTISTIC Modernism based its identity on a rejection of content in favor of pure form, and was secure and at peace with this understanding of itself. Formalism – the doctrine enunciated in the works of Clive Bell, Roger Fry, Clement Greenberg, and others, and based more distantly on the aesthetic theory presented by Immanuel Kant in the *Critique of Judgment*[2] – held that the only aesthetically active aspect of an artwork is its form, and that issues of content are not only irrelevant but even pernicious. Content, denounced as "subject matter," was seen as an essentially literary element improperly imported into the visual arts and functioning there primarily as a distracting and obscuring element in relation to aesthetic form. In the writings of Greenberg and the many critics who followed him, this became the "purely optical" doctrine – the doctrine that the essence of the artwork is only visual, with no social or conceptual aspect or admixture whatever, and that aesthetic experience somehow bypasses the cognitive centers of the brain.[3]

At the height of the late Modernist period – the age dominated by Abstract Expressionism – this doctrine was so solidly in place that it seemed a given, like a law of nature; to question it seemed outlandish or perverse, perhaps hostile to the artistic project in general. Yet in the last twenty years or so this doctrine has progressively lost credibility, on two

primary counts. First, in the flux of events of the 1960s and after, it came to seem insupportable to presume that any expressive act could be completely divorced from the social forces which had contributed to shaping the personality which was expressing itself. Formalism came to seem an attempt to create a blind spot in the mind behind which social forces could operate with impunity, or without inspection by the mind's skeptical and critical activities. Thus formalism, seen in social context, seemed to be an essentially regressive position which, by detouring energy which might flow into social awareness, was hiddenly supportive of the status quo, whatever that might be. A purely aesthetic or "optical" approach to art on the part of an artist came to be seen as a kind of delusion in which, for the sake of career emolument, one semi-willfully allowed oneself to be distracted from issues of social justice and social change. Since the class that mostly deals with the so-called high arts is essentially a privileged class, the formalist doctrine came to be seen as a device whereby this class maintained its privileges and its sense that it deserved them. It came to be associated with the age when art was a plaything of the rich and privileged, and artists supported themselves by, say, making Fabergé eggs for Czars' children.

Even more fundamentally, the formalist claim that aesthetic experience bypasses the cognitive activities of the mind came to seem ill-founded or wishful. In light of depth psychology, behaviorism, and much else, it seemed impossible – or in any case unaccountable – that any mental activity whatever could occur outside the web of memory, association, and conditioned response. The intense desire to believe in such a free area of consciousness came to seem an essentially religious desire, a desire to believe in the transcendent type of existence traditionally attributed to the soul in Christian theology. Formalism thus seemed discredited as regressive both in terms of individual psychology, which it replaced by theology, and of social awareness, which it hid behind a screen of aesthetic contemplation. As the transition from Modernism to post-Modernism advanced, throughout the 1970s and 1980s, formalism became progressively obsolete. A view of art has arisen and is achieving increasing prominence both in critical thought and in artistic practice that holds that artwork relates not to aesthetic factors alone, but to aesthetic, cognitive, and social factors all at once, in a complex and shifting web of interrelationships among these three categories.[4]

It is at once intriguing and troubling to apply these distinctions to Georg Baselitz. Here is an artist whose importance in recent years can hardly be exaggerated; to encapsulate that importance, it would not be unreasonable to describe his oeuvre as the most convincing argument for painting in the Western world today. Yet, in a decade when much painting has been informed by the practices of conceptual art and moved itself away from the purely aesthetic to a more cognitively engaged approach, Baselitz is generally described by his critics as an unreconstructed formalist and seems, by his own account, to invite or even demand such a description. One critic, for example, describes Baselitz's work as "painting for its own sake," and speaks of Baselitz's "liberation from the classical idea of subject matter."[5] Another asserts that Baselitz's concern is not with "whatever happens to be represented," and that in his work "the sole function of the motif is to provide a pretext for . . . manipulation of the medium" toward the creation of "autonomous pictorial structures."[6] Yet another says the work is to be described by "intrinsically visual criteria," emphasizing "the priority that Baselitz assigns to formal syntax and . . . the extent to which he subordinates iconographic coherence to it."[7] "Baselitz's pictures do not represent anything," says yet another.[8] "Baselitz is not communicating ideas." On the contrary, he is "devoted to the destruction of thought."[9]

Baselitz himself has contributed to this style of discourse about his work, referring to its content, for example, as its "coloring and materiality."[10] "No social or personal situation," he writes, "will govern, influence, prevent, or make inevitable the artwork. . . . A picture is autonomous."[11] "What art really comes down to is imagery rather than content or religious fervor or things of that kind. It is a question of the cogency of the pictorial construction."[12] "The only explanation for every brush stroke you make comes from the picture itself."[13]

Under the influence of this approach, critics have interpreted the stages of Baselitz's career as a series of tactical advances in the overall strategy of eliminating the taint of content from the purity of aesthetic form. The various ways he devised for "fracturing" an image – dividing it into halves horizontally, into discontinuous strips, into masses that tend to float apart, and so on – were intended to eliminate the referentiality of the representation by abstracting it from its usual appearance. The most famous and devastatingly effective of these tactics was the inversion of the image which

began in 1969. As one critic puts it, "The decision in 1969 to turn the image upside down was tantamount to pouring out the contents."[14] By this act, another says, "representation has been cut to pieces in the interest of an extreme formalism."[15] But at this point the question arises, if Baselitz indeed wanted to empty his work of all representation, why did he not become a so-called non-representational or abstract painter?

Post-Modernism in the visual arts is first of all characterized by a denunciation of formalism, the cardinal doctrine of the Modernist age against which it was reacting. At the present moment, however, it bears remembering that what was called post-Modernism a few years ago has changed a good deal already, though the same term is still being used. The years following the death throes of formalism – which were noticeable in the visual arts by about 1967[16] – were characterized by a fiercely dualistic reaction which saw formalism as, in effect, an evil to be eradicated. This puristic phase now seems to have been a disguised alter ego of formalism, with its structures and values still in effect, but reversed.[17] More recently the rigidity of this reaction has loosened. It no longer seems threatening that the purely aesthetic approach to art should still be practiced. A relativized and pluralized situation seems to be emerging in which even pure aestheticism may be experienced without anxiety as simply another voice in the counterpoint of it all. While aesthetic, social, and cognitive elements are all acknowledged, they may mingle in many combinations; the particular proportion in which they are combined is now one of the principal expressions of individual sensibility. There will be some for whom one element or another will seem absolutely dominant. Thus each limb of the trichotomy has its primary champions and representatives, who serve to clarify its nuances and restate its programs as circumstances change.

But even granting that a lingering fascination with the aesthetic is more healthy than a puritanical repression of it, it is still questionable whether this issue is rightly applied to Baselitz, either by his interpreters or by himself. An investigation of the issue of content in his work does not entirely support the claim that it is an example of pure formalism.

To begin with, it's manifestly an exaggeration to say that Baselitz's pictures "do not represent anything"; some are pictures "of" eagles, or humans, or trees, and are often titled as such. But Baselitz has remarked,[18] "All my contents should be referred to in quotation marks and with question marks

after them," to indicate the distancing of conceptual meanings within a dominant visual matrix. As he puts it,[19] he recognizes that all motifs have meanings, only he does not want to exaggerate the importance of these meanings in his work; to investigate a certain type of visual treatment he might as well have chosen one motif as another. Therefore his representations are to be bracketed in various ways – intellectual, discursive, typographical – to indicate the immersion of the reality of their content in the emphasized or foregrounded reality of their formal treatment.

But still these contents are not to be neglected altogether. Though distanced and bracketed – no longer eagles, humans, and trees but *"eagles"?*, *"humans"?*, and *"trees"?* – they are still not conceptually blank; they are representations and function as such when looked at as such, while, when looked at in another way, they function as pure form. Within this bracketed but still discernible zone of meaning there are contents of several types. The eagle, for example, is a provocative icon for a German artist to fix on and repeatedly display. A symbol of the Third Reich, the eagle, Baselitz says,[20] has become a taboo image in Germany, as if it were pornographic. He uses it partly for shock value, he says, and partly for the iconographic significance of its inversion.[21] This then is an element of historical and political content, notwithstanding the fact that the visual treatment seems to be foremost in the artist's intention.

Religious contents also appear at various places in the oeuvre, for example, in *Die Nacht* (1984–85), which Baselitz himself has connected with a thirteenth-century Byzantine depiction of the Death of Mary.[22] He asserts that it was not the Christian motif as such which attracted him, but the picture which happened to contain it. Nevertheless, the fact that elements of Christian iconography occur elsewhere in the work, too, invites interpretation. *Nachtessen in Dresden* (*Dinner at Dresden;* 1983), for example, is based in part on traditional depictions of the Last Supper. These religious motifs in turn seem to merge with autobiographical ones. As a child Baselitz grew up some thirty kilometers from Dresden and, at age seven, he witnessed the saturation bombing of that city, which he recalls as the most riveting memory of his childhood.[23] It is hard, then, not to interpret *Nachtessen in Dresden* as to some degree a metaphoric homage, or memorial, to the sacrifice of that city. In this connection the eleven sculptures of 1990 called *Die Dresdner Frauen* (*The Women of Dresden*), with their angst-ridden faces, may

Georg Baselitz, *B für Larry* (1967). The Saatchi Collection. Courtesy of the Pace Gallery.

seem a chorus of lamentation for that sacrifice. Without regarding these readings as primary or restrictive, one may nevertheless feel that a sacramental sense of life and of art may underlie this oeuvre in a vague and non-specific way.

The theme of the forest and the tree in Baselitz's work again suggests a sacramental sense of the interchangeability of substances, as in motifs of humanity merging with nature.[24] A number of pictures homologize the human figure with the tree in different ways. In *Der Jäger* (1966) and *B für Larry* (1967), the human body and the tree tend to occupy the same space, which is to say to merge their volumes. In *Drei Streifen – Der Maler im Mantel – Zweites Frakturbild* (1966), part of the human body is replaced by a tree trunk. In *Der Baum 1* (1966), the tree has wounded appendages like

127

the stumps of amputated human limbs. In *Der Bote* (1983), a human figure holds little trees in each hand. In *Die Verspottung* (1984), a human holds a little tree in one hand. In *Pastorale, Der Tag* (1986) and *Pastorale, Die Nacht* (1985–86), female figures have trees associated with their genital areas, and so on. Other examples could be mentioned.

Baselitz's sculptures, which began in 1979, extend this analogy. Each human figure is sculpted from a single tree trunk, as the mythological motif of the human who turns into a tree is inverted to a tree becoming a human. Further, Baselitz works the wood not with traditional sculpture tools but with chainsaw and axe, instruments for cutting trees down. The figures in the so-called fracture paintings of the middle 1960s are often represented as woodsmen holding axes, a role which the artist himself later adopts in making his sculpture. As in the sacramental suggestions of some other works,[25] there are implications of an underlying oneness between humanity and nature, a vaguely intuited pantheism that sees nature and humanity as interchangeable in the sense in which different substances are interchangeable in a sacrament. This interchangeability can be approached by way of the punctuation that Baselitz requests: *"tree"?*, for example, being interchangeable with *"human"?* in the sense that neither is literally intended as simply itself but as a reality masked behind both which is indicated by the distancing punctuation.

The phenomenon of the classical expressionist brush stroke offers another approach to the seemingly hidden reality suggested by this unusual typography. Since 1962 (but with increased intensity since 1974) Baselitz's work has conspicuously featured the separately distinguishable brush stroke, usually applied, in the artist's own words, with "great speed."[26] In part this demonstrates his kinship with the Abstract Expressionists, some at least of whom are famous for working very quickly, featuring the sense of the living muscularity of the brush stroke, and denying that content was the point of their work. Like Clyfford Still, Willem de Kooning, and other American artists of that generation whom Baselitz admires, his brush strokes create an atmosphere that seems charged with meaning even without any particular act of representation being required. The point is that the mark of the brush, when emphasized and foregrounded in the mode known as Expressionist, is more than a formal element; it carries evidences of energy, will, and presence which are themselves elements of content. Conceived as events in

space, Baselitz's brush marks are like forces in the air that both surround the represented *"objects"?*, move through them like a wind, and constitute them like the elements of their being.

In a metaphysical sense the individual brush stroke evokes the smallest entities of which a world is made – atoms, point monads, moments of perception, traces of moments of sensibility, and so on. In Baselitz's work the aggregations of these minima vary in significant ways. Differences in densities of marks, for example, are apt to distinguish figure from ground (a tacit acknowledgment of the act of representation), creating different feelings of inside and outside. The storm of brush strokes within the outlines of a *"thing"?*, constituting its shape, suggests the ontological forces flowing within an entity and giving it the power to be, the raw electrical surging which enables life, the intensity and reality of the internal nature of the *"thing"?*. At the same time the identity of the *"thing"?* as a collection of momentary surging impulses suggests a tendency to fly apart as these various winds play through its boundaries in different directions.

Complementarily, the external brush strokes which constitute the space around the *"thing"?* – the *"eagle"?* or *"human"?* or *"tree"?* – seem not only to rain upon it but also to hold it together. The thickness or density of the atmosphere surging around the *"thing"?* presses on its boundaries and keeps its selfhood from flying apart. There is a drama and a kind of narrative as the internal brush strokes seek to explode the *"thing"?* and the external ones press it together. There are tragic overtones to the drama as selves are portrayed with ragged edges, lacking wholeness or integrity yet possessed of will and energy; a dynamic view of the *"thing"?* is implied, as made up not of essences but of forces. The ubiquity and randomly constitutive energy of the marks, flowing now into one shape, now into another, imply a substrate underlying all *"things"?* – *"tree"?*, *"human"?*, and *"eagle"?*. Like winds in the atmosphere they rush everywhere, uniting all things, like the Pythagorean idea of the unifying breath of the universe.[27]

The two statements that preface this essay – one, that it is important to work with something that moves the spirit, and to move the spirit one must have content, and the other, that each content should be named with quotation marks and question mark – do not seem to refer to the same thing. Taken together, they imply two levels or types of content. First there is the commonsense everyday mode of content

which is simply equivalent to the denotation of the word – tree, human, and so on. Then there is a content which moves the spirit yet which is not bound to any specific name-and-form; it resides in things as something underlying and unifying their particularities – it is the same in tree, human, and bird, and it is what is referred to by the unusual typography in *"tree"?*, *"human"?*, and *"bird"?*. It is the first of these two which must be bracketed and the second which is necessary to move the spirit.[28]

Baselitz's inversion of the subject matter – his literal painting of upside down *"trees"?*, *"humans"?*, and *"birds"?* – is the most discussed element of his style. Though he did not introduce it till 1969, it has nevertheless become the signature or trademark of his oeuvre. It is also the aspect of his work which has aroused the greatest skepticism, sometimes being regarded as a superficial trick or marketing device in an age which values novelty. Some critics have pointed out that the inversion of the figure is not in fact meaningless, but radiates an energy that moves in the realm of iconography. It has been said, for example, to suggest a world that is upside down or inside out or otherwise out of tune, with an implied imperative to put it right side up or tune it. This reading, while undeniable to an extent in its obviousness, interprets the inversion as a negative comment on the state of things in the world. It is worthwhile in this connection to refer to Baselitz's remark that he has no knowledge of the state of things and that his work does not relate to that. Rather, it may be that by putting things upside down he feels that he has in fact set them right. In *"Lieber Herr W."* (1963) Baselitz wrote, "Stand the topsy-turvy world on its head." This sentence is often arrayed in conjunction with the inversion of the figure. It should be noted, however, that if the world is already topsy-turvy, then to stand it "on its head" would be to put it right side up.

A principal question about Baselitz's oeuvre is why, if he wished to radically denigrate content in relation to form, he did not become an abstract painter. Perhaps, as in the case of some other painters called "neo-Expressionist," he feels that the Abstract Expressionists have already ploughed that ground. The dialectic of the historical interplay between abstraction and figuration in the last century or so seemed to call for their integration in the 1980s (Baselitz was early). In any case, by his inversion of the figure Baselitz pushes his *"content"?* closer to the realm of abstraction without altogether losing the vocabulary of representation. But there is more to

Georg Baselitz, *Orange Eater X* (1981). Private collection. Courtesy of the Pace Gallery.

it than this. While it is a device to mediate the claims of form and content, or abstraction and representation, the upside down position also effects a shift to a meta-level of meaning. Placing the representations of things upside down performs the same restructuring as their repunctuation as *"things"?*. The nature of their "thingness" is reconceived through an invocation of a universal dimension. The upside down iconograph points to something they have in common which goes beyond their separateness as particulars – something which in fact denies their separateness as particulars. The upside down position is a visual analogue of this commonality, as the repunctuation as *"things"?* is a typographical one. The upside down position, then, is not simply an iconographic element, any more than the upside down figure remains simply a figure; it is a meta-step in the game of meaning. It is not iconography but *"iconography"?*.

In 1979 Baselitz began making sculptures. Ever since, a sculptural tendency has moved through his work. This tendency involves elements not present in painting, to which this preliminary unpacking of an iconography – or an *"iconography"?* – may or may not apply. "All sculpture is a thing," Baselitz points out[29] – unlike paintings which are more obviously or unavoidably based on representation than on presence. Both of course may represent, but the sculpture, while it represents, is still an object in the space of the viewer, obstructing his or her passage and vision and so on. The painting, by hugging the wall surface and pretending to be two-dimensional like it, seems more thoroughly engrossed in the act of representation, more invisible as an object in itself – perception of which would suddenly render it a sculpture. "Attempts to escape from the fact that the sculpture is a thing," Baselitz says, "simply lead to new things."[30] Such attempts have led to imitations of the flatness of paintings, such as floor sculptures, which do not intrude either on one's vision across a room or in one's walking; or to emphases on the surrounding space, as in installations; or on imitations of furniture and other things which for social reasons are not experienced as obstructive in space. Baselitz wanted sculpture on a pedestal that does not deal with the space around it but flatly acknowledges its thingness. "The potato on the pedestal," he calls it.

The interplay between painting and sculpture in Baselitz's work of the 1980s is complex and has moved in both directions. On the one hand the sculptures have become steadily more painterly in terms of the working of their surfaces. The

cut has replaced the brush stroke as a force slashing through the surface to the inside, letting the reality of the inside flow out, the bodily fluids of the *"thing"?* so to speak. On the other hand, his painting practice has been steadily drawn closer to sculpture. (In 1981 he remarked, "I am sculpting my paintings.")[31]

This is seen most vividly in the recent work *45,* a single work of 1989 which consists of twenty paintings on wooden panels, each 200 × 162 cms, hung tightly together to form a rectangle about four and a half meters high and seventeen meters long. The wooden panels are not simply painted on, however. Loose grid patterns are chiselled or gouged into the wood, and the painted image is laid down lightly on top of the chiselling, seemingly floating before it. These objects combine the presences or modalities of painting and sculpture and somewhat resolve this dichotomy in his oeuvre. The surface is painted, scraped down, and painted again. Simultaneously, the grid patterns are repeatedly reincised through the paint, revealing fresh wood. In this process the media of painting and sculpture are involved in an allegorical war: the sculptural nature of the incised panel with its real objecthood or thingness cohabits with the painterly nature of the image overlaid on the scratched or gouged wooden grid, with its representational illusionism getting in the way of any attempt to see it in its thingness as its own object. The process of scraping out the channels of the wooden grid involves a direct attack on the illusionistic surface of paint; the reapplication and reworking of the inner will of the paint, in its turn, spreads over the wooden surface, obliterating it step by step.

In terms of content, these works, like the sculptures, proceed directly and simply to the generic self-portrait, the representation of the human, as a childlike representation of a human female head fills the center of each panel.[32] The grid, iconographically, represents the idea of order, the idea that the world is conceivable and measurable, the idea that one can locate a place in space, that one can occupy a place in space and know where one is, and so on. The human face located in the grid, however, seems at odds with it. Floating in front of it, it is detached yet somehow still imprisoned by the gridwork. The loose organic style of the depicted faces contrasts with the implied order of the grid; and the grid itself, sometimes so loose as to hardly be a grid at all, questions the idea of order, or its viability, at the same time that it asserts it. Humanity, represented, as in most of Baselitz's

paintings, by the female example, is seen as ambiguously and somewhat tormentedly relating to the idea or aspiration of order. At the same time there is a nobility to the human plight, which suggests humanity attempting to create or live up to the order of civilization wrested with difficulty out of the raw nature of the wood. Baselitz has remarked[33] that he adopted the grid in this work because he noticed that his compositions were dominated by the concept of the center and he wished to push them toward an allover mode. But in fact the center remains the location of the figure, or motif; the imposition of the grid seems not to have altered this, but rather to have occasioned a kind of meditation on the relation between center and field, or figure and ground. Figure and ground relationship in turn carries suggestions of individual and society. This work, in other words, by importing some of the thingness of sculpture into the painting, moves the work somewhat out of its felt aesthetic isolation and into the world.

This preliminary unpacking of an iconography brings with it the classic problem of the status of the artist's conscious intentions. Baselitz has said that for him the only active or relevant facts about an artwork are its formal appearance and the artist's intentions.[34] This is a characteristic high Modernist notion that contains a certain contradiction. If the formal elements of an artwork are sufficient, then they do not need any special knowledge of the artist's intentions, which should be well enough expressed by the work itself. Here the so-called Intentional Fallacy formulated by the American New Critics in the 1930s comes into play, and cracks in the formalist doctrine begin to appear. If the form is expressive enough by itself, then it does not require invocation of the artist's intentions. But the form will, it seems from experience, express itself differently to individuals of different classes, of different cultures, of different ages, and so on. So the form does not seem, in fact, a stable and reliable container of the essence of the work. Then the appeal to the artist's intentions comes into play in order to correct possible misconstructions by sensibilities other than the artist's. But if the essence of the work lies in the artist's intentions, then the expression of the artist's intentions is all that is needed; the work itself is not needed. The appeal to form and the appeal to intentions, in other words, contradict one another. If on the other hand we say that the only true expression or container of the artist's intentions must be the form itself, then we are left with the absurdity of variant readings of the form

suggesting a variety of conflicting intentions on the artist's part. If an artist says that he or she did not intend this or that, should that rule them out of the experience of the artwork? Something arbitrary emerges. If a viewer experiences something that the artist says he or she did not intend, how is one to account for that? By an inadequacy in the artist's expressive means, or in the viewer's receptive ability? Finally, it seems clear, no viewer but the artist him or herself will receive the work with precisely the intentions that went into its making, and even the artist will do so only at the exact time of making the work, before the variety of conditions that affect his or her mood can change. There is then a tautological quality to the appeal to intentions: the work can only be perceived properly by its maker at the moment of making it. Yet even this seems absurd in terms of experience, since often a maker will learn more about his or her work afterward, sometimes long afterward. It seems that the nature of intention, finally, needs to be re-inspected.

Are there channels to the reality of the artwork which do not go through the artist? It is arguable that the concept of intention, as usually understood, is too narrow or simple in its assumptions about selfhood and its conditions. If the self is constituted at least in part through society's imprints, then the self's intentions are not its own alone, but those of society as refocused through a specific set of conditions and circumstances. History, society, family, the whole network of worldliness signified by memory, all contribute to the act of intention. If the self is decentered, then intention is decentered, too. If language, as Roland Barthes remarked, is the author of the book, then what is the painter of the painting? History, art history, society, class, and other collectivities will have entered into the particular point of view around which the universal set of conditions is momentarily ordered to imprint a specific work. Here it might be best to enter the realm of punctuation that mediates the individual and the collective – to see the *"painting"?* lying in the stream of history as the *"potato"?* lies on the pedestal.

CARLO MARIA MARIANI'S DIALOGUE WITH HISTORY

CARLO Maria Mariani's work exhibits a polished command of a sophisticated Western canon of beauty. Psychologically, it evokes imaginative projections of ideal realms which are both comforting and exhilarating. Yet this work is not mere pretty pictures; it also exerts a considerable appeal to the intellect through a set of references to Modern and classical motifs and styles which interact in a variety of controlled significations. This is an art which deals with the theme of ideal beauty while at the same time subjecting it to the *elenchus* (as Plato called it), the "test" or "trial," of the intellect. At a moment when the contemporary art world is becoming more and more aware of and open to non-Western ideas, Mariani's work is a compelling visual argument for reconfronting the classical vocabulary of the European tradition.

The rules under which art history has been written by Westerners depend on various ethnocentric value projections. Western historiography has regarded certain historical sequences as especially significant, even inevitable, as if preordained by providence or destiny.[1] The possibly excessive reverence accorded the art of the Renaissance is one example of this; the elevation of Cubism to a place of special privilege and authority in the Modernist canon is another. These and other selected passages of history are supposed to define the peak experiences, the high moments, of a mainstream of development, with everything else a minor motif in the pattern, either preparatory or transitional or peripheral. In the resulting hierarchy, non-Western art, if it is recognized at all, is tacitly relegated to the periphery and the bottom.

In recent years, especially in the last decade, both art and scholarship have subjected this system to devastating critiques. In the global village of the late twentieth century

these value projections seem not only outmoded but possibly poisonous, lingering remnants of a colonialist view that dismissed non-Western cultures as irrelevant or incomprehensible and chose to see Western hegemony as inevitable. The first unmistakable manifestation of this so-called post-Modernist outlook in the visual arts was the quotational approach to artmaking that dominated the 1980s. Quotational work has functioned as a critique of the Modernist obsession with originality. Instead of concealing influences and models, quotational artists openly acknowledge them and directly incorporate them into their work. Much quotational art also points to the parochialism of the Modernist idea of the inevitability of certain historical sequences. To discombobulate the rules of art historiography inherited from the imperial age, it tosses the deck of cards of developmental sequences into the air; it juxtaposes quoted elements from different art historical periods while introducing counterweights from other cultures or (as in Pop art) from previously taboo layers of our own culture.

At first glance, Mariani's work – with its neoclassical style shaped by Thorvaldsen, Canova, and Ingres and, starting in 1988, borrowings from Dürer, Beuys, Calder, Duchamp, de Chirico, and others – might be seen as an example of this kind of quotational art. Mariani does sometimes seem to be seeking to disorient the sense of the inevitability of historical sequences. On closer analysis, however, his work appears to represent a different approach to history. As he has said, for him the point is not so much to recall the past as to be of another time. His relationship with neoclassicism is less an example of quotation than of identification. In the hands of other artists, quotational practice is often no more than a promiscuous juggling of images from many sources, none of them given any special weight. Mariani's artistic incorporation of neoclassicism provides a foundational solidity that goes beyond this to involve deep feelings of identification with a past era. (In fact, his commitment to a particular area of imagery is somewhat comparable to a Modernist commitment to a certain style.) Rather than introducing chaos into the inherited patterns of thought or rejecting them outright, he presents a visual argument for reconsidering inherited ideas about cultural history and shifting their emphases, which leads to a qualified reaffirmation of some of them.

Mariani began exhibiting his complex quotations, transformations, and recombinations of classical and neoclassical

styles and images in 1975. The date falls between two land-mark events of crucial importance in the history of recent Italian art, indeed of contemporary art in general: 1967, when the Italian critic Germano Celant declared Arte Povera – the work of Jannis Kounellis, Giulio Paolini, and others, with its primarily sculptural use of classical fragments – a coherent tendency, and 1980, when Achille Bonito Oliva announced a new generation of Italian artists, the so-called Transavan-guardia, most of whom had returned to the traditional me-dium of painting and some of whom (most conspicuously Sandro Chia) featured classical or neoclassical imagery.

Intense ideological differences between these two groups are reflected in their usages of classical imagery. For Kounel-lis and other Arte Poverists, classical fragments often con-note an ideal historical period that has been shattered but that actually existed once and can conceivably be regained in a new form. For Chia, Clemente, and others of the Transa-vanguardia, on the other hand, the ideal realm is ahistorical, or transhistorical; it never existed in the everyday historical sense yet always exists in a metaphysical or archetypal sense, and recovering it is a matter not so much of social change as of shifts in individual psychological awareness. For Arte Poverists, in other words, the classical fragment represents an objective reality, albeit an objective reality of the past, whereas for the Transavanguardia it represents a subjective reality, a perfection attainable in the realm of the mind and the spirit but hardly to be anticipated in the hard facts of society except as a secret and mysterious governing force whose presence is inferred contrary to the evidence of every-day means of perception.

Mariani's classicism stands chronologically between that of the Arte Poverists and that of the Transavanguardia. He began his classically referenced paintings in 1973, well before the "return to painting" of the late 1970s and early 1980s had become widespread and well before the idea of the Transa-vanguardia had been articulated (when Clemente, for ex-ample, was a Conceptual artist). His painting thus shares with Arte Povera a certain historical realism, or critical con-cern with society, but its influence in Italy may to a degree have precipitated the Transavanguardia, with which it shares a fascination with an ideal realm beyond particularity.

Mariani's work has been called post-Modern[2] and neo-classicist.[3] Both terms seem roughly applicable (with some qualifications already mentioned), the latter being a subhead-ing of the former. His work is embedded in the past (and

vice versa) through complex layers of allusion which are in effect a summation of Western art history. At the root of the tradition his work alludes to and participates in is archaic and classical Greek sculpture (and painting, though little of that is extant).[4] That body of work is the origin of the naked figures with a minimum of symbolic attributes, the "measured" or mathematically symmetrical heads, the level Olympian gaze, the casual look of repose. Mariani also clearly adopted elements of the art of the Renaissance, when the look and to an extent the humanistic content of classical Greek art, so long excluded during the Christian millennium, was reimported into the European tradition. Until 1988, for example, he began each work by making a detailed sketch the same size as the projected painting, a Renaissance practice best known from Leonardo's famous cartoon in the National Gallery of Art in London of the Virgin and Saint Anne. Also following the Renaissance style of facture, Mariani then applied layer upon layer to turn his sketch into a finished painting.[5]

But the central focus of Mariani's references is neither the formative era of ancient Greece nor the Renaissance but rather the next major resurgence of classical imagery, from Mengs in the eighteenth century to Ingres in the nineteenth. It is the quintessential neoclassicist era – the years 1790 to 1810 – that Mariani focuses on. Here was an art, at the transition between the Age of Reason and the Romantic era, which affirmed the supposedly rationalist humanism of the Greek art of the figure while at the same time infusing it with a sentimental nostalgia in the form of the Romantic cult of the fragment, with its lingering resonances of lost paradises. Appreciating this choice in Mariani's quotational practice is a key to understanding the intent of his work and the mood which infuses its classicism. When Kounellis uses classical fragments he is referring to the Renaissance and, behind it, the classical era of ancient Greece, the two cultures that Western ideas have isolated as ideal ages. For him the fragments signify the shattered remnants of those ideal cultures, ages in which humanity fitted the world around it with no incommensurability. For Mariani, too, the classical fragment refers in part to the feeling that an ideal humanity lies shattered, but the route of the reference is different. It refers not directly to the ideal or classical ages but to a neoclassical age, in which the loss of the classical harmony was already felt with a powerful nostalgia.

The Renaissance gloried in itself; it experienced the classi-

cal ideal not as something lost but as something found, as something it felt that it embodied and expressed in its actions. It was filled not with nostalgia for a past that it aspired to reincarnate but with the onrushing present. The neoclassical period, on the other hand, saw the classical period not as something that it incorporated and vigorously embodied but as something that was lost. Its feeling for the classical ideal was permeated with loss and nostalgia. At the same time, the eighteenth century was the beginning of Modernism,[6] and in that sense it was an intensely forward-looking age. It was, for example, the age of revolution, a Greek ideal which demonstrates that the classical is not necessarily static, and the age of the writing of democratic constitutions embodying mechanisms of social change. Thus eighteenth-century neoclassicism was more ambiguously placed than either the classical Greek period or the Renaissance. It looked toward the past with nostalgia and a sense of distance or loss and at the same time toward the future with a revolutionary dynamism. It was therefore more of a linking era between our era and the classical past. And it is that linkage that Mariani's work refers to.

Mariani's choice of the eighteenth-century model provides a clue to a central question about his work (and about its relationship to both Arte Povera and the Transavanguardia): Does his positing of an ideal realm suggest an ideal *objective* reality – that is, does it evoke the theme of cosmic harmony with its validation of existing social forms – or is it presented as a *subjective* reality, a projection of human feelings, intuitions, and wishes? An answer is suggested by a comparison of the social situations of two phases of Western cultural history. Renaissance neoclassicism was aristocratic; it served the ruling class by positing an unchanging classical order, including class structure, as a quality of objective reality. Eighteenth-century neoclassicism, on the other hand, was bourgeois; it was based on the upsurge of bourgeois subjectivity, which was the soil from which Romanticism grew, rather than on claims about objective order.

Something similar is seen in the articulation in the eighteenth century of the distinction between the beautiful and the sublime.[7] According to Burke and Kant, beauty is a quality of form, and as such, it must be visible; hence the form which contains or expresses it must be finite, in order to be perceived by the visual sense. So the beautiful is about things on a human scale and apprehensible by the human eye and mind. The sublime, on the other hand, is infinite and

thus cannot be apprehended by finite senses. It is vast and threatening, out of human scale, an infinite and awesome surround which contains all finite things and at the same time threatens them with annihilation because it is in the infinite that they will perish and yield up their limited and transient power to be. The beautiful, then, is an essentially gratifying and reassuring presence; by its pleasing qualities it seems to validate the world it arises from as also pleasing, and by its apprehensible scale it reassures the human subject that reality is on his or her level. The sublime is the opposite of reassuring. It signifies the abyss of nonbeing in which all being will perish. In human experience it is encountered primarily in forces of nature that are conspicuously out of human scale and control, such as storms at sea, mountain vistas, and the open sky. In art it is encountered in those moments when the manageable image dissolves into the unmanageable vastness around it, or when the figure dissolves into or is consumed by the ground.[8]

The point of the distinction, in terms of the layered tradition of classical imagery and its recurrences, is that the Renaissance (like the classical Greek period, insofar as it is known) was primarily about the beautiful.[9] The eighteenth and nineteenth centuries, by contrast, were characterized as much by the sublime as by the beautiful, or by the interplay between the beautiful and the sublime. This was the essence of the transition in which eighteenth-century rationalism gave way to nineteenth-century Romanticism: the beauty and orderliness of a universe supposedly comprehensible by human reason was threatened with annihilation by the encroachment of the terror and loneliness of the sublime. What had seemed to be under control now seemed to be out of control. It was the engorgement of the rational into the sublime, its confuting and reversal by the sublime, that was the central theme of Romanticism, an ideology in which the finite self was encouraged to seek contact with the infinite even at the risk of losing its existence in that vast nonbeing.[10]

As the intersection between the beautiful and the sublime, that transition in the eighteenth and nineteenth centuries was again a link between classical antiquity, which was primarily concerned with the beautiful, and modernity, which was obsessed with the sublime. While the forms of art in that age looked back to the beauty of antiquity, uncontrollable darknesses entered that looked forward to the annihilating vastness of the abstract sublime. The dark areas around the edges and corners of, say, David's *Oath of the Horatii* (1785) show

the sublime lurking to consume both the plans and the beings of the finite figures – the beautiful – in the foreground. Thus the eighteenth-century intersection between the beautiful and the sublime was connected both to the past, the Renaissance heritage of the beautiful, and to the future, the twentieth-century obsession with the sublime.

These various themes combine in the relation of Mariani's iconography to the present cultural moment. Mariani "was against the principal artistic trends of the early 1970s." Accordingly, he started "a dialogue with history, . . . calling back to mind the important experiences of Art and European Culture." And "one day," he goes on, "I reinvented a new kind of classicism, to demonstrate that something was not quite right in the present day."[11] He describes his work as in part a search for what is lacking in society today, and that, he believes, is mystery and the sublime. People long for this greater reality, he feels, though they no longer like to admit it (as many were wont to do at the height of the Romantic era, which lasted until sometime in the 1960s).

The many references in Mariani's recent work to Duchamp, and also to Calder and Brancusi, cluster around the era of the First World War, the era in which twentieth-century culture came face to face with the confrontation between the beautiful and the sublime – between the beauty and finitude of civilization and the sublimity of the annihilation with which worldwide war threatened it. In Mariani's work the classical figures incarnate the idea of beauty, but they are often either oddly suspended, dreamlike, asleep, or falling into dream. Meanwhile, as in David's work, the darkness or obscurity that represents the sublime lurks secretly around them. In *Aria di Roma* (*Air of Rome,* 1990), for example, a work involving several allusions to Duchamp, the figures represent the beautiful, but the darkness behind the Duchampian double door is the threatening mystery of the sublime. In *Viva la Scienza Vittoriosa* (*Long Live the Victorious Science,* 1990), the dark gateway at the end of the tunnel in the hedge shows the sublime hidden in the midst of the finite reality of the beautiful; it is like a black hole from an anti-world, through which the annihilating infinite might pour or through which the finite self might slip into the astral voyage.

References to Duchamp dominate much of Mariani's work of the last few years. Duchamp represents what Mariani sees as the beginning of the end for art and for humanity (or for certain inherited ideas about art and humanity, anyway) –

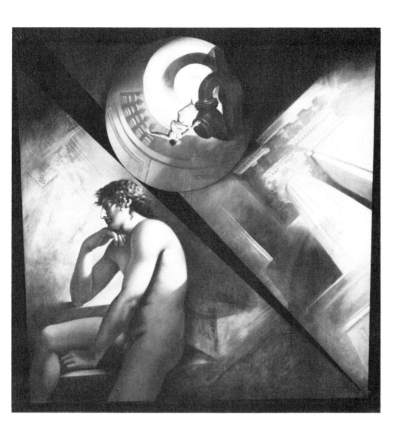

Carlo Maria Mariani,
*Occhio non vede, cuore non
duole* (1990). Private collec-
tion. Courtesy of the artist.

again a view which many would link with the First World
War, an event which seemed to announce a revised identity
and definition for the human project and thus for those who
might carry it out. Mariani's Duchampian allusions, then,
while not hostile to Duchamp in their feeling or tone, sug-
gest a tragic premonition in his project.[12] In *Scolateste* (*Head-
rack,* 1990), for example, heads from classical sculpture are
impaled on the spines of Duchamp's *Bottle Rack* (1914) as on
a butcher's devices. The ideal humanity is shattered and sac-
rificed by the mechanical terrestriality of a world hungry for
mere meat, which Duchamp's resolutely secular icon sym-
bolizes. The artist's head, the one with the gilded laurel
wreath, proclaims the end of the Age of Beauty. The blue of
the hand of the artist functions as a spiritual color, a color
associated with the sublime as the infinite sky and with the
myth of the artist's ability to contact the sublime through
the work of beauty, to find the sublime at the heart of
beauty. Similarly, the Duchampian double door in *Aria di
Roma* conceals the darkness of destruction behind it: Du-
champ opened the door through which humanity might
walk to an end and, potentially, a beginning, but a beginning

143

tragically invisible and out of control. In *Occhio non vede, cuore non duole* (*The Eye Does Not See, The Heart Does Not Hurt,* 1990), the sleeping figure represents our time, caught in its post-Modern reverie of the past because it is terrified of a present in which god has become a mechanical device (represented by the Dadaist work of Schamberg).

Mariani's "dialogue with history," finally, is a complex conversation which suggests a variety of directions. It involves both the tradition of the ideal in art and the critique of the present moment in light of it. In some works he is the champion of the ideal in the midst of a vulgarizing pop collapse of the high into the low, a collapse in which the high has been brought low much more than the low has been brought high.[13] His work is an attempt to infuse into the present moment an awareness of classical roots and the idea that something remains viable in them. While it accepts the reality of the present moment, it insists on remembering that the classical itself is a mechanism of change and growth rather than a static holding pattern. It sees the moment, finally, not as cut off from the past and rushing headlong toward an unknown future but as a coherently layered continuum which contains the past in ways that may be usefully redefined and recombined toward a future with a self-knowledge that is less than desperate.

PAT STEIR AND THE
CONFRONTATION
WITH HISTORY

P AT Steir's work is often luxuriously beautiful in a pictorial way that may seem to champion traditional values of painting. Yet at the same time, like an X-ed out image, it shows everywhere the influence of the Conceptual art which was dominant in her early years as an artist. It is formed out of the tense intersection of these conflicting impulses – on the one hand, a Conceptualist tendency to deconstruct pictorial values and, on the other, a redemptive urge to reconstruct an image from them.

Around 1970 the complex interplay between these impulses began to unfold an iconography of motifs and references. In *Bird* (1969), for example, an interplay between blue sky and blue paint suggests a Magrittean distinction between representation and presence, painting as illusion and painting as paint.[1] Grids appear with a variety of Conceptual and Minimalist references, including the work of Sol LeWitt. Pencil lines running in parallel across the space incorporate a reference to the paintings of Agnes Martin. A trompe l'oiel pad with words scrawled on it introduces the theme of language, its place in a picture, and its ability to do service as a picture; references to typography, mechanical drawing, and instructional manuals introduce non-art visual signifiers with ties to the practical world and science. Despite the Conceptual nature of the issues raised, the piece is aesthetically cohesive; the manner in which the parts appear as separately iconic yet belonging together in an unexplained way that does not seem to need explanation is reminiscent of Jasper Johns. Somewhat as in Johns's work, the painterly elements remain parts of an analytic vocabulary despite their apparent aesthetic feeling. Painterly abstraction, even in lush epiphanies, appears as an art historical reference more than as an appeal to the pleasure of pure form. Even when it is abstract

the work is representational, because it is representing abstraction rather than simply being it.

Throughout the early 1970s Steir's conceptual-painterly inventory of motifs – scribbles, drips, grids, color charts, X-ed or canceled images, Magrittean clouds, Martin-like pencil lines, daubs of paint, crudely drawn primary shapes, coiling lines that Steir calls her "Rembrandt's hair" motif – expresses an analytic impulse to break the painting down into its atomic constituents and show how it can be built up again through recombining them. It is not, in other words, an impulse only to regress to the beginning, but also to find there the elementary building blocks of the image and to explore the paths of their recombinatory expansiveness. Repeatedly in works of this era Steir breaks down the pictorial vocabulary into dot, line, shape, and solid, echoing passages in the *Republic* and *Timaeus* in which Plato describes the ontological first things in the sequence in which he imagines them to emerge from nothingness. He begins with the elementary numbers 1 through 4, which are accompanied by spatial correlates. To the number 1 corresponds the dot; to 2, the line (two dots joined); to 3, the shape (the first shape is the triangle, three dots joined); to 4, the solid (the first solid is produced by four dots joined, one on a different plane than the others; it is the tetrahedron, which has triangles for each of its four faces). For Plato these numbers with spatial correlates represent the way the world of complex forms flows out of nothingness. Out of these forms, through addition and combination, others arise, eventually articulating the complex world of the senses. Similarly in Steir's sense of these things the complex image flows by stages out of the empty page or canvas. There is a correlation between cosmogony – the emergence of a world from nothingness – and art – the emergence of an image upon an empty surface.

In the *Republic* Plato speaks also of the "receptacle" or "screen," a shadowy reality which lacks existence on its own but provides the empty surface on which the flowing pencil point of the Demiurge may draw the world of forms. The screen is the infinitely malleable stuff of nothingness which the first dot electrifies into existence, then draws out into a line, joins into a shape, and stretches into a solid form. In the spirituality which has accompanied much Modernist painting, the surface of the canvas is like this metaphysical membrane between being and nothingness, a surface which is not purely passive but, like the surface of the primal ocean, has

the ability to yield up forms from within itself when properly stimulated. In Steir's works of the early 1970s this Platonic metaphor, which underlies the tradition of the abstract sublime since Kasimir Malevich and Piet Mondrian, is repeatedly articulated. The gessoed canvas surface is like a consciousness which resonates to the artist's awareness of visual vocabularies. It is felt as pregnant, a screen which arbitrarily begins to crawl with life as the elemental components of the image-world emerge, combine, and recombine.

Steir's work of this period involves a special homage to Agnes Martin, whom she visited in New Mexico in 1970, and the influence of repeated visits to that state for years thereafter. In a sense the influence of Martin's work, the delicacy and openness of its treatment of space, merged with the influence of the New Mexico topography, with its openness of sky and land that suggests a hidden dynamic – the drive of the potential to pass into the actual by means of the space of emptiness. *Looking for the Mountain* (1971) is a direct reference to this visit. (Calling from the airport, Steir and her traveling companion were told by Martin to drive "toward the mountain.") It shows a symbiotic response to the encouragement offered by the older woman artist, as Steir's painting works out implications of Martin's work which Martin herself has chosen not to address. The mountain which is implied by the grids in Martin's work, but never seen,[2] begins to make itself visible in Steir's more complex vocabulary, in which Martin's puristic reductionism is only a reference, not a binding law. (Steir's sense of driving out into the open matters that were tacit in Martin's work was fairly conscious; a series of prints from 1973 was titled *Between the Lines for Agnes Martin*.) This picture also shows, in the childishly drawn line-ends around the periphery, a Cy Twombly–like inclination to use primitive scribbles as signifiers of a primal moment when culture separated itself from nature by the making of a mark upon the void. An intention to regress to a beginning, prominent in both Martin and Twombly, becomes a permanent element in Steir's medley of motifs of spiritual progress.

The Way to New Jersey (1971) is a schematic inventory of the emerging vocabulary: bull's-eyes, pencil grids, color swatches, cancellation marks; dark and light rectangles, Pollock-based drips; a Twombly-like doodle at the bottom which takes the corkscrew form; a night bloom or dream flower making an appearance in the nocturnal rectangle. Steir

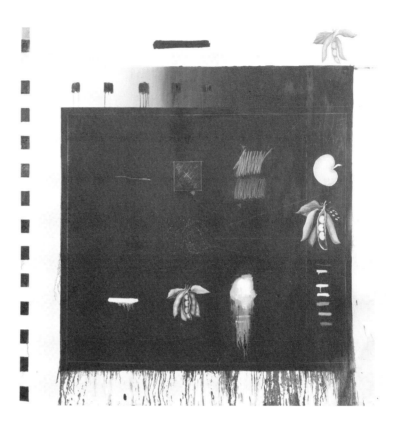

Pat Steir, *Line Lima* (1973).
Courtesy of the Whitney
Museum.

thinks of this work as a painting of a landscape painting, but deconstructed – an inventory of the elements from which such a work might be assembled.[3]

The flower image which appears in *The Way to New Jersey* stands for the figure; it portrays the self as sensitively open to the influences around it while actively radiating color and scent. Both active and passive, it hovers indefinitely and with a mystical glow in the black of night. But Steir's relation to her visual vocabulary is not direct and simple; her flowers blossom to be canceled out, as in *As I Am Forgotten* and *Word Unspoken* (both 1974). The flower and the canceling X balance one another as signs of the constructing and deconstructing impulses.

In *Word Unspoken* the central rose bears mystical associations about the elusiveness of the soul or self and the difficulty of the quest for it that go back to Medieval texts such as the *Romance of the Rose*. At the same time, it is cancelled by an X, seemingly demonstrating a resistance to figuration. The theme of the self, or of the quest for the self, is torn on this issue. Is the rose or the X a better sign for the idea of a hidden selfhood that needs to be pursued along intuitive interior paths? Is the self's efflorescence, its tendency to grow

148

and bloom and express itself, its essential feature, or is the
self's negation, its elusiveness, its unspecifiability, all sug-
gested by the X, more true to its reality?[4] This symbol, and
the questions it brings with it, would remain prominent in
Steir's work for years, until, in the *Brueghel Series* of a decade
later, it implies a universal signification as in certain ancient
religious iconographies.[5]

In the late 1970s Steir began to emphasize the disjunctive
or analytic aspect of her work by presenting images in a
multi-panel format which a few years later would become a
signifier of post-Modernism. At the same time the works
show a deepening commitment to abstraction, a rumination
on Ryman and the monochrome in general, and a continuing
investigation of the signification of the Pollock drip. *Beauti-
ful Painting* (1977–78) and *Beautiful Painting with Color* (1978)
are multi-panel works in which several abstractions combin-
ing stylistic elements associated with specific artists comprise
a single work out of the interplay among them. *Van Gogh/
Goya* (1978) offers what might be called abstract "portraits"
of those artists. Van Gogh is a single white dripping brush
stroke, Goya a black one. These primal painterly signs –
single brush marks with dripping bottom edges – have taken
on the iconic status that the rose had in Steir's work of the
earlier 1970s. They are now the marks of both the painterly
process and the quest for the self, which are increasingly
merging.

At this time the quotational tendency in Steir's work was
not so much a post-Modern critique of historical order as an
acknowledgment of the continuing viability of classic visual
modes when practiced with an attitude broader than that of
Modernist formalism. *Painting for 1984* (1981) reintroduces
figuration – or a representation of the idea of figuration. A
crucifixion based on Gauguin's rendering of a classical Flem-
ish picture enters the inventory alongside the "Rembrandt's
hair" squiggle and the horizontal brush mark – the funda-
mental curvilinear and rectilinear statements which combine
to make all images. The crucifixion is an example of the
arbitrary outcome of the quasi-Pythagorean mating of these
abstract motifs – also the first instance in which Steir quotes
an image, rather than a style, of another artist. In *Triptych
with Still Life* (1981), the iconic brush stroke and coil are
joined by a post-Cézannean still life. These panels – the
crucifixion, the still life – are not forthright representations;
they do not represent a world so much as representations of
a world. There are rules akin to those of sympathetic magic:

if an element has occurred in the history of art as part of the vocabulary with which painters have represented the real, it is eligible to represent the whole process. *Abstraction, Belief, Desire* (1981) introduces, in the multi-panel arrangement, references to Leonardo, Munch, Gauguin, Van Gogh, and early Italian perspectival painting.

In the early 1980s Steir's investigations of Eastern and Western art history led her to feel that the role of *japonisme* in the formative stages of proto-abstraction was insufficiently acknowledged. She incorporated this art historical reflection into her work in the flower paintings of the early 1980s. *The Tree* (1982), *Morning Tree* (1983), and others of the period were based on Van Gogh's copy of Hokusai's *Apricot Tree in Blossom*. Other works, such as *Blue Iris on Blue Ground* (1983), refer to Van Gogh without the explicit Asian reference. Such paintings laid the groundwork for the monumental union of flower painting and scholarly quotationalism in the *Brueghel Series*.

Steir's work has moved like a series of shock waves in reaction to a deepening realization about history and the possibility of self-actualization through engagement in it. In the early 1970s, the period of inventorying contemporary motifs, her pictures placed themselves within the art historical frame of their moment without much sense of the power of past and future. Subsequently the vastness of history as an embracing temporal matrix came into focus. The quest for the self was redefined as a quest for the history which flows into, constitutes, and passes through the self. History began to present itself as a transpersonal reality that yet did not deny the personal.

The *Brueghel Series: A Vanitas of Style* (1982–84) is based on a Netherlandish painting, Jan Brueghel's *Flowers in a Blue Vase* (1599). The appropriated work functions as an icon or sign of art history as enshrined in the Western museum tradition. Steir brought to bear on this found image her customary gridding of the surface, dividing it into 64 (8 × 8) rectangles.[6] Each of these rectangles was then transferred to a canvas 21 × 26 in. in a style referring to a particular artist or art historical moment. When assembled on a wall, the canvases form a multi-paneled work about 20 feet high, through which a multitude of stylistic currents flow, all European or American, from the Renaissance to the 1980s.[7]

The Brueghel vase as repainted in 64 panels now contains a somewhat lacunary visual history of Western easel painting. It becomes a massive icon, a kind of Platonic Ideal of art

Pat Steir, *The Brueghel Series: A Vanitas of Style* (1982–84). The Kunstmuseum, Bern. Courtesy of the artist.

history from which countless particulars could be derived; at the same time it has broken art history down into its atomic or elemental constituents. This dual function – of analyzing or breaking into parts, on the one hand, and regathering or synthesizing into a new whole, on the other – is the culmination of the long ritualistic process in which, over the preceding decade or so, Steir had broken art practice down into elementary units, which now are recomposed in order to build it up again out of the fragments.

The *Brueghel Series* is passionate and learned at the same time. It arises out of a desire to incorporate the sensibilities of past artists and unify them momentarily in a single person. The process might be likened to the incorporation of something into one's body by consuming it bit by bit: in these 64 homages Steir is ritually constituting her selfhood out of the history of art. This sense of history as a constitutive or ontogenetic force involves an ambivalent stance toward the Modernism–post-Modernism distinction. As quotational and learned the *Brueghel Series* is post-Modern, involving among other things the rejection of the Modernist cult of pure originality, of the obsessive Modernist quest for new forms, and so on. But the work's passionate incorporation of history as both an icon and a constitutive force shows a fundamentally Modernist reverence for history. Indeed, it is hard not to see this work as participating in the Modernist belief in Spirit as something that incarnates itself through history. It is like a massive icon or altar to history as the realization of spirit. On this altar something like the mystery of the transubstantiation takes place. In the interpenetration that exists both backward and forward in time between elements in a self-conscious tradition, such as European oil painting, Steir's piece suggests that any one painting contains, by implication or accumulated causal linkage, all paintings. An auratic worship of oil painting in itself is implied. The separation of art from social realities, its embeddedness in a formalist developmental history, its absolute value independent of its use in the world – all these essentially Modernist concepts hover about.

Paradoxically, a relativistic view of the evolution of artistic styles is implied by the piece's subtitle, *A Vanitas of Style* – a "vanity" painting in the seventeenth century being one that alludes to the transience of worldly pleasures; the delight of indulging a style thus takes its place beside rotting fruit and aging beauties as an infirm site in which to reside one's sense of self. Styles, Steir remarks, "are simply grids . . . of

the conventions of a particular era."[8] Yet through their shift-
ing veil, the *Brueghel Series* seems to imply, we glimpse a
complex universal that is art. The role of the individual artist
is similarly both relativized and universalized – on the one
hand an empty medium through which the conventions of
an age express themselves, on the other a Wordsworthian
Romantic soul through which an invisible universe moves.
Brueghel's vase of flowers becomes a transcendent concept
that cannot be fully caught by any artistic style, yet incar-
nates itself partially and imperfectly in all. The traditional
symbolic weight of the womblike vessel as both source and
receiver, a common image in goddess-worshiping cultures,
and of flowers as signifiers of the cyclical recurrence of beauty
and warmth, suggest additional transhistorical associations.

The *Brueghel Series* was like a gateway into history. To
participate in history in a linear way after its compaction into
a universalized simultaneity Steir chose a stylistic sequence
that combines nineteenth-century proto-abstraction, *japon-
isme,* and action painting. This art historical investigation
took form through a focus on the depiction of water in the
Chinese, Japanese, and Western painterly traditions. In Taoist
painting theory, which underlies much of the Chinese land-
scape tradition and its later ramifications in Japanese art, the
landscape picture was to reflect the differentiation and bal-
anced interaction of yang and yin through the subject matter
of mountain (yang) and water (yin).[9] Steir's decision to focus
on the yin aspect to the apparent exclusion of the yang relates
to the genre of Chinese painting in which Taoist scholars are
portrayed in the act of prolonged gazing at waterfalls and to
the Japanese genre of the wave painting, most familiar in the
West through one of Hokusai's *100 Views of Mt. Fuji* (II.40),
in which, though the yang element is present, it is greatly
diminished in relation to the yin. A prolonged contempla-
tion of the yin element is said to have tonic effects on the
personality, rendering it more fluid and adaptable.

The Western tradition about water as the universal solvent
is not dissimilar. It relates to the concept of yin as the receiv-
ing and dissolving medium. Something similar again is found
in Thales' assertion that all things come from, and presum-
ably go back to, water, which in turn echoes the Old King-
dom Egyptian concept of the pre-historical world as an oceanic
soup in which all the gods or essences were mixed together.
(As Ferenczi brought out in *Thalassa,* there is a kind of
identity between the primal ocean and the amniotic sac.) In
addition, in terms of Steir's focus on art history as a conger-

ies of specific individual styles, the special approaches to the depiction of water found in Leonardo, Hokusai, Turner, Monet, Whistler, and many other great artists provided a historical arsenal of references to be dissolved together in the yin embrace – as the history of flower painting had done in the *Brueghel Series*. For Steir these Eastern and Western traditions flow together in the age of *japonisme* – the influence of Japanese graphic design on European artists in the nineteenth century – through the universal dissolution works of Turner in the 1840s and the near-monochrome seascapes of Whistler a generation later.

In the early 1980s, while the *Brueghel Series* was still in progress, Steir began painting waves based on Courbet's *The Wave* and on various works by Turner (especially *Light and Color [Goethe's Theory] – The Morning after the Deluge*). In 1986 a series of square-shaped oil paintings of waves were inspired by Hokusai, Hiroshige, Leonardo, Turner, and Courbet. As traditions became watery and began to dissolve together, the pictures tended to treat one or two basic models – especially Courbet's *The Wave* (1866) and Hokusai's *The Underwave off Kanagawa* (1831) – with multiple stylistic inflections: *The Wave after Hokusai* (1986), *The Wave after Hokusai as Though Painted by Turner* (1986), *Spring – The Wave after Courbet as Though Painted by Ensor* (1986), *Summer – The Wave after Courbet as Though Painted by Monet* (1986), *Autumn – The Wave after Courbet as Though Painted by Turner Influenced by the Chinese* (1985), *Winter – The Wave after Courbet as Though Painted by an Italian Baroque Painter* (1985), and so on.

In a series of circular paintings of 1987 based on a classical Japanese type, a single breaking wave almost fills the canvas, the viewer gazing obliquely down the wave's curl (what surfers call the "tube"). The circle represents the moon, which is understood to be almost obscured by the wave. Behind the tumultuous brushwork of these paintings is the explosive historical energy of the eruption of proto-abstraction in nineteenth-century Europe. In its turn from the finite and beautiful to the infinite and sublime, painting approached abstraction through attempts to represent natural forces so vast or so elemental that they innately hover on the edge of abstraction – the out-of-scale reality that cannot be represented all at once, which Edmund Burke had called the sublime. As Monet's lily ponds and Turner's late seascapes show, the watery element is especially an interface between abstraction and representation. Compressing into these works

the formal sequence that leads from Chinese and Japanese origins through *japonisme* to Abstract Expressionism, Steir portrays history as an oceanic force that is always casting up new forms and taking down old ones. In fact, her mixing and layering of historical moments embodies something of this process.

Beginning in 1987 Steir's waves gradually transformed into waterfalls. The transitional work was *Last Wave Painting – Wave Becoming Waterfall* (1986–90). In this picture the full-bodied circles of the wave paintings are surrounded by a variation of Pollock's drip-and-splatter technique of action painting. This element was selected from her varied vocabulary as an open sequence in the sense in which George Kubler uses the term in *The Shape of Time* – a developmental sequence which was suspended in the past, perhaps under the impression it had been completed, and which can be re-opened in the future through an act of will by an individual artist. Unlike appropriationists such as Mike Bidlo and Vernon Fisher, who have quoted specific Pollock works as icons, Steir reopened the Pollock sequence in a context of history and carried it forward, into works that, while they cannot be regarded as what Pollock would have done if he had lived longer, yet contain something of that aura. At the same time the affinity with the Chinese and Japanese flung ink styles compresses into this signage the linkage between East and West that runs from classical Chinese and Japanese painting into *japonisme* and from thence into Modernist abstraction and Abstract Expressionism.

In most of the waterfall paintings a brush oversaturated with diluted white paint is drawn across the top of a canvas; the extra paint drips down to the bottom. The multiple brush marks that are seen in *Waterfall of Many Possibilities, Graphical Waterfall,* and *Dragon Tooth Waterfall* (all 1990) are gradually reduced, through works such as *Wolf Waterfall* (1990). The 1991 versions are often based on the motif of the mark that bleeds downward that appeared in miniature in many of Steir's analytic paintings of the 1970s. There is a single brush stroke at the top of the canvas; the middle area of the painting creates itself through gravity, and the up-splash area at the bottom is made by flicking paint from the end of the brush without touching the brush to the canvas. So in a sense each painting is just the primal mark of presence which is the signifier of the whole long and varied tradition of self-expression.[10] The dripping water-diluted paint *is* the waterfall that it represents, somewhat in the way that a flung

ink character is simultaneously a picture and a word, the sign and the thing.

The painting develops from the initial brush stroke through a natural or automatic process, with no further control by the artist except through predetermined factors such as the thickness of the medium. The painting emerges, in other words, as many Conceptual works emerged, through the artist establishing conditions that allow the work to take shape by itself. In some cases Steir eliminates even the initial brush stroke, throwing the paint at the top area of the canvas from a bucket.[11] The Conceptual base of the method is evident also in Steir's refusal to edit or select from the paintings made in this way, which are exhibited regardless of her preferences among them. The aesthetic presence of the works does not result so much from the attention of a controlling aesthetic sensibility as from the sense of completeness that these paintings derive from the coherent history of the oeuvre: Steir's patient working through the idea of the mark, from simplicity into complexity and back to a more fully integrated and understood simplicity again.

The sense of meaning and coherence in Steir's oeuvre emerges from its prolonged confrontation with issues of history and its absence. The transition in attitude that is often referred to as post-Modernism, post-history, and so on, was enacted clearly at a certain moment in her oeuvre, then thoughtfully and with deliberation was rescinded or compromised in the name of carrying on what Jürgen Habermas referred to as the "unfinished project" of Modernism.[12] Steir's work went in a sense from being pre-Modern, or pre-historical (the work of the 1970s which inventoried the present moment without much regard to the past), to being post-Modern or post-historical (the *Brueghel Series*). In its presently ongoing third phase, which might be called neo-Modernism or Modernist Revival, she rededicates the work to a history that is widely perceived as over though clearly it is not yet fully resolved.

Steir feels that painting has not yet made its final statement, that it is a resource which has not yet been dried up. Her present ambition as an artist is less to defend painting from the repeated claims of its "death" than to participate in its rhythms, including the rhythm of its endings. She desires, she says, to make the "last painting," but not in the apocalyptic sense in which Malevich, Mondrian, Klein, and Reinhardt described their works as the "last paintings." Those classical Modernists were imbued with the Hegelian myth of

the end of history and the sense that art works would an-
nounce or herald that end. Steir, practicing a very modified
type of Modernism with heavy influences of post-Modern-
ism, sees her work, on the contrary, as possibly constituting
the closing of a sequence left open, as a "last painting" in
this limited sense of constituting a resolution which might
lead to a cyclical or recurring pause in the onrush of history.

FLOWER POWER

Trying to Say the Obvious about
Sigmar Polke

ROUND 1960 painting lost credibility for a while. This
happened in both Europe and America. Its credibil-
ity in the preceding era had rested in part on a claim
of supernatural or transcendent vision. According to this
idea, the painter ventured intuitively into the abyss of the
unknown and wrested from it a vision which, transferred to
a physical surface, was the painting. Among the most self-
conscious embodiments of this idea were works in the tradi-
tion of the sublime – especially the abstract sublime – and,
quintessentially within that category, Abstract Expression-
ism with its obsession with the primal or originative mo-
ment. A picture such as Jackson Pollock's *The Deep* or Bar-
nett Newman's *Day One* was understood as a view through
what Hölderlin called "the gateway of all image" – like the
sight glimpsed in the first light of creation. It was primal and
thus preceded corruption and thus was incorrupt – even
incorruptible.

Around 1960 this began to seem like a misleading assess-
ment. (For some it had long seemed so – as in the skepticism
that Marcel Duchamp had felt about painting's relationship
to real life as early as 1912–13.) The idea of representation
began to break through the idea of abstraction and raise
questions about it. Even granted that the painting repre-
sented something primal and incorruptible (and that in itself
was getting hard to believe as commodification advanced
apace), it was still not the thing itself but a representation of
it – and there was no telling how much corruption had
entered into the representation through its maker's desperate
ambition for the incorrupt; perhaps the painting's apparent
credibility resided simply in the artist's ability to fool himself
so well that he in turn fooled others.

Painting at this point tended to give way to sculpture in

various modes, including performance, or "living sculpture."
A sculptural ethic arose that was characteristic of the 1960s
and 1970s: the main point was that sculpture occupied real
three-dimensional space – the space of the viewer – unlike
the illusionistic metaphysical depth which the canvas sug-
gested even in the hands of the most advanced preparers of
the surface. In the sculptural experience there was suppos-
edly less room for illusionism, and also less room for the
idea of magic, which lay all over the painted surface like a
glossy nocturnal sweat, or an Osirian eye glistening at the
beyond in a cavern where mummies sat up and took notice.
Sculpture acknowledged the reality of the body, and that
could be the beginning of a materialistic and social art. It
occupied the gap between art and life that Robert Rauschen-
berg had thought he would work in. And so-called living
sculpture, later called "performance," was in this sense its
ultimate form. Resisting the concept of theater and the pros-
cenium arch, performance was felt to go even beyond sculp-
ture in the elimination of illusion and the coming-to-terms
with real life.

It may be that in Germany there was a special urgency to
these issues, insofar as Theodor Adorno's precept, "To write
poetry after Auschwitz is obscene," may have been most
obviously relevant there. Clearly this precept applied to tra-
ditional easel painting as well as to poetry. The picture, with
its false exclusion of the immediate world and its claimed
glimpses of a picturesque beyond, was as suspect as poetry
with its false metrical voice and its habit of fantasied beauty.
In fact, the question that Adorno was pointing to went
beyond both poetry and art, and applied to all cultural activ-
ity. It asked how one might do something that continued the
tradition that had led up to the traumatic or psychotic break
while still acknowledging that break and confronting its de-
railment of that tradition: how to continue the karmic thread
that was history while acknowledging that history had dis-
credited itself.

Joseph Beuys investigated the terrain of this paradox im-
pressively. First he turned to sculpture and living sculpture
as more real alternatives to pictures of things. These works
contained a real stance toward the Adornean question. When
Beuys exhibited withered sausages and turd-like things in a
vitrine and labelled it *Auschwitz* he was rubbing our noses in
what Walter Benjamin called the *faeces et urinam* of history,
stressing its nature as, in James Joyce's words, "a nightmare
from which I am trying to awaken." After this, how could

one participate innocently in art history again? Beuys acquired students or disciples, and he told them one could not paint anymore; that would be the betrayal. This statement was powerful and courageous, but then there were problems. In time, the performative impulse crossed the line between art and life and became life; then life, in turn, became a vaguely grandiose mummery based on apparent strategies of avoidance of what it had intended to confront. Shamanic retreats into nature gave way to royal elevations into heavenly realms.[1]

The next generation of German artists had to contend with Beuys's example. His attempt – only partially successful – at reconciling the exigencies of recent German history with the impulse to make objects for disinterested contemplation, posed a challenge which was theirs either to take up or to neglect. Polke was one of Beuys's students to whom the prohibition against painting was made, and his reaction against the teacher's mummery included painting as a gesture of rebellion. There was in this decision a certain attempt not to be overcome by the karma falling from the past – as Beuys was – to be more in the present moment and out of the coercive framework of history. This was an option that seemed to be offered to the generation of the flower child, who felt able to slip off communal karma like a uniform thrown on a dump and walk away clean. Part of the syndrome of release was the chemically induced psychedelic experience – especially that induced by the psilocybin mushroom – through which it was undeniably possible to step out of history into an overwhelming presentness, at least for a while. Polke conjoined the act of painting with a transgressive life-style that took form through drugs, alcohol, hippie-style visits to non-Western cultures, biker communes, and so on.

I am now referring primarily to Polke's work of the 1960s, the decade in which he was in frequent contact with Beuys. Although this work may be seen as a transgression of the Beuysian imperative not to paint, it did not consummate the transgression by affirming the traditional values of painting. It extended the transgressive act to include a critique of the aesthetic values and traditions that had propped painting up for so long. His works of the early 1960s parodied the visionary tradition with strategies that were partially shared with American Pop art and with Conceptual art's reductio ad absurdum of the idea of the beautiful. (His parody of the abstract sublime, for example, in *A Higher Power Commands:*

Paint the Upper Right Corner Black! [1969], had something in common with John Baldessari's *Painting with Only One Property* and other works of the time, both European and American.)

Was Polke's use of painting to critique the tradition of painting in some way a continuation of Beuys's troubled confrontation with recent German history? Or was Polke assuming that it *is* all right to write poetry after Auschwitz, as long as one waits long enough after it – as long as there has been a generation of penance first, the penance that Beuys worked out in various ways – and providing, of course, that the poetry (or painting) is critical in nature rather than naively aesthetic?

Polke's stance on this issue seems to have evolved; it is convenient to see it as stages, without implying any rigid barriers between them. First was the critical painting of the 1960s, just referred to, in which the cultural project was

Sigmar Polke, *Höhere Wesen Befahlen,* 1969. The Froelich Collection. Courtesy of J. W. Froelich.

Höhere Wesen befahlen: rechte obere Ecke schwarz malen!

continued but without naive faith in its means. Skepticism and parody removed the painting from the suspect visionary tradition and served as its ethical justification. In these ways, Polke was performing a critique of culture from a standpoint inside culture, but his critique implied the possibility of a stance outside of culture or history. (His reported complaint about the work of Rothko, for example, supposedly on the grounds that there was too much art history in it, implies a desire for an ahistorical stance.)

In the 1970s this desire came increasingly into the foreground. This seems a decade in which painting was backgrounded in Polke's activity. Many of his works of this period were realized through chaotic collaborations that repudiated the art-historical imperative of the author. Many were photographic and thus participated in the 1970s Conceptualist tradition of opposing the illusion of the painting with the documentary reality of the photograph. Photographs of bums, in New York's Bowery district, Sao Paolo, and Hamburg, affirmed the idea of dropping out of society and rejecting its hierarchies. Photographs of mushrooms suggested the greater reality of the ahistorical consciousness. Photocollages showing Amerindian people seated ritually around a psychedelic mushroom affirmed the idea of dropping out of Western civilization into pre-Modern and ahistorical modes of feeling.[2] Photographs taken in Iran and Pakistan similarly associated the non-Western with access to alternative realms: a water pipe, an opium den, and so on. Photographs in which the artist himself seemed to merge with nature, becoming a tree or other natural object, suggested a retreat from culture and its history.[3]

In the 1980s painting again returned to the forefront of Polke's work, at least as it has been exhibited and recorded. Now a more complex response to the problem of history began to be articulated. It appeared in the incorporation of volatile natural stuffs – like pigment of violets in the *Negative Value* series (1982) and mineral dust in the series *The Spirits That Lend Strength Are Invisible* (1988) – into the painting process, with an implied rejection of the conventional materials of painting along with its pretensions to historical inevitability. The impulse toward the ahistorical also underlay the artist's increasing interest in alchemy, which, like psychedelic experience, seems to offer access to ahistorical positions within the world.

This phase was more radical than the phase of cultural critique in that it implied entering nature rather than critiqu-

Sigmar Polke, *Hochsitz mit Gänse* (1991–92). The Art Institute of Chicago. Courtesy of the Pace Gallery.

ing culture. (This is the "reversal" that critics have noticed but not defined in his work around 1980.)[4] But in another sense this radicality fades into a long Germanic tradition which some have found suspect. It replays in another medium the problem of Beuys's strategy. Beuys entered nature symbolically through such acts as conversing with the hare, living with the coyote, sinking into the bog, and so on. His escape sleds with fat and flashlights imply a desperate flight from civilization into a redemptive wilderness. Beyond Beuys, this is a long Germanic tradition which will not in itself help to escape Germanism. The idea of fleeing culture into nature evokes the folkloric tradition associated with the Brothers Grimm and the Teutonic archetype of Siegfried who knew the language of the birds – and the Wagnerian tradition that exalted it. It has seemed suspect to some because of its trivialization of the values of civilization, inviting their abuse.

This reversal – if that is the right word – involved a new stance toward the relationship between culture and nature, or between history and the ahistorical, which unfolded in two parts. First were the paintings depicting concentration camp images – such as *Camp* (1982) and the *Watchtower* series

163

(1984–88) – which represent, as far as I know, this artist's first overt reference to the question of German history. The French Revolution paintings of 1988 – for example, *Le Jour de gloire est arrivé . . .* and *Liberté, Egalité, Fraternité* – may be regarded as continuing this direction. These works evince a deep distrust of the idea of civilization, which presents the most horrific events as in a pretty brooch (*Médaillon*, 1988). Sometimes – as in *Jeux d'enfants* (1988) – the pretensions of civilization seem about to be overgrown by natural forces claiming it back. In these works the Hegelian evaluation of culture (the Work) and nature (Madness) is reversed, or the dichotomy is collapsed (the Work *is* the Madness).

Over and against these works which directly address the issue of history are paintings that seem increasingly Abstract Expressionist and visionary, as far as their look goes, including the paintings executed for the 1986 Venice Biennale and the series *The Spirits That Lend Strength Are Invisible*. Yet at the same time they employ devices to offset this impression, such as random effects gained by scattering dust – the randomness belying the idea of masterful aesthetic control. Seen as the product of random forces, these works present less an image of aesthetic deliberation than a nature-like image like, say, rust or fungus. Especially important is the chameleon-like nature of these works which employ chemicals such as silver nitrate to effect changes in color or appearance in response to ambient changes in temperature and humidity. Thus, they are like natural, rather than cultural, entities, responding to the environment, changing in ways not controlled by the cultural dominion of the maker, refusing to exhibit a fixed nature, like organisms going through their changes.

The appearance or surface of these works offers the viewer the option of regarding them as abstract paintings participating to a degree in the tradition of the sublime. This is their danger. Do they show the artist becoming more easygoing in his middle age, more a pawn for the aesthetic appreciation that critics and viewers undoubtedly accord this work? Or does their incorporation of poisonous chemicals, with its implied or symbolic threat, offset the easy aesthetic response? While the random practices involved in their making remove these works from the zone of heavy aesthetic control that the abstract sublime represents, other aspects stress this association. The idea of the pure or primal origin was the principal subject matter of the Abstract Expressionists. Sup-

posedly in the grip of the sublime, the painter was held to be like a medium through whom the painting made its statement or created itself. The painting came into existence like a world rising out of primal blackness. There is an analogue in Polke's attempt to have the painting create, or recreate, itself through random initial steps that lead to ongoing changes not controlled by the artist. Without transcendentalist aspirations, the work is still posited on the idea of a pristine self-creation outside of cultural interventions.

The title *The Spirits That Lend Strength Are Invisible* is said to be taken from an Amerindian text. Polke's use of an American theme in his turn toward nature reflects the eighteenth-century European view that America was ahistorical, that the karma of Europe did not fall upon it, that a new and innocent society might exist there already. This is the same mythologem that Beuys invoked in his paean to the Amerindian, *Coyote: I Like America and America Likes Me* – the idea that Europe is culture and America nature. Polke's incorporation of what he calls "Neolithic tools" (meaning Amerindian arrowheads) into these paintings suggests a flower-child impulse to recreate a pre-Modern and ahistorical culture that is virtually a part of nature. The technique of blowing powders onto a prepared adhesive surface also alludes to the paintings in Paleolithic caverns such as that at Lascaux.

Thus Polke's dive into nature with the "chameleon" paintings is, in a veiled way, a contribution to culture. It is a re-entry into culturally positive attitudes by way of incorporating nature into culture as a potentially healing force. The early works solve the Adornean problem by the tactic of using culture to critique itself rather than uncritically to affirm itself. The more recent work seeks a deeper channel, and finds it by turning to nature; instead of doing culture as culture the artist-alchemist now does nature as culture. There is an attempt here to preserve the principles of 1960s counterculture as a simultaneously critical and constructive force in the 1990s.

What is most commonly said about Polke's oeuvre is that he did everything first in terms of the return of painting from its exile (or rather, he did everything first for a second time after Picabia had done everything first for the first time). His importance for American artists in this respect is well known. But in the midst of his preservation of the medium of painting he has shown a more intense awareness

of the problems that painting represents than have his American avatars. It is this internal contradiction – his refusal to either give it up or exculpate it, his obstinate insistence on forcing it into new corners from which new escapes must be found – which is his work and his madness at once.

CECI N'EST PAS UN BIDLO?

Rethinking Quotational Theory

UCH of the art that was characteristic of the 1980s involved overt references to other artworks, usually iconic, or art historically crucial, works of the past. This referentiality took hold on a very broad basis, among artists who would be called Modernist as well as post-Modernist. There was an enormous range to the references, which were like indices to the long cumulative formation of the character of civilization – especially Western civilization, but not exclusively. From the Paleolithic horses that reared in Elaine de Kooning's paintings to the wide-eyed Sumerian faces peering psychedelically from paintings by Gino de Domenicis; from Francesco Clemente's Indian Moghul-style miniatures to Masami Teraoka's humorous redeployments of medieval Japanese graphics; from Julian Schnabel's Caravaggesque youths to Mike Bidlo's recreated Duchamp Readymades – the iconic moments of human visual self-definition gazed out from many contemporary gallery walls.

Sometimes such work was a precise replication of a specific earlier painting or sculpture, sometimes a looser reference to the style of a certain artist, school, or period, but always it was overt, even conspicuous, in declaring its sources. The overtness of this referentiality was perhaps the chief distinguishing trait of 1980s art, though in truth it had appeared earlier – in some Pop art, in the work of some nonconformists of the 1950s and 1960s such as Elaine Sturtevant and Richard Pettibone, and, more remotely, in certain of Marcel Duchamp's works, such as *LHOOQ*.

Various terms have been used to designate this practice, some hostile, some not: plagiarism, pilfering, scavenging, simulation, appropriation, quotationalism. (I prefer the last as more descriptive and less judgmental than the others.)

When quotational work first forced itself on our attention as something that was not an eccentric footnote but a new mainstream element – roughly in 1982 – one common critical reaction was that this approach was severely limited. How long – the question seemed obvious – could artists get by with simply copying past works? How long could it interest the artists themselves to do so, not to mention their audience? Surely, many felt, quotationalism was only a momentary phase, called into being by specific needs, and would disappear once those needs had been fulfilled.

Despite its adoption by some residually Modernist artists, the cultural need that seemed to have called quotational art into action was widely associated with the shift in cultural attitude that has been called post-Modernism; it was in effect the pictorial aspect of that shift. Specifically, quotational work was generalized as a critique of certain elements of Modernist ideology that had come to seem not only outworn but undesirable. It was understood, in other words, as a visual strategy of deconstruction. Above all, the act of copying was said to critique, or gesturally reduce to absurdity, the Modernist cult of originality, in which artists would usually hide the influences on their works rather than conspicuously flaunt them. The quotational artist, then, was pointing out that all cultural production is conditioned by the past – that there is no creative miracle or spiritual tabula rasa.

Another but related way of viewing the matter was to say that the appropriating or quoting artist was critiquing the aura, in Walter Benjamin's term, of sanctity which traditionally clung to the original masterpiece as to a holy relic. If, as Benjamin thought, mechanical reproduction would eliminate the aura of the original, how much more this almost mocking re-enactment of the primal moment of creativity, reducing it to absurdity by showing it to be not unique but infinitely repeatable.

Yet another, also related, approach was suggested by ideas about post-industrial society's supposed lack of sequences or priorities, especially Jean Baudrillard's formulation in *The Precession of Simulacra* that there is no longer any original, that the copy is as prior to the alleged original as vice versa – like the chicken and the egg – and so on.

The conventional wisdom was that first the various forms of the Modernist cult of the original – an essentially archaic religious idea – would be reduced to absurdity by this per-

formative critique. Then, after a few years of this demon-
stration, once the culture roundabout had absorbed the cri-
tique, the transition to post-Modernism would be made. At
that point the quoting practice, having served its essentially
transient or transitional purpose, would fall away naturally.
At least so the conventional wisdom said.

This has not, however, been the case, and in fact there
now seem to have been a number of errors in this way of
looking at quotational art. To begin with, the sense that all
of this art served a single purpose now seems clearly to have
been mistaken. It is true that the movement, if such it can be
called, did effectively critique or ridicule the Modernist cult
of originality. But beyond this the range of practices in-
volved served many different purposes in the hands of differ-
ent artists. Bidlo's early appropriations of iconic master-
pieces such as Jackson Pollock's *Blue Poles,* for example,
served, in his mind, to liberate these paintings from the
elitist commodity system they had been absorbed into and
to restore them in some sense to the people, even to the
street. In contrast, Sherrie Levine's reduced-size watercolor
versions of iconic paintings by male heroic Modernist artists
served as a substitution of the feminine for the masculine, as,
that is, a specifically feminist revisionist practice. For many
other quoting artists it was not so much the quotational act
itself as the particular iconographic value of the quoted ele-
ment that was central. DeDominicis's Sumerian quotes in-
volve a revery upon the historical formation of Western
identity. Jannis Kounellis's varied reworkings of Kasimir
Malevich's *Black Square* serve to align him with a certain
ideological strain in avant-garde practice. Schnabel's various
quotations and references, from Caravaggio and many oth-
ers, constitute his sense of his own artistic pedigree, as well
as of heartfelt homage. Simon Linke's appropriations of *Art-
forum* advertising pages constitute a critique of the closed-off
or exclusionary quality of the art market. Alexander Koso-
lapov's quotations of Mickey Mouse and Mao, or Malevich
and the Marlboro Man, and so on, involve complex reflec-
tions on the relationship between capitalist and communist
cultures, and between East and West. T. F. Chen's mixtures
of Eastern and Western quotations are instruments intended
to hasten the dawning of a universal culture involving the
merging of cultural identities. Robert Colescott's black-faced
revisions of famous masterpieces were reminders of the rac-
ist exclusionism of Western art history and attempts to insert

this awareness into it. This list could go on. The point is that the quotational approach has proved far more varied and subtle in its usefulness than had at first seemed likely.

Another point to be reconsidered involves issues of style, a much disputed topic in recent art discourse. Since the passing of the Modernist heyday, much iconic Modernist painting has been seen as mere graphic style artificially freighted with a sense of destiny or transcendent content. Quotational art seemed at first a critique of this Modernist fetishization of style. So intense was the fetishism that when a high Modernist artist like Mondrian or Pollock had developed a signature style, he stuck by it with a kind of fanatical devotion as if convinced that it expressed aesthetic universals. The post-Modernist quotational artist, in contrast, seems to reject the idea of personal style altogether, even to mock it by moving from one quoted style to another with no apparent commitment to any. But this appearance also has proved misleading. While it is undeniable that, in the mid-1980s, quotationalism did accomplish this critique, or parody, of the Modernist fetishization of style, it is equally clear, after a full decade of quotational art, that it has proved to be a rich new source of stylistic nuance.

One way of seeing this is to picture the stylistic options available on a two-dimensional surface as a finite continuum – meaning that there are just so many ways one can stylistically occupy a flat surface and that these can be arranged in sequence by similarity. Modernist art, especially abstraction, was a process of scouring these options out and crystallizing them in classic articulations. Basic stylistic conformations such as Mondrian's or Pollock's or Mark Rothko's were like cuts into the continuum, each clearly separated from the others, each secure in its undeniable integrity. As this process went on, however, the cuts through the continuum got closer and closer together. Malevich's use of the square, Ad Reinhardt's use of it, Joseph Albers's, Hans Hoffman's, and others' ways of using it – while each was distinct from the others, all occupied a small area of the continuum. In time, as this communal exploration reached fullness, there was no longer much open space on the continuum. New cuts were inserted tightly in between others already there and already packed close to each other. The possibility of really surprising innovation was fading away, as there was little or no new room to explore.

At this point the stage was set, and quotationalism entered. Seen in this sense, it was not called into being only as

a deconstructor of Modernism, but also, somewhat ironically, as a continuation of the Modernist imperative of stylistic innovation. The tactic of quotation involved a stepping back from the continuum of traditional visual elements – palette, handling, painterliness versus geometry, and so on – in a metastep by which the prior cuts could be seen as individual elements available for new styles to be compounded out of them. The artist would no longer feature such elements as color sense, paint handling, and compositional format as the building blocks from which to construct a style. Rather, past styles, already so constructed, would themselves be used as building blocks for constructing new metastyles. Modernist styles became elements contributing atomistically to post–Modernist metastyles. A classic art historical style became a brush stroke, so to speak. Or past cultural icons became found materials to be recycled. Through this step a new continuum was found. The various approaches of the quotational artists referred to above represent primary cuts into this fresh continuum.

Seen from this point of view a parallelism between the Modern and the post-Modern practices emerges. Bidlo's quotational practice was one of the first and foundational cuts into the new continuum, and his work follows a set of rules which amount to a stylistic signature. The typically Modernist approach to style of course involved an aesthetic focus on a rigorously limited arena of options that would be investigated in extreme detail and nuance – an approach based ultimately on the model of the scientific investigator ruminating lifelong over a tiny body of experimental options. Unlike Pettibone, who makes miniature replicas of iconic works, and Levine, who reduced the size and transferred the medium, Bidlo has rigorously maintained actual size and original materials. These rigid constraints function in his oeuvre like the self-imposed narrow limits of the oeuvres of, say, Mondrian, Reinhardt, Robert Ryman, and Daniel Buren.

It is not, then, as has often been claimed, simply the choice of the work to quote which is Bidlo's own input. In fact, he characteristically chooses the most art historically representative examples of an artist's work, such as the judicious selection of the current group of Légers, representing each of the artist's various periods by an iconic work or two. His approach, then, reflects the iconicity of the canon with the eye of an art historian. (When he discusses his work, too, it is often with an art historian's type of attention and con-

cern.) But beside this element of choice, within the narrow parameters of his work there is as much room for creativity or sensibility as within the oeuvres of many rigorously self-consistent Modern masters.

A central trait of Bidlo's methodology, which reconnects the circle leading back to Benjamin's argument, is that he works from reproductions. There is an interesting interplay here between Bidlo's work and the Benjaminian theory. It was the reproduction that Benjamin felt would invalidate the aura of the original. But in this case the reproduction is itself,

Mike Bidlo, *Not Léger (Nudes on Red Background, 1923)* (1992). Private Collection. Courtesy of the artist.

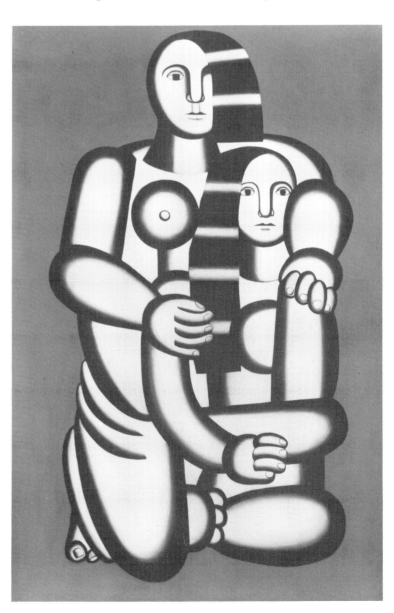

in terms of its hands-on facture, another original. Sherrie Levine once astutely asked, "What's the difference between a picture of a picture and a picture of anything else?" In Bidlo's case, since he works from reproductions, it is a question of a picture of a picture of a picture. The photographic moment hovers cryptically in between the two painterly moments. The mechanical or artificial moment hovers between the two handiwork moments and distinguishes them ontologically from one another: the first laying on of the hands is prior to the mechanical reproduction; the second is posterior to it. The second, then, both restores authenticity and mocks it at the same time.

The reproductions that Bidlo works from are usually those he finds in ordinary art books, often without having seen the original works. He starts out, then, from the position of the unprivileged outsider, the ordinary art aficionado gazing at little reproductions in books. This position echoes his desire to reclaim the works for a non-elite audience. The fact that his own works are now rather elite commodities does not alter the premises of his method. The reproductions are of course usually smaller than the originals and thus lack detail. The general framework of each piece, then, is derived from the reproduction, but the finish of the work, the final articulation of the surface (that value so prominent to the formalist critics), is not copied, and may bear little resemblance to that aspect of the original. His works have, in fact, a distinct Bidlo finish. In a televized interview with Bidlo conducted for Channel 4 in Britain the interviewer asked very skeptically what one has when one has Bidlo's copy of this or that. After a long silence, with a somewhat pained look, Bidlo replied, "You have a Mike Bidlo work – that's all." Indeed, this answer is correct. The Bidlo is no more a mere copy than a Buren is a mere copy of wallpaper. Given the conditions and parameters of Modern and post-Modern art, a Bidlo is to be appreciated as such, not as a reproduction of something else. It is an original, with its aura of originality still palpable, though ironically askew.

FRONTAL ATTACK

The Work of Leon Golub

I feel very much separated from Western art as we see it today. Because . . . it comes out of a late Renaissance "art for art's sake" notion of art.[1]

Leon Golub, 1965

L EON Golub was born in 1922. In terms of American art history, he was of the generation that matured immediately after the dominant achievement of the New York School. Eighteen or nineteen years younger than Willem de Kooning, Mark Rothko, Clyfford Still, and Arshile Gorky, and eleven years younger than Jackson Pollock, he was roughly contemporary with Sam Francis, Roy Lichtenstein, and Larry Rivers (all born in 1923), Kenneth Noland (b. 1924), Robert Rauschenberg (b. 1925), and Cy Twombly (b. 1928). For artists of his generation, the choice was whether to continue one thread or another of Abstract Expressionism (as, say, Francis, Twombly, and Noland did) or to rethink the assumptions behind art-making and embody this rethinking in reconceived objects (as Lichtenstein, Rauschenberg, and Golub did in different ways).

For Golub the choice framed itself partly in terms of the fact that he was a member of the Chicago art scene before the New York one. To many Chicago artists who watched from afar as Abstract Expressionism unfolded with incredible impact in the late 1940s and early 1950s in New York, the New York School's subservience to the School of Paris seemed effeminate or "Frenchified," lacking in the rugged individualism that seemed more appropriate to American art. The overwhelmingly high critical estimation in which the heyday of the New York School is still held, not only in New York itself but in Europe and indeed throughout much of the world, seemed simply a mistake. A critic who has

championed German Expressionism rather than Cubism as the central movement of Modern art has described Abstract Expressionism as simply the exhausted last gasp of the School of Paris, which had washed up on American shores to die.[2] Less satellites of Europe, Chicago-based artists tended toward figuration as a kind of embodiment of individualism and society. Golub participated in a figurative group there that became known as the "Monster Roster" for its attraction to and depiction of unconventional life forms, including the reception of influence from primitive art and the art of the insane.[3]

> *Abstract expressionism was . . . bad for art and the artist.*
> *. . . These painters were essentially turning away from the*
> *world in their work. And they were giving up on the idea that*
> *an artist might have a social role.*[4]

Like much of earlier European art, Abstract Expressionism was based on the Platonic myth of pure metaphysical Forms and a transcendent faculty – the Eye of the Soul – which bypassed everyday experiences to gaze exclusively toward that eternal realm. This ideology underlay Kandinsky's view of the spiritual in art, Mondrian's Theosophy, Yves Klein's Rosicrucianism, Barnett Newman's Cabalism, Jackson Pollock's Jungianism, and so on. Their works were intended as revelations, to offer a privileged – indeed virtually miraculous – glimpse of the most remote metaphysical realities.

But at the same time that their art was resolutely otherworldly, the leading artists of the New York School were mostly left-leaning politically. Convinced of the Kantian doctrine of the autonomy of the aesthetic faculty, they did not mix their politics and their art. Barnett Newman, for example, actually ran for office in New York City at one time, yet in his art he said that he was aspiring strictly toward the sublime. While these artists' social praxis might reflect Enlightenment-era orientations toward the society of this world here and now, their artistic praxis was radically contradictory, invoking realities that, by definition, negated the concerns of this world.

> *I was never interested in abstract art.*[5]
> *There were things missing.*[6]

The lack of continuity between the social and artistic aspects of these artists' lives came to seem to the generation that

followed them a fatal flaw. Among various strategies that arose to counter it was a restoration of the representational painting that had lately been regarded, after generations of abstraction, as hopelessly naive. It was soon discovered, with some surprise, that representational painting is a far more versatile and manipulable tool than had previously been thought. Above all, it had an analytic and critical capacity that had long been forgotten. This realization began with the works of some of Golub's generation in the post-war period. Alex Katz (b. 1927), for example, practiced a frankly representational art which yet was cut off in the main from direct social realities. Pop artists incorporated real world imagery such as advertisements and comics into the formerly theological embodiment of paint and stretched canvas. Among these various strategies Golub's has come to seem, in retrospect, the more radical.

> *History is missing – this sense of things beyond any one of us, but which involve us greatly. Also, man is missing. Especially man in action.*[7]

Golub's response took form as much in his critical writings as in his paintings. In a statement of 1950 he defined the role of the "contemporary" artist as "his conscious effort to seek those modes of thought and meaning that are to be the necessary symbolism of the time." The essential linkage of the artist to the expression of his own time is the crux. Abstract Expressionism, like abstract art in general, had not dealt with fully historicized conceptions of time, but with claims to formal realities that transcend history. In the same essay Golub rejects the Romantic-Platonic belief in the inherent value of aesthetic beauty, stating that "in its most significant aspects, contemporary art is ugly and chaotic, a threat to the ordering of society and man's conventional concept of himself." Art, in other words, is a critical tool. Artists whom he admired – including, among others, Dubuffet, Picasso, Beckman, Giacometti, and Orozco – tended to "peril the traditional self-contained images of society; spawned from disorder, they invoke disorder . . . [and] destroy the decayed authority-ridden symbols of our time."[8]

> *Contact "out there" no longer seemed to matter to these artists. Contact was something they made impulsively, almost unconsciously, with the paint on the canvas. I didn't want to paint unconsciously.*[9]

176

In 1954, Golub girded himself for a direct attack on the Abstract Expressionists, noting that they "wallow in a pa-roxysm of some primeval abyss or portray a dead–end turgid effect of the second law of thermodynamics, the running-down of the universe."[10] "The creative act," he wrote," is a moral commitment transcending any formalistic disengage-ment."

Post-war Western governments found the opposite idea more useful, encouraging the cult of beauty as a distraction from moral and social considerations. The notorious use of the work of the Abstract Expressionists in this way has been well documented.[11] In a series of exhibitions starting in 1956, sponsored in part by various branches and agents of the United States government, the work of the New York painters was shipped abroad to clash ideologically with the socialist realism coming out of the Soviet Union. Artists who had conceived themselves as radically other found themselves used as champions of the society that they felt personally alienated from. Over the next generation or so it came to be perceived that art which arose from a purely aesthetic im-pulse could be used against itself. It had not, as Edward Said says of texts, "placed itself in the world"[12] with sufficient preciseness. Its intentions being left vague, it could be placed by others, more or less anywhere they found convenient.

> . . . at that point I felt ready to take on New York. . . . In a sense that [essay] was throwing down the glove. Of course, the throwing was unnoticed. But I'm always throwing things down on empty streets.[13]

In 1955 Golub issued a frontal attack in an article called "A Critique of Abstract Expressionism." In a few powerfully reasoned paragraphs he struck at the assumptions behind the work of the New York School, especially the idea of a pre- or non-cognitive apprehension through which a primal vi-sion of pure form could occur. He questioned whether "the sophisticated artist" can really attain "an action that is pre-logical, pre-cognitive, and a-moral. Reversion or regression to primitive means," he ventured, "can only be a romantic device, as modern man – for all his willful (and perhaps necessary) regressive hopes – must consciously seek and articulate what was once primitively experienced."

Thus, helplessly dominated by the Modernist mode of consciousness that had shaped him, "his forms only simulate pre-conscious activation." Primitivist gestures such as Ac-

tion Painting appear to be empty affectations, or silly delusions, which miss the essentially moral commitment which the act of representation assumes. Worse, something dangerous was seen in society's encouragement of such delusions. "Gigantism" with a "primitivist bias," Golub suggested, was "characteristic of the devaluation of the individual in society and art."[14]

> *Why did I want to paint such ugly things? This is a question that troubled me a good deal when I was in school.*[15]

In the artworks he was making in the same period – the late 1940s and early 1950s – Golub confronted the massive historical problem of World War II, Fascist totalitarianism, and the Holocaust.[16] Two of his works of 1946 – *Charnel House* and *Evisceration Chamber* – are derived from the recently published photographs of concentration camp victims. *Charnel House* evokes the horror of Edvard Munch's *Scream* in a swirling smoke-like shape, as in Goya's portrayal of the "dream of madness." *Evisceration Chamber* shares strong jagged energies with various works of Beckman and Picasso – whose *Guernica,* which came to Chicago in 1939,[17] had a powerful impact on Golub. He had located his subject matter – the dark hidden side of history – and was formulating his art historical lineage out of European predecessors not primarily involved with School of Paris decorativeness.

Golub was aware at once of the discontinuity that had been revealed between history and aesthetics, that discontinuity which Theodor Adorno would express in his dictum "To write poetry after Auschwitz is obscene." Golub set out at that time to find a means of making paintings after Auschwitz which would not be obscene – which would not willfully turn away from the truth of history into an idealized head-in-the-clouds fixation on transcendentally pure and historically empty forms. Seeking modes of representation which would acknowledge the tragic and insurmountable incommensurabilities of human aspirations and circumstances, he juxtaposed various European influences with the influences of primitive works seen in the Field Museum of Natural History.

> *Primitive and insane art gave me a handle by which to take ahold of the world . . . not the world of New York painting related to European tradition, but a world which had . . . an*

irrational . . . violence to it . . . inexplicable qualities to it.[18]

These supposedly conflicting modes begin to coalesce in pictures such as *Dead King* (1951), where the influence of Rouault can be seen alongside that of ancient Near Eastern royal icons with sacrificial associations. Pictures such as *Priests II* (1951), *The Bug (Shaman)* (1952), and *Female Rouge* (1953) echoed *art brut,* Dubuffet, and various so-called primitive models. *Clank Head (Jo-Jo)* (1953) resembled tribal sculptures of various proveniences, African American funk assemblage, and various other contemporary art phenomena.[19] *Anchovy Man I* and *Bone Fetish* (both 1953) invoked Oceanic and pre-Columbian imagery with a late Modernist *art brut* spookiness. The pre-Modern world offered Golub both a way to avoid his own tradition, which seemed to have historically betrayed itself, and an avenue into supposedly pre-civilized areas of the psyche whose covert survival might account for the explosive disruptions of civilization. The concern for the "violent" and the "inexplicable" also reflected a focus on psychoanalytic excavations of the psyche.

I took the figure from the Belvedere Torso and created a work of remarkable ugliness from a work of remarkable beauty.[20]

As early as *Hellenistic Memories,* a drawing of 1948, a strain of classical influence began to appear alongside the primitivist ones. *Thwarted* (1953) is in part based on the Belvedere Torso. *Tête du Cheval* (1953) has classical antecedents that extend from Roman sarcophagi back to the Parthenon frieze. Some have seen the dialectic of the primitive, and the classical as the inner force driving Golub's work. The classical, in one analysis,[21] represents the objective, the primitive, the subjective, or respectively the extroverted and the introverted. Such projections may or may not be accurate assessments of the differences between pre-Modern and Modern societies, but they represent a way such differences could be perceived from within Western culture at that moment. With these qualifications, one could add that the classical in Golub's oeuvre seems to represent the ideal of culture or civilization, and the primitive the tendency to dissolve the forms of civilization back into nature, the tendency for civilized forms to fragment under the onslaught of primeval destructive instincts, revealing such instincts as the hidden and more fundamental face beneath the mask of civilized aspirations.

179

I, myself, believe that we continue and enlarge the classic traditions of Western civilization, the Greek humanist heritage.[22]

Golub's reaction to Greek, Etruscan, and Roman culture – encountered in various travels abroad – involved a gesture of acceptance that he could not give to either American or European culture of the mid-twentieth century. It was not that he thought sentimentally that these ancient cultures lacked destructive social realities, but that, for one thing, they were sufficiently distant that the sting of their deficiencies had blurred a bit and, for another, their tradition of public art offered a desirable alternative to the extreme subjectivity that was the premise of contemporary art in both Europe and America.

The body of *Male Figure* (1958) was derived from the Anavyssos Kouros in the Athens Museum; the face was influenced by more archaic Etruscan objects. *Reclining Youth* (1959) echoes the *Dying Gaul* statue in the museum at Pergamum. *Head XIV* (1962) recalls an ancient head of Demosthenes. The *Colossal Heads* series, 1959 and after, was inspired by the fragmentary remains of oversize representations of the emperor Constantine. Other influential ancient relics included the frieze of the Siphnian Treasury at Delphi, the Great Altar of Zeus and Athena at Pergamum, the Mausoleum, the wrestlers in the Villa Orsini at Bomarzo, and the Column of Trajan.

I would like to use, in a sense, this notion of Greek art as an ultimate.[23]

Orestes (1956) seems to refer to an ancient statue with its arms broken off, but the inadequacy of this reading by itself is indicated by the work's similarity to the mutilated human of *Damaged Man* (1955).[24] It is not, then, simply a broken statue, but an image of torment, a reference to Greek tragedy and to the unconscious forces dealt with in psychoanalysis. Golub's classical references are all ambivalent or multivalent like this. The various sphinx works, beginning in 1954, the *Philosopher* paintings, beginning in 1957, the *Fallen Figures,* beginning in 1958, and the *Gigantomachies,* foreshadowed by *The Victor* (1957) and fully realized in *Gigantomachy I* (1965), show his themes penetrating deeply into classical wells of imagery and remaking or re-evaluating them for his own purposes.

In the works of this period Golub implies a sense of continuity with and approbation of the democratic ideals of ancient Greece. He reproduces the essential cultural – or self-defining – move of the Renaissance humanists in choosing to overleap the intervening Judeo-Christian period and re-attach himself to the prior Greco-Roman level. But Golub's focus was not equivalent to Renaissance and Enlightenment Hellenism, which emphasized the classical period when Athenian democracy was functioning. Some of the ancient models that influenced Golub were from the archaic period; most were Hellenistic or Roman. They were, in other words, from both before and after the age of the democracy. It was not the highly idealized Periclean Golden Age that seemed to him to represent reality, but first the stressful period of oligarchic strife in the archaic period and later the Hellenistic monarchies and the totalitarianism of the Roman Empire.

> *I was always interested from the beginning in a tragic notion of man. . . . That is one of the reasons I turned to Classical art.*[25]

The difference in emphasis is crucial. The early Greek model of democratic society stressed the suffering of the individual whose personal whims and conditionings are discontinuous with those of the group or state; tragedy was a reflection on the problems of free will, the essence of the democratic ideal in the early period. For Aeschylus and Sophocles, nobility was the inner meaning of tragedy, with always something of Aeschylus's dictum in the *Agamemnon*, "Learn through suffering." A shift away from individual autonomy can already be seen in Euripides, and by the Hellenistic and Roman periods the emphasis had definitively shifted from the hero's nobility to his helplessness. Under the heel of first Macedonian and then Roman authoritarianism, free will was no longer the foregrounded topic. It was no longer the individual who was foremost on the stage, but the surrounding causal web, or the state, which had begun to loom over the individual with a seemingly inexorable force like that of fate. Tragedy had begun to drift into pathos as the notion of free will became, for the Roman Stoics, say, a matter of struggling against fate itself.

> *It's the whole notion of struggle . . . and, in a way, the notion of fate.*[26]

By 1960 the classical had become the dominant visual refer-
ence in Golub's oeuvre. The primitive had, as it were, gone
into the classical, infusing it with an ambiguous new spirit.
Classically based images such as *Thwarted* (1953), *Philosopher
I* (1957; which combines Hittite with Greek influences), and
Male Figure (1958) express the infusion of the primitive into
the classical through the flattening or pictographic treatment
of the generally rounded three-dimensional classical models.[27]
This treatment also seems to rob them of the classical ideal
of free will; the naked and seemingly half-enraged male fig-
ures gaze out at us like robots. To a degree they are related
to the tradition of the *kouros,* but the *kouros,* though archai-
cally frontal and flattened, has, in its forward-thrusting left
leg, a three-dimensional tendency to penetrate into deep space
that these Golub figures pointedly lack. They are captives of
a flattened world in which there is no room to move and
express free will. Their destructive impulses might almost
be a result of the rage and frustration of occupying such a
space.

> *The harsh paint residues have a dry brittle torn abrasive
> reality. . . .*[28]

In 1950 Golub began experimenting with a method of apply-
ing paint, then scraping it off, sometimes scraping only the
figures, sometimes both figure and ground. It is as if a
resistance to the implications of the act of painting led him
to develop a quasi-sculptural process. As a traditional sculp-
tor removes the exterior surface of his material, so Golub
scrapes the paint off till the tooth of the canvas clearly shows
and the thinnest film of color is left in the interstices, giving
the images a certain ghostly translucence.

In 1979 Golub began to use a meat cleaver for this process,
an instrument chosen for its practicality but also unavoidably
suggesting violence, mutilation, and slaughter. The process
involves a dialectic of both building up and tearing down the
surface, of both creating and destroying the image. The
canvas becomes the site where a kind of excoriating ritual of
union and disunion takes place, of layering and dissolving,
redeeming and sacrificing, affirming the substantiality of the
world of form, then denying or destroying it again.[29]

> *These paintings can be thought of as fragments of a once great
> whole – some great theme – now disassembled, dispersed,
> eroded. . . .*[30]

Through this method the image is constructed like an arche-
ological site with various strata. The cultural object (includ-
ing the person) is portrayed as an accumulation of various
influences with little or nothing essential in its painfully con-
structed and deconstructed selfhood. The figures, as Golub
has remarked, seem to have been worn down by the passage
of time.[31] The patchy scraped layers, like eroded soil or
archeological detritus, are also like the hotbed of nature from
which tooth and claw emerge dripping red. In the *Burnt Man*
paintings, which refer to concentration camp victims, the
surface of the figures' skin and the surface of the paintings
themselves are pocked and torn and blistered with agony.

> *The Sphinx is a creature who is part human and part ani-
> mal: therefore, one is indicating characteristics of humans by
> making Sphinxes. There are no such things as Sphinxes!*[32]

Golub's sphinx paintings are related to the tradition of the
Chicago Monster Roster even more obviously than is his
oeuvre as a whole. The subject matter first appeared with
Siamese Sphinx I (1954), in which (as in *Ischian Sphinx,* 1956)
the sphinx's dual nature is redoubled again in a suggestion of
an infinite regress displacement of its meaning: one can never
work one's way through its reduplicating appearances to its
essence. In 1955 appeared *The Prince Sphinx,* a dimly seen
creeping leonine creature, as did *Riddling Sphinx,* a mysteri-
ous feline, made up of roughly collaged patches of canvas,
gazing from a mottled field of almost *art brut* painterly tex-
turing, and others. The subject disappeared from Golub's
work for many years, then reappeared in the late 1980s. To
this day the sphinx remains the only non-human subject in
his large oeuvre – but in a sense, as Golub has noted, it *is*
human, because it represents the riddle of human nature.

A sphinx has a lion's body and a human (either male or
female)[33] head; it is a monster in the ancient Greek sense of
the word as an entity that has the traits of two or more
species at the same time. It aptly encapsulates the sense of
double nature, of inner struggle, that Golub's anti-hero/
heroes project. The battle of two natures, or of two conflict-
ing impulses in human nature, is fundamental both to Go-
lub's work and to Greek tradition. The idea is structurally
parallel to the Judeo-Christian polarity of good and evil, but
is more closely linked in feeling to the Freudian idea of an
animalistic substructure underlying human nature, and even
more closely to the Greco-Roman theme of the Apollonian–

Dionysian dichotomy, which is expressed in the many classical themes of mythological battles that seem to take place within the infrastructure of human psychology, the Battles of Gods and Giants, of Lapiths and Centaurs, of Greeks and Amazons, and so on.

In the ancient myth, which is preserved primarily in Sophocles' *Oedipus Tyrannus,* the sphinx had brought a plague on the human community, which could only be lifted through a correct answer to its riddle. Those who answered wrongly were destroyed by the sphinx's violent animal nature. When Oedipus rightly replied that the riddle's answer was "Man," or "Humanity" (or "people," or "myself"), the sphinx destroyed itself instead. Indirectly, then, the sphinx's riddle is the riddle of human nature – the riddle to which the answer is "Man" – but the myth is very ambiguous about this.

On the one hand, the sphinx is already half animal and half human, so the answer implicit in the sphinx's own physiognomy would seem to be that man is half civilized and half Hobbesian savage. Man is a monster in the bispecies sense, like the sphinx. All the dualities of Golub's work, between the classical and the primitive, the hero and the anti-hero, sculpture and painting, seem to be reflected here.

On the other hand, the key figure in the myth, not seen in Golub's paintings yet presumed outside the frame, is Oedipus. The answer he came up with, Man, or Humanity, embodies the characteristic and distinctive Greek theme of self-knowledge. It appears in the mandate "Know Thyself" inscribed over the portal of Apollo's temple at Delphi, in Socrates' maxim "The uninspected life is not worth living," in the second chorus of Sophocles' *Antigone* ("There are many strange things in the world but the strangest is man"), and elsewhere. This theme is one of the definitive elements of the tradition of Greek humanism. Golub refers to it in his observation that Greek sculpture is a set of "procedures by which man confronts himself – man sees himself."[34] This inquiring aspect of Greek sculpture starts with the archaic *kouros,* which, naked and without any cultural baggage at all, seems an early visual attempt to get at a fundamental idea of human nature aside from culture-specific traits.

So Oedipus's answer to the sphinx may tell more about human nature than does the sphinx's half-animal composition. His cool-headed and rational dealing with the riddle and its fatal threat may have been intended, as least in Sophocles' version, to suggest another answer – that Man is

rational. When Oedipus successfully seeks his way through a crisis to a self-reliant or self-aware posture, the sphinx gives up and destroys itself, seeming to leave the rational, decodifying side of the former duality not merely supreme but alone.

A similarly positive feeling toward Greek ideas about the rational individual and the society such rationality might produce appears in other Golub works of the period, especially the *Philosopher* series (1957–58), which shows single male figures in classical garb gazing directly ahead like *kouroi* – yet seated in postures of contemplation rather than the *kouros*'s gesture of stepping forward into space. Golub has said that these figures represent "man in control of his environment through rationality."[35]

> *To show then dramatic struggle, to retain belief in classic art and man as mediator in his own destiny.*[36]

Golub's single male figures derived ultimately from the tradition of the *kouros* were established by the end of the 1950s as a basic vocabulary element in his oeuvre. He then began to work with the element in more syntactically complex statements such as the pairs of naked wrestlers in the *Combat* series (1962 and after), which are based to a degree on the compact composition of metopes in Doric friezes and on the wrestlers found in the Villa Orsini. In these works the contemplative activity of the philosophers has given way to the more active theme of the "dramatic struggle" in which man seeks not only to arrive at a hard-won sense of his own nature, but also to become a "mediator in his own destiny." These struggling pairs in turn expanded into the huge horizontal multi-figured groups called *Gigantomachies*, produced between 1965 and 1968, which, in terms of their sense of pictorial space, are based rather on the continuously flowing space of the Ionic frieze than on the compacted rectangle of the Doric metope.

> *This is not art for art's sake, nor for the sake of any ironic mode, nor are these toys.*[37]

The *Gigantomachies* present an essay on the human situation. Their chief ancient forerunners include the battle of gods and giants in the frieze of the Siphnian Treasury, such Hellenistic works as the *Laocoön* (the subject of Golub's first painting upon his entrance into art school), and above all the friezes

from the base of the Great Altar at Pergamum – where are found perhaps the ultimate pictures of humanity as struggling and anguished, without hope yet with consciousness. Roman sarcophagi with related scenes of mythological battle, such as the *Alexander Sarcophagus* in the Istanbul Museum, also figure in their background. Modern influences on the compositions include photographs of team sports such as Rugby.

In the *Gigantomachies,* groups of naked men strive against one another, and against unseen enemies or forces outside the frame, in a murky and undefined space. Some of the men knock one another to the ground, kick one another, and so on, while others run from the frame, whether fleeing or pursuing is not clear. The scenes are presented as universal embodiments of the human condition. There is no suggestion of precisely what the embroilment is, nor any indication of different sides. The men are all naked like *kouroi,* and all look much alike. They may be from the same tribe or clan. There is no apparent distinction between protagonists and antagonists, as there had been in the classical – or at least the pre-Euripidean – period of Greek tragedy. These figures may all be regarded as protagonists, or perhaps all as antagonists, and the cause they strive over is as undefined as the terrain they strive upon.

> *The human figure in motion is a marvellous means of representing the history of the world.*[38]

The *Gigantomachies* give an allegorical picture of history as a meaningless and endless battle. Human nature is seen as fundamentally aggressive or competitive, and history functions as both a record of this aggression and a contributor to it. Human nature is expressing itself through the struggle for power, but at the same time it is being manipulated pathetically by the very force of history which its actions set in motion. The combination of power and pathos extends the theme of the duality of human nature. "There's often one hand which is threatening," Golub observes of his struggling giants, "and the other hand which is defenseless."[39]

All the specific accoutrements of historical narrative – time, place, nationality, and so on – are stripped away to reveal the inner core of meaning as simply force blindly struggling with force. To a degree Hegel's view of history as driven by the dialectic of the master and the slave lies behind Golub's allegory, but in his pictorial formulation the

distinction between master and slave, as between god and giant, or protagonist and antagonist, is unclear. All are reduced to the same fundamental inner nature on what Matthew Arnold, in "Dover Beach," called "a darkling plain / swept with confused alarms of struggle and flight / where ignorant armies clash by night."

> Then Vietnam, and . . . I wanted to make contact. How could I put the work in touch with these events?[40]

In the late 1960s and early 1970s Golub's work underwent a crisis precipitated by the American experience of the imagery of the Vietnam War. The *Gigantomachies* stood as allegorical emblems of armed conflict as a universal, but in a concrete sense they seemed to have little to do with the actual conflict going on at that moment in Vietnam – and in the United States. The naked figures glimpsed out-of-time were detached from events somewhat as abstract painting was, though less uncompromisingly. Meanwhile Golub saw the United States government – his own national government – even after its nightmarish experiences of subjugating native Americans and African Americans – inscribing yet another racist genocide into its history. The still fresh memory of the Holocaust was agonizingly stirred.

A powerful but imperfect resolution of the dilemma occurred in the *Napalm* series, beginning in 1969. The Holocaust–Vietnam analogy was made explicit as the *Burnt Man* paintings, which had originated from photographs of Holocaust victims, modulated into the *Napalm* pictures. Golub's existential-classical warrior figures were now depicted with napalm wounds. Other elements attempted to bring the work into the contemporary world. While the kneeling figure in *Napalm I* (1969), for example, is based on the Hellenistic sculpture known as the *Wounded Gaul* (250–200 B.C.), the fallen figure combines classical references with the influence of a news photograph of a shot Sicilian gangster. Yet aside from such arcane details and the change in the title, much else remained the same; the figures were still mythically naked and unlocated in time and space.

> . . . the imagery was too internalized, too pulled in. What I have tried to do – for 30 years – was to give these monsters a more objective figuration.[41]

The *Vietnam* series, starting in 1972, showed figures clothed in modern military uniforms, carrying modern weapons,

and engaged in gestures of modern rather than classical com-
bat. The urgency underlying this evolution is indicated by
enormous shifts in physical format. First was a new empha-
sis given by scale: *Vietnam II* is an incredible forty feet wide.
Second, the distancing afforded by hanging an image against
a surround of blank wall which separates it from the social
realm around it was diminished: the new works were hung
only six or eight inches above the floor, so the figures con-
fronted the viewer not only as giants but also as directly,
even threateningly, intruding into the viewer's own space.
This effect was emphasized by an alteration in the figures'
gaze. Whereas the figures in earlier works had looked slightly
upward, over the viewers' heads, the figures in the *Vietnam*
series and after gaze directly at the viewer.

> The figure virtually says, "If I step off the canvas, watch
> out."[42]

The classical Giants lumbering painfully through the stiff
dancelike combats of the *Gigantomachies* were monstrously
out of time, like symbols of primal destructive forces present
in human nature at all times and places – but especially
focused on the roots of the Western tradition. They were, in
this sense of existential universality, not unlike Giacometti's
naked men walking toward nothing in an atmosphere of
nowhere for no reason. Golub's soldiers, mercenaries, and
interrogators, in contrast, represented not only a generalized
sense of human nature, but also a sense of human nature as a
force in intimate, even inextricable, meltdown with history.
The figures who had been naked variations on the universal
model of humanity offered by the *kouros* now wore clothing
and were rooted in specific times – though they remained
less clearly defined in terms of place. These changes could be
summed up by saying that the work has undergone a transi-
tion from classical allegory to history painting.

> I made approximately 100 portraits from 1976 to 1979 on
> such subjects as Brezhnev, John Foster Dulles, Pinochet,
> Zhou En-Lai, Franco, Kissinger, Nelson Rockefeller, Ho
> Chi Minh.[43]

Golub's so-called portraits involve ironic inversions of the
set of social relations that the portrait situation usually brings
with it. To begin with, it is ordinarily the sitter who has
requested, or commissioned, the portrait; further, it is

understood that the artist is in effect working for the sitter
and that the outcome will be flattering or in some way
ingratiating to the sitter's sense of his or her self; the artist
usually works at least in part directly from a seated subject,
though photographs are often used between sittings. In por-
traiture that arises from personal feeling – from Courbet's
portrait of Proudhon to Katz's portraits of his wife Ada –
the genre suggests intimacy, affection, and homage.

Golub has methodically reversed these social dynamics,
taking the reins of the situation from the sitter's hands into
his own. It is he who decides to do the portrait, and the
subject has nothing to say about it. Further, he is under no
obligation to flatter the subject and may indeed work from
motives that are subversive in terms of the subject's self-
image. His use of photographs alone instead of the direct
optical presence of the person, and of news rather than per-
sonal photographs at that, reflects the distance and indirec-
tion through which power operates and behind which such
figures are cloaked.

In Golub's large paintings the figures are more than life
size, generally from one and a half to two times human scale.
These portraits, however, are never more than half larger
than life, and in general seem to be about life size. They
express the smallness and ordinariness of these individuals,
somewhat in line with Hannah Arendt's famous phrase "the
banality of evil."

> *For the most part, not as good guys, not as bad guys, but men*
> *who have political power in their hands. What the hell do*
> *they look like?*[44]

Still, despite his desire to subvert the portrait subject some-
what, Golub avoids caricature and strives for an impression
of cool observational impartiality. What most often comes
through is a sense of the stiff public personas with which
individuals endowed with positions of special power desire
to present themselves to those whose lives they control
whether openly, as in the series of portraits of Franco, who
has the haughty carriage of one who knows that a historic
light is shining on him, or hiddenly, as in the portraits of
Rockefeller, who tries self-consciously to present himself as
an ordinary guy.

It was not Golub's intention to express these characters'
personalities so much as to present them as empty, almost
lifeless, masks. The thinned paint surface on the unprimed,

unstretched[45] canvas seems to possess individuality without warmth. The viewer, Golub feels, might have a sense of the relatively uninflected gaze one often sees upon glancing in a mirror, discovering the monster of power both as an ordinary being like oneself and as a hidden content of one's own selfhood.

> *I begin by projecting drawings or parts of photographs onto the canvas – each figure is a synthesis of different sources.*[46]

The portraits completed a massive transition from the universal to the particular. It was on the basis of these studies of individual physiognomies that Golub began to portray his larger-than-life, phallic-aggressive figures as explicitly characterized individuals, like figures in fictional narratives or movie stills. Henceforth, Golub rooted his scenes directly in the flow of imagery of the moment – the U.S. war in Vietnam until 1976, then incidents of apartheid in South Africa, foreign interventions in Central and South America, civil wars in Southeast Asia, and so on.

Golub went beyond the pages of the daily newspapers, seeking images of the dark forces of history in the trade media of the war industry such as *Soldier of Fortune* magazine,[47] publications found in military bookstores, photography magazines, and, for the *Interrogations* series, sadomasochistic publications. This approach involved synthesizing images from many sources, as an analogue to the way our minds are conditioned by floods of disconnected and fragmentary images entering them uninvited from all sides. As Golub, decades earlier, had taken just the posture of an arm from the Column of Trajan,[48] so now he would take a foot from one photo, a twist of a torso from another, a sideways glance and a grin from yet others and synthesize these elements into new creatures – monsters in the Greek usage of the word mentioned above – who represent the flurry of images stirred up by the energy, often destructive, of winds from the surrounding world.

> *For example,* Prisoners – *the photo sources derive from Vietnam, Algeria, Thailand, etc. The painting refers to the Middle East. . . .*[49]

Out of such sources came the works that Golub would refer to as "public" paintings, meant to remind American art viewers what kinds of acts, committed by distant agents of

their own government, were maintaining the inflated wealth of their privileged society: first the *Mercenaries,* beginning in 1976 and referring implicitly to Africa and elsewhere, then the *Interrogations,* beginning in 1981 and referring primarily to the consequences of American neo-colonialist interventions in Latin America, the *White Squad* pictures beginning in 1982 and the *Riot* series of 1983 and after, both seemingly referring to South Africa among other places. Here as in the ancient friezes and sarcophagi, yet now in contemporary cultural terms, scenes of horror and aggression unfold as if endlessly. Mercenaries carry a tormented captive like a slain deer hung from a shoulder hoist (*Mercenaries, 1976*) and leer out at the viewer as if enjoying their games (*Mercenaries I, 1979*); interrogators beat a victim hung upside down like a side of beef (*Interrogation I, 1981*), prepare casually to torture a hooded naked man (*Interrogation II, 1981*), reach for a bound, naked, and blindfolded woman (*Interrogation III, 1981*), and so on.

Golub's style in these works refuses to accord to the figure the degree of selfhood or wholeness that the art of the figure has traditionally suggested. He accentuates the stiffness of his characters, whom he wants to appear awkward and caught

Leon Golub, *White Squad II* (1982). Seattle Museum of Art. Courtesy of the artist.

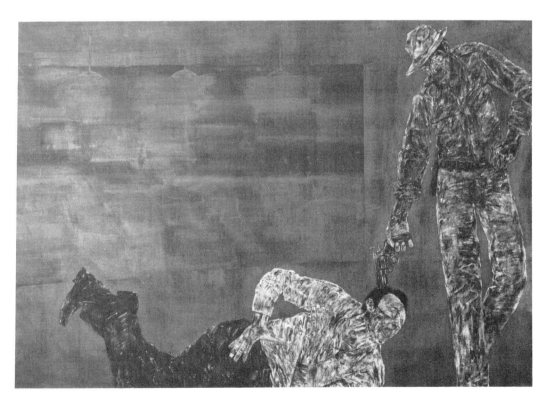

off balance; the odd put-togetherness of their bodies, which results from his method of collaging bits of different people into one, deny them integrity of selfhood. The eroded or strip-mined paint surface renders them elusive and insubstantial at the same time they are threateningly real.

> *Men are running, something's happening, you are not sure what. What's going on?*[50]

By 1980 these works had reached a troubling maturity that integrated their phases of development. One can still see the generalized mythological events of the *Gigantomachies* in the background – the giants flexing their muscles beneath the modern clothing, as it were – of the agonists in a picture such as *Mercenaries IV* (1980); still, in the moment-to-moment "raunchy restlessness," as Golub described it,[51] of white and black mercenary soldiers presumably at work in Angola or South Africa, one confronts the historical, not the mythological, world. These two levels are maintained in an uneasy balance. The classical tendency to view the fighting male figures as heroic and larger than life is still maintained in the scale, but at the same time their derivation from media images, their scraped surface, and their low hanging on the wall tend to demythologize them.[52] The idealized shallow backgrounds of Pompeian red seem to place the figures in a transcendental space,[53] while at the same time thrusting them aggressively into the viewers' world.

> *[The] background is . . . a "no-space" . . . universalized to a very large degree. . . . This is the "now" space of contemporaneity and actions [depicted in it] can occur virtually anywhere.*[54]

In Golub's classically based works of the 1960s, such as the *Gigantomachies* or the *Philosophers,* the space surrounding the figures is undefined for the sake of universality. In a sense this allies Golub with abstract painters whose work expresses very different aspirations to universality – with, for example, Kandinsky's dictum "Not here, not there, but somewhere" and the mysterious space that de Kooning refers to, saying, "There's a place where it happens."[55] In some pictures the evenly painted Pompeian red grounds offer a further association with color field painting.[56] But of course the disparity of intentions becomes hugely, even absurdly, obvious when one inquires exactly what it is that "happens" in

the "place." Further, the emerging gestures toward whole-
ness of space – the extension of the depth axis, the integral
red fields – were simultaneously cancelled as Golub began to
eat away at the support itself, mutilating his canvases, cut-
ting them, after painting them, into irregular shapes that
recalled skins hung on walls, ancient moth-eaten papyri, and
half-burned pages of books salvaged from wars.

> *One claims to support humanist values, liberal points of*
> *view. But maybe at some level you're identifying with those*
> *guys, deriving a vicarious imaginative kind of pleasure in*
> *viewing these kinds of macho figures.*[57]

Three kinds of gazes have been remarked on in Golub's
pictures of mercenaries, interrogations, and so on.[58] The
viewers gaze at the image; looks are exchanged back and
forth by figures within the image; and figures within the
image sometimes gaze out at the viewers.[59] The network of
gazes, mutually stimulating and mutually challenging, en-
tangles the viewer in a variety of feelings. Sometimes, as in
White Squad IV, El Salvador (1983), the perpetrators within
the picture seem to look resentfully outward as if the viewer
were catching them at their dirty work. At other times, as in
Interrogation II (1981), the figures seem to include the viewers
within their conspiracy or, as in *Mercenaries V* (1984), to
mockingly challenge the audience to do something about it.
Golub speaks of "an aggressive shoving of these images right
back at a society which tolerates these practices, which hatches
them, like saying, 'You're not going to evade this, you're
not going to pretend this doesn't exist.' "[60]

> *. . . I am bringing into* your *space, the art space,* real *world*
> *pressures.*[61]

In a sense this web of implications and glances, this inter-
locking system of accusations, conspiracies, and mutual rec-
ognitions, *is* the work. Some viewers have resented this kind
of extra-aesthetic entanglement. They have complained that
Golub is trying to make bourgeois art viewers feel guilty by
confronting them with the fact that these evidently evil peo-
ple are distantly carrying out our own will in ways we have
not consciously articulated, or even admitted to ourselves.
"His characters are ugly, unpleasant men and women," one
critic writes. "[He] encourages us, the viewers, to identify
with them. . . . [He] wants to implicate us."[62]

*. . . these images are intended to be as objective as possible.
Objective refers to correspondences to reality, to what is, to
what occurs.*[63]

There is another gaze involved, that of the artist contemplat-
ing the tangle of gazes between artwork and audience. Golub
takes great pains, amid all the conflict, not to seem to take
sides – somewhat like the Olympian gaze of Greek sculpture
of the archaic and early classical periods.[64] Alongside those
who have said that Golub wants us to identify with the
malefactors he portrays, others have suspected that we are to
feel threatened by them. In terms of the Greek tragedy and
metope which tinge the root of his practice, Golub's blurring
of the distinction between the protagonist and the antagonist
is like that of the tragedian closest to him, Euripides, who
repeatedly, as in, say, the *Medea* and the *Rhesus,* blurs that
line.

Has Golub, then, by this time, under pressure of the
Vietnam War, lost the tendency (as in his day Euripides was
felt to have done under pressure of the Peloponnesian War)
"to retain belief in classic art and man as mediator in his own
destiny" that he referred to approvingly in 1963? His appar-
ent motive in making these paintings suggests a negative
answer to this question. In the very act of revealing the
seemingly incorrigible wickedness of human motives, Go-
lub's urge to see this situation clearly and dispassionately
demonstrates a condition of sanity and clarity that cannot be
described as hopeless. The artist's own point of view stands
as relatively uncorrupted, despite the seemingly universal
corruption presented in the paintings, and implies a social
constructivist ambition.

It is a realist art because it essays to show power.[65]

Many artists of Golub's generation and after who shared his
conviction that the beauteous veil of Modernist abstraction
had covered up a less beauteous truth, and who accepted the
imperative of creating a critical art that would look behind
that veil, felt that painting itself was polluted as an instru-
ment of truth or criticism by its long deceptive use as deco-
ration. They turned away from painting into sculpture, per-
formance art, photography, video, installation, earth art,
Conceptual art, guerrilla theater.

Golub chose to stay with painting because he saw that the
painterly tradition includes more than the decorative veil and

has more uses. The public character of Roman murals in part saved the medium for him – but in addition there are precedents for his work in the European tradition. It is interesting, for example, that he admires Michelangelo's *Prometheus* and *Flayed Self-Portrait*. But in terms of Modern art there are more important connections with nineteenth-century history painting and Realism.

Golub's early alienation from the School of Paris did not turn him permanently against all French art. His obsession with the art of the figure, and the scale and proscenium of his pictured stage, relate him to David. His realism relates him to Courbet and Daumier, his theatricality to Couture, Gérôme, and Géricault.[66]

> *It's a good feeling to know that the work is aggressive enough to hold its own – I don't mean with other art but with reality, bare-ass reality!*[67]

The French Realist movement of the nineteenth century arose in the wake of the riots and insurrections of 1848 and "was considered at its inception . . . to be an expression of the new radical social forces unleashed by the revolution itself."[68] Golub's explicitly political works of the 1980s similarly arose out of his participation in the anti–Vietnam War protests of the 1970s. The nineteenth-century French movement had the "dual character of protest against, yet expression of, a predominantly bourgeois society."[69] A similar ambivalence can be seen in the social situation of Golub's work being collected by Charles Saatchi,[70] while it is ostensibly aimed against the interests of the privileged class which collects art and other expensive things. Clearly in Golub's work and some of the French Realists' there is a somewhat similar conception of the role of painting or of representing in society.

Yet few works of Courbet and his peers approach the directness of political intervention in Golub's *Mercenaries, Interrogations, White Squad,* and *Riot* paintings. Goya's *Third of May, 1808* (1814) is close, as is Manet's *Execution of the Emperor Maximilian* (1867). These works are said to embody "the acceptance of what is immediately experienced, and of nothing beyond it, as the entire meaning of the event depicted,"[71] a cool or dispassionate stance similar to Golub's appearance of dispassionate observation in which he seems not exactly to take sides with either perpetrator or victim but, it has been suggested, to invite a degree of identification

with both. Manet's technique, in the *Execution,* of gathering eye-witness accounts and reconstructing the event out of various points of view relates structurally to Golub's technique of piecing together a scene from found photographic materials in a kind of social collage. Manet in fact used a number of photographic sources for the *Execution,* and other Realists commonly used photographs as sources – Courbet, for example, in his posthumous portrait of *Pierre-Joseph Proudhon and His Family* (1865–67). Of course, the aims are a little different. For Manet and Courbet photographs were valuable in terms of the historical accuracy of the representation. Golub, in directing his representation through an assortment of other eyes and accounts, creates a kind of communal seeing derived from the mass media and hence true to the shared visual consciousness of the time rather than to any specific historical reconstruction. His intermingling of photography and painting, with sculpture in the background, acknowledges the historical connection between photography and realism that Paul Valéry remarked on: "With photography . . . realism pronounces itself."[72] Golub's commitment to intervening in the deceptive surface of the social order echoes Signac's plea, in 1891, that the painter "fight with all his individuality against official bourgeois conventions by means of a personal contribution."[73]

> *These damn paintings get uglier all the time, uglier in human type, uglier in intention, to take over the ugliness that is the political reality of these common circumstances.*[74]

In terms of twentieth-century art Golub's work has affinities with German Expressionism, especially the works of Max Beckmann, who stated his own position like this: "In my opinion there are two directions in art. One, which is the more dominant at the moment, is the art of surface and stylized decoration, the other is concerned with space and depth. . . . for myself, I pursue the art of space and depth with all my soul."[75] Despite its relatively shallow depth axis, Golub's work is as passionately rejective of the curtain-like surface in favor of the space behind it where life occurs. The sense it gives of an epic challenge presented by an individual invokes comparisons with Mexican muralism, especially Orozco, whose *Prometheus* (like Picasso's *Guernica*) impressed Golub deeply at an early age.

In terms of modern American painting there are various

relationships, all somewhat awkward and inverted as they reflect Golub's adversarial, or agonistic, stance in that milieu. Somewhat ironically, in terms of the relationship with Beckmann, who stressed depth and space, Golub's work relates also, in an odd and convoluted way, to the decorative surface of Abstract Expressionism. In the pictures, for example, in which he has scraped the whole surface into one texture, there is an echo of the allover field characteristic of Pollock, and even more of Jasper Johns's allover painterly texturing of the representational surface. Yet Golub has reversed the ideological relationship: instead of putting the paint on the support with a brush in an allover way, he scrapes it off with a meat cleaver in an allover way; the peculiar process both suggests an act of aggression against the tradition of the decorative surface and continues that tradition in a tormented way. It has also been remarked that Golub's red grounds are somewhat similar to color fields such as Newman's large red rectangles – except of course that Golub's red fields have figures on them, interactions among the figures, and more.

Golub's work relates in a similarly inverted way to neo-Expressionism, which also was gaining ascendancy around 1982. Within the New York art world Golub and the neo-Expressionists were experienced together in the early 1980s: both were seen as part of the Return of Painting after the era of Conceptual art. But they were of different generations, and there was a certain surprise at the realization that Golub had been doing this straight through since the age of Abstract Expressionism. Predictably and somewhat simplistically, Golub was perceived as a prescient forerunner of neo-Expressionism. Later in the 1980s, however, he came to be seen as an adversary or, anyway, a counterstatement to the neo-Expressionists: what was widely perceived as a lack of integrity in their easy relationship with market forces was balanced and opposed by his seemingly unquestionable integrity, his far slower rate of production, and his tendency to challenge rather than court market forces – not to mention his far greater emphasis on both the social and the cognitive aspects.

I want it to be as universal and timeless as I can make it . . .
I want to paint the most generalized notion of man that I can
under the most austere circumstances that I can and make it
go.[76]

Newman once remarked, "I hope that my work can be seen and understood on a universal basis."[77] His hope was premised on the Platonic idea of the artwork as a recollection of a primal glimpse of eternal forms. Golub also expresses aspirations toward universality in his work – but what a different type of universality.

Golub's idea that his representations of humanity might be considered universal applied primarily to the classically based works – his sense that the plain nudity of the Greek portrayal of humans was a kind of absolute or universal since it had no ethnocentric accoutrements.[78] The later paintings also have a claim to a kind of universality, but with an interesting inversion: the paintings' claim to universality rests on their contingency. The fact that they are patched together out of many images in the public media – "made up from the flood of images that are knocking my head around,"[79] as Golub has put it – lends them a claim to universality understood as a collectivity or commonality. In addition Golub proposes an ironic inversion of abstract painting's idea of specifically aesthetic universals; the paintings are universal not in their forms but in their subject matter: "There is a near universal history," he observes, "of the use of violence as a social practice."[80]

> I don't think there's a real place for these paintings at present. . . .[81]

In the late 1980s and early 1990s Golub turned his attention from direct scenes of war to scenes of what transpires not on center stage but on the periphery of social violence: black people, suggesting South Africa, in non-violent social modes expressing repression and resentment in idle moments (the *Horsing Around* series, 1982 and after); American white redneck males asserting their aggressive/repressive ethic (*Try Burning This One,* 1991, and others); nightmarish mottled blue and green fields where police actions and nameless moments of violence occur (*Night Scenes I–III, The Prisoner,* and *The Arrest,* all 1989), and so on. The work of the 1970s and early 1980s was clearly alienated in the simple sense that it was dedicated to opposing major policies of the government it was made under. This work is less overt but similarly simmering in protest.

> Of course there are museums, but there is no specific place for paintings that have a meaning.[82]

Golub's oeuvre demonstrates the sanity of Plato's decision to exclude representational art from his utopia. That ancient philosopher's role as an "enemy of the open society," as Popper has called him,[83] was reflected in all his thought, including his theory of art.[84] Like the American government in the era of Abstract Expressionism, Plato seems to have felt that abstract art could be a positive force for maintaining the status quo, by virtue of its redirecting of attention to the beyond, away from the current social situation, and also through its presumption of unchanging aesthetic forms which were supposedly reflected in unchanging social and political forms.[85] It seems, in fact, that it was specifically figurative painting that Plato forbade (in *Republic,* book 3), on the ground that it could manipulate feelings in too focused a way. The current anxiety, today, about representation, involves primarily manipulation of sexual feeling. But it was probably other factors that underlay Plato's prohibition – especially the fear that feelings could be manipulated to cause resistance to the caste system he was proposing and the militarism that was to maintain it.

It is precisely in this sense that Golub's remark, "I was never interested in abstract art," becomes most meaningful. Abstract art, in this somewhat simplistic but still basically functional model, represents being duped by the idea of eternality into distracting your attention from what's really going on around you in terms of individual human lives that are being carried out in physical bodies.

Okay. I made these monsters. . . . In one sense I am simply a reporter. I report on these monsters because these monsters actually exist.[86]

The early flowering of Golub's work stressed themes of human insufficiency and suffering that seemed almost the result of congenital disturbances, as in the family-doom-filled aura of Greek tragedy. *Orestes* and *Damaged Man,* for example, are amputated, helpless, dysfunctional. The middle flowering, as in the *Gigantomachies,* shows the figure more functional in the sense that it can act but still deeply insufficient in terms of the nature of its action. Human life is presented in a transhistorical allegory, a ceaseless panorama of aggression and reaction to aggression, as if it were being observed by a not cynical but dispassionate gaze. The later phase, which commenced when the figures put on clothes around 1972, while on the surface even more pessimistic

than the earlier two, deals nevertheless directly with society, as if to imply that social problems may perhaps be resolved by paying sufficient attention to them.

The first interlude of sphinx paintings occurs at the very beginning of Golub's middle or classical period, as an abstract posing of the question of human nature. In 1988, more than 30 years later, in the midst of the highest intensity of his New York presence, Golub once again painted sphinxes. *Red Sphinx* is a canvas cut into six discontinuous pieces as if to emphasize its split or fragmented selfhood; a human head floats above as if lost from its context – unsure of its nature. The picture presents a riddle that the other three sphinx paintings of 1988 seem to analyze in explicit terms.

In *Wounded Sphinx* the Pompeian red ground of the mercenaries and interrogators squirms and congeals and exudes a double-human-male-headed monster with a feline body, four feet on the ground, heads gazing upward as in frightened expectation. *Yellow Sphinx* stands on its hind legs with a human male face staring into an indefinite architectural volume shot through with flashes of electricity. He seems ready to defend himself. *Blue Sphinx* lopes through a murky haze in a scraped rip-zone of space, sees the viewer, and draws back, frightened, one foot raised in attack mode.

The three enormous and troubled pictures may be read as the three stages of the sphinx's riddle as Sophocles records it: What goes on four feet in the morning, two at noon, and three in the evening? Oedipus, in Sophocles' version, proposed that the human baby crawls on four, the adult walks on two, and the elder hobbles on three, with a cane. Thereupon, the half-human half-feline female cast herself from her sculpture pedestal screaming over the cliff to her death. In the ideology of the ancient Athenian democracy, the answer "man," meaning not male humanity but all humanity, destroyed the ancient matriarchal monster with its thirst for human sacrifice, and instituted the age of humanism.

These pictures refocus the weight of Golub's oeuvre fully on the question of human nature, involving both the troubled history of its past and the equally troubled imminence of its future – possibly in a bio-engineered sci-fi reality of new and unanticipated monsters. As the three paintings unfold before the viewer – and keep unfolding cinematically – the bi-natured sphinxian humanity, with its orphic riddle that it does not really know the answer to, is enveloped in turn by each of the three primary colors. Is it overpowered

helplessly by the color-saturated environment – as if trapped in one of the color-defined holding places of the *Tibetan Book of the Dead?* Or is it succeeding in hiding within the color curtain from some unseen enemy – perhaps itself?

NOW READ THIS

RECENTLY Julian Schnabel and I walked through the almost completed installation of his exhibition in the Museo d'Arte Contemporanea Luigi Pecci in Prato, Italy. With us was another critic. We stopped before the painting *70th Week,* and Julian said, "I like this one because it's so fucked up." "Yes," I said. "It really is fucked up. I like it too." The other critic, however, questioned this as a positive critical term. He inquired further why Julian had painted the words "70th Week" on the canvas. The fact that in some cases Julian didn't know why he used certain words seemed to bother him, too.

The critic's questions raised significant issues which have been shaping themselves with increasing clarity in this artist's work over the past decade. These include the aesthetic issue – is fucked up beautiful? – the issue of the place of language in the visual arts, and the issue of randomness or lack of accountability. These issues are all involved in the most significant event in recent art history – the overthrow of the Kantian theory of art which dominated Modernism with its ideas of universality and unchanging quality, and its subsequent reinstatement in a radically modified form.

In general, neo-Expressionist painters have not significantly altered famous and bankable signatured styles – anymore than the Abstract Expressionists did in their day. There is a reason for this. According to the Kantian theory, the essential aesthetic reality does not change; an artist who radically revises his or her style is at the same time rejecting his or her earlier style and denouncing the works that embodied it. Since the new work evolved out of the old, invalidating

the old by radical change, rather than slow aesthetic development, may invalidate the new also. Schnabel's tendency to abandon aesthetic territory already won, and move unpredictably into new modes, has led him partway out of the realm of neo-Expressionism and brings up a limited but visible comparison with the oeuvres of artists such as Gerhard Richter, Bruce Nauman, Yves Klein, Jannis Kounellis, and others whose work is making a conceptual point by its wild variation.

Schnabel's work started out the decade perceived as more or less pure painting – meaning Expressionist painting with overtones of existentialist ideology. There was talk about the emotionality of his brush stroke (which he was driven to publicly deny). His oeuvre ends the decade as a decidedly impure painting, anti-aesthetic and conceptual impulses prominent alongside the ever more perverse pleasure of the brush or the spray can. There is no doubt, of course, that Schnabel's work involves expression, but his mercurial or even quixotic shifts of expressive mode imply a relativization of expression – almost a critique of it.

Schnabel's earlier work seemed to stand up for painting in a confrontational, even pugnacious, way, with its intense authoritarian control of materials and surfaces toward personally expressive aesthetic ends. There was an *art brut* aspect, but it was tamed, or chained. In the last several years his work has increasingly questioned the expressive parameters of form. While the formal elements in pictures such as *70th Week* have something in common with Surrealistic biomorphs, they reject the finished aesthetic surface of Surrealism for a deliberately rough, left-handed, nervous, and off-balanced composition which the artist has compared to accidental stains on one's pants. The seeds of this aesthetic awkwardness – or redefinition – were already vaguely present in a work like *Saint Sebastian – Born in 1951* (1979) and were further developed in works like *Mutant King* and *Portrait of God;* since about 1986 they have often come to dominate the foreground of the work.

In the same period Schnabel's works have increasingly renounced polychromy. The emphasis on white in so many of the recent paintings has obscured his emotional coloristic tendencies and emphasized the annihilation of the self and the anxiety of facing death. His nagging analogy of paints as bodily fluids sees the semi-transparent whites as milky. A raw biological version of the idea of expression arises, of the

artist's pouring out parts of his or her innermost self into (or onto) the work – like an ejaculation, or an expression of milk from the breast, or a letting of blood.

Schnabel's work has long exhibited the post-Modern traits that typified the 1980s, such as the quotational practice which has been prominent in his work since *Exile* (1980) and the desire to get in between painting and sculpture that was involved in the early massive plate, antler, and timber works. Yet still his work was strongly linked to Modernist aesthetics by its commitment to the heritage of Picasso and Pollock, the two giants of Modernism. The aesthetic values that Schnabel's work has displayed in the last few years, on the other hand, have incorporated various anti-aesthetic impulses, or impulses to stretch the limits of the aesthetic into the realm of the ugly – the fucked up. This practice raises questions about an aesthetic universalism such as Kant's.

Kant held that aesthetic judgments had a certain unchanging validity. When the boundary of the aesthetic category moves over to incorporate precisely what had lately been the anti-aesthetic, it shows that this is not so. At the heart of the post-Modern project is attention to the fact that taste has a history. The fact that taste changes – radically – not only from generation to generation but even, in unstable situations, within a single generation, shows that taste is a faculty that responds to external formative influences. It is not an essence, but a transient epiphenomenon of changing conditions. This fact relativizes aesthetic judgments, and takes away the issue of essential quality.

Without being consciously guided by theory an artist often acts it out. Schnabel's work, for example, though not deliberately referring to theoretical issues, has reflected them closely. Its shifts reflect communal shifts in societal attitudes and especially the shifting state of the Kantian theory in recent years. At the heart of that theory is a model of the human personality as made up of three separate faculties, the aesthetic, the ethical, and the cognitive. These faculties are held to be essentially and eternally separate from one another. None of them can comprehend the things that the others comprehend. None of them can comment on or criticize the others' domains. In this way they're like the senses – described, it would seem, on the model of the senses – which are not able to confirm or deny one another's perceptions directly, but only through indirect inferential strategies.

Granted the Kantian premise that the three faculties are

independent, it follows that the artist, when making art, must deal only with the aesthetic faculty, operating through an aesthetic mode of "feeling" that is inaccessible to the others. The other faculties are not only irrelevant to art but cannot even reach it. They can only get in between the viewer and the artwork, distracting the aesthetic feeling from its true object. This idea was the basis of formalism, an attempt to purify the artwork of any ethical or cognitive elements, leaving only the aesthetic.

This approach, understandably, produced countless brilliantly aesthetic works in the Modern period. But, also understandably, in time it came to seem inadequate to a troubled society in a changing world. Was the artist to fiddle while Rome burned? In the 1960s and 1970s, Minimal artists, Conceptual artists, and performance artists put art through a rigorous purification in which an attempt was made to eliminate the aesthetic as if it were mere frivolous decoration – to eliminate precisely the aspect which had ruled the previous age. The artistic quest reversed direction; now many artists strove to make artworks which had as little aesthetic intention and presence as possible, but with strong cognitive or ethical aspects. Works such as Hans Haacke's installation of a UPI ticker tape machine in the Museum of Modern Art, Joseph Kosuth's exhibiting of thesaurus and dictionary entries, and Hanne Darboven's works miming mathematical lists, while they do of course involve design decisions, attempt to subordinate these to the cognitive aspect.

Then around 1980, the purification by austerity seemed to have run its course. The next step in the evolution of a new conception of the artwork was the appearance of neo-Expressionism, followed closely by the media scavengers. The attempt to completely eliminate the aesthetic aspect had been a polar reaction; it had to be counter-balanced. What neo-Expressionism did, in terms of the theory of art, was to reintroduce the aesthetic aspect and its roots in Kantian "feeling." In the art-politics of the time this was seen as a regressive impulse, a resurgence of the archaic religious superstition of Modernism.

When Schnabel's work first became widely known, at the beginning of the 1980s, it was caught in this rancorous dichotomy between neo-Expressionism and the fading Conceptual art of the 1970s. At the same time the anti-aesthetic, cognitive, and ethical cause of the first generation of Conceptual artists was supposedly being carried on by the media scavengers, appropriationists, and so on, who, it was said,

emphasized analysis over expression. The dichotomy seemed real at the time. Neo-Expressionism was seen as traditional painting, media appropriationism as anti-painting. An ethical dichotomy was perceived between the brush and the camera, holding that paintings were simply luxury commodities, like toys or souvenirs, whereas media criticism was a socially useful and enlightened process involving critique of the commodity. But as the decade went on, this dichotomy became less clear cut in various ways. For one thing, the media-scavenging work became as commodified as the neo-Expressionist, losing the ethical edge. More importantly, certain structural shifts occurred in the concept of the artwork itself which greatly diminished the distance between these modes.

What was not at once apparent a decade ago is that neo-Expressionism did not reintroduce the aesthetic aspect in the old Kantian spirit, which would require an *exclusively* aesthetic approach. Instead it reintroduced the aesthetic aspect alongside the cognitive and ethical elements which had come to dominate in the 1970s as more or less one among equals. The doctrine of the separation of the three faculties – the root of formalism – was abandoned, and the three were allowed, indeed required, to co-exist within a single work. Currently, over a broad spectrum of art making, a new formula has emerged: the artwork should express all three of the Kantian faculties about equally. It should have an aesthetic aspect, which might take the form of graphic design involving photography and typeface, or of Expressionist painting, or any other form. It should also assert a cognitive aspect, which most typically takes the form of incorporated language elements – the title, in effect, moving into the work – but can also take other forms; both iconography and quotation, for example, are language-like systems of reference which appeal to cognition. Finally, the artwork at the end of the 1980s must have an ethical aspect, also, which may take a forthright and direct identity as, say, in Haacke's work, or a less articulated role as a claimed intention on the part of the artist that the work, however unobviously, is somehow "about" some issue such as ecology, AIDS, feminism, ethnic identity, homelessness, the media, and so on. The 1970s were a molten age; the 1980s have been an age of lava cooling and forms solidifying, and one of the emerging or solidifying forms is this tripartite conception of the artwork, which is in effect across the board at this moment and is likely to last awhile.

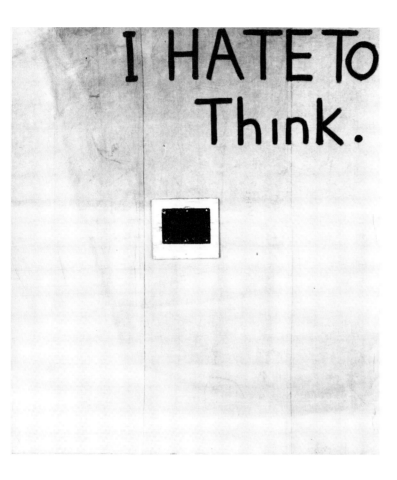

Julian Schnabel, *I Hate to Think* (1988). Collection of the artist. Courtesy of the Pace Gallery.

Schnabel's paintings since the *Recognitions* series have re-introduced imagery and reacknowledged the aesthetic intentions associated with neo-Expressionism; at the same time they involve words painted on the canvas, signifying or acknowledging the cognitive aspect; and increasingly they exhibit ethical concerns as content. In his case the display of ethical concern does not usually focus on a generalized social theme but on a personal emotion that is projected outward as a commentary – part lament and part homage – on the human condition. It often expresses a tragic sense.

Structurally such a painting is not so different from a work of media analysis involving photography and language elements – though differences in their mood or feeling tone may be felt. Both are pictures; both are two-dimensional rectangles hung on a wall at eye level; both use images and design. Both observe the tripartite structure, incorporating seductive elements of design with cognitive elements bearing on current events in some way. And both often involve a

shifting or ricocheting of the artistic energy from one aspect to another, conflating and interpenetrating them kaleido-scopically. The essential difference that is left to activate the dichotomy is simply the difference between the brush and the camera. Aside from that, the works are structurally very much alike. The distinction between expression and analysis seems less than clear at the end of the 1980s. At the beginning of the decade these matters were in flux and the conflict was real. Now things are stabilized around a new concept of the art object, and the conflict is fake.

Another sign of the breakdown of the Kantian theory is the introduction of chance elements into the work, a process which Duchamp began early in the century. Randomness is, in effect, a part of nature, a way we perceive it to work; it signifies unpredictability and inaccessibility to control. Introducing it into the artwork erodes the barrier between nature and culture which, on the Modernist view enunciated by Hegel, is the bulwark of civilization – its way of keeping its head above the ocean of chance. To introduce chance into the project of civilization is to confound it. At the end of the second millennium of perhaps five millennia of civilization, chance shoots through the fabric of things. Nature intrudes. The barrier between nature and culture becomes a joke. What then become of the ideas of humanity and history?

"There is No Place on this Planet More Horrible than a Fox Farm during Pelting Season" is a phrase that arose at random, a found phrase, written in red ink on a ten dollar bill given as change. Perhaps the notation of an animal rights advocate, it seems to criticize the fur industry. For Schnabel, it signifies humanity, and the plague of AIDS. A sadness which derives personally from the multiple deaths of friends from AIDS is projected outward as a lament or dirge for humanity in general at the present social moment. The emphasis on red in these paintings extends the idea of paint as bodily fluid. The amorphous, fucked-up compositions and the sometimes grinding intersections of red and blue distance any light or decorative reading of the works, which seem to invite a sombre, even horrified response.

In a broader cultural context these paintings refer to the fact that the traditional distinction between nature and culture is breaking down (like the parallel distinction between expression and analysis). This is partly because culture has come up with instruments of destruction that dwarf even those natural destructive marvels, the tidal wave, hurricane, earthquake, volcano, and twister. Culture was supposed to

be a force that would protect us from nature, from the cold and the storm and the famine and so on. Now we look helplessly to nature for some cure for culture.

But nature may not be there to give a cure. It has been proposed recently that the natural world is no longer nature, because it has been so altered by cultural interventions that nature is now a part of culture. This distinction also works two ways, for in a sense culture has showed itself to be a marauding force of nature, only superficially disguised as a force separate from and somehow above it. This is the double bind in these paintings.

The fox farm shows nature entrapped and manipulated by culture, and culture sunken into the chaos and randomness of nature.

NOTES

I. INTRODUCTION

1. This idea-system was hiddenly religious: in the idea of Progress lurked a faith in Providence; in the idea of the artist forging onward both prophet and Messiah were hidden; in the idea of the end of History lay the Millennium. The cult of History could be regarded as the last – or anyway a late – form of Christianity – Christianity rephrased for a supposedly secular age.

2. SEEKING THE PRIMAL THROUGH PAINT

1. Pseudo-Longinus, *On the Sublime,* ed. W. Rhys Roberts (New York: Garland, 1987).
2. Presented by Plotinus at *Enneads* 5.8.1.
3. F. W. Schelling, *System of Transcendental Idealism,* VI.3. See Albert Hofstadter and Richard Kuhn, eds., *Philosophies of Art and Beauty, Selected Readings in Aesthetics from Plato to Heidegger* (Chicago: University of Chicago Press, 1976), p. 373.
4. Which Rudolph Otto wrote of in *The Idea of the Holy* (Oxford University Press, 1968).
5. Schelling, *System of Transcendental Idealism;* Hofstadter and Kuhn, *Philosophies of Art and Beauty,* p. 372.
6. James McNeil Whistler, "Ten O Clock Lecture," in *The Gentle Art of Making Enemies* (first ed., New York: John W. Lovell, 1890), p. 155.
7. Cited by R. W. Alston, *Painter's Idiom* (London: 1954), p. 132.
8. P. D. Ouspensky, *A New Model of the Universe* (New York: Random House, 1971), pp. 6–8.
9. Cited in Alston, *Painter's Idiom;* my emphasis.
10. William Seitz, *Claude Monet, Seasons and Moments* (New York: Museum of Modern Art, 1960), pp. 23, 30.
11. From Rene Gimpel's unpublished journal; cited in ibid., p. 4.
12. Cited in *Claude Monet: Letzte Werke,* exh. cat. (Basel: Galerie Beyeler, 1962), p. 6.
13. Ouspensky, *A New Model of the Universe,* pp. 6–8.
14. Cited by Lucy Lippard, "The Silent Art," *Art in America* 55, no. 1 (January–February 1967): 58–63, cited at 59.
15. Kasimir Malevich, "Suprematism," in L. Hilbesheimer, trans., *The*

Non-objective World (Chicago: Theobald, 1959), pp. 66–102, cited at
67.

16. Ibid.
17. Ibid., figs. 79 and 80.
18. Ibid., figs. 87 and 88.
19. For example, Jacques Dupin, who writes: "Through painting Miró
 rediscovers the way all the mystics followed." *Joan Miró, Life and
 Works* (New York: Abrams, 1961), p. 160.
20. As in *Composition Abstract* (1927; Musée d'Art Moderne, Paris).
21. For example, *Dreieckscomposition* (1928; Walrauf-Richartz Museum,
 Cologne).
22. As in *Komposition Nr. 122* (1941), Wallrauf Richartz Museum, Co-
 logne, a green near-monchrome with token Platonism of thinly
 painted blue triangles.
23. As in *Relation de lignes et couleurs* (1939), a white near-monochrome
 with four little squiggles of different colors.
24. As in *Composition-Relief* (1937), a geometrical abstraction in the style
 of Mondrian but almost entirely white.
25. In the Wallrauf-Richartz Museum, Cologne.
26. For Klein's life and work, see Thomas McEvilley, "Yves Klein,
 Conquistador of the Void," in *Yves Klein, A Retrospective* (Houston:
 Institute for the Arts, and New York: The Arts Publisher, 1982).
27. For details, see Maurice Tuchman, ed., *The Spiritual in Art: Abstract
 Painting, 1890–1985* (New York: Abbeville Press for the Los Angeles
 County Museum, 1986).
28. See Thomas McEvilley, "Yves Klein and Rosicrucianism," in *Yves
 Klein, A Retrospective,* pp. 238–55.
29. "Discourse on the Occasion of Tinguely's Exhibition in Duesseldorf,
 January, 1959," trans. Thomas McEvilley, ibid., p. 234.
30. From Yves Klein, "The Monochrome Adventure," ibid., p. 220.
31. Translated as in G. C. C. Chang, *The Hundred Thousand Songs of
 Milarepa* (New Hyde Park, N.Y.: University Books, 1962), pp. 102,
 103, 128, 146, 147.
32. Ibid., p. 147.
33. From "The Monochrome Adventure," in *Yves Klein, A Retrospective,*
 p. 220.
34. Related to the author by Rotraut Klein-Moquay, Klein's widow.
35. Cited by Enrico Crispolti, *Lucio Fontana, catalogue raisonné des pein-
 tures, sculptures et environments spatraux,* 2 vols. (Brussels: Arxiu Lucio
 Fontana-La connaissance, 1974), vol. 1, p. 7.
36. Ibid.
37. Fontana in the 1951 *Manifesto Tecnico,* in ibid., p. 120.
38. Ibid., pp. 123–24.
39. Otto Piene cited in Lawrence Alloway et al., eds., *Zero* (Cambridge,
 Mass.: 1970), p. xxi.
40. Ibid., xx.
41. Ibid.
42. Ibid., p. 14.
43. Ibid.
44. Mack cited in Alloway et al., eds., *Zero,* p. xi, from the exhibition
 catalogue, "Vision in Motion – Motion in Vision" (Antwerp, Hes-
 senhuis: March 1959).
45. All quotations are from Alloway et al., eds., *Zero,* pp. 230–32.

46. Piero Manzoni, "Free Dimension," *Azimuth,* no. 2 (Milan 1960): 46–47.

47. Piero Manzoni, in *Piero Manzoni, Paintings, Reliefs and Objects: Writings by Piero Manzoni,* translated from the Italian by Caroline Tisdall and Angelo Bozzola (London: Tate Gallery Publications, 1974), p. x.

48. For example, *Untitled 1948/49,* Wallrauf-Richartz Museum, Cologne.

49. Irving Sandler, *The Triumph of American Painting* (New York: Harper and Collins, 1970), p. 158.

50. Ibid., pp. 158, 162, 170.

51. Barbara Rose, *Readings in American Art* (New York: Praeger, 1968), p. 142.

52. Clyfford Still, in T. Sharpless, *Clyfford Still* (Philadelphia: Institute of Contemporary Art, University of Pennsylvania: Institute of Contemporary Art, University of Pennsylvania, 1963).

53. Barnett Newman, *Tiger's Eye* 1, no. 6 (1948), 51–53.

54. Barnett Newman, "The First Man Was an Artist," 1947, in Herschel B. Chipp, ed., *Theories of Modern Art: A Sourcebook by Artists and Critics* (Berkeley: University of California, 1968), p. 551.

55. Gershom Scholem, *Major Trends in Jewish Mysticism* (New York: Schocken, 1954).

56. Henry Bowie, *On the Laws of Japanese Painting* (New York: Dover, n.d.), p. 43.

57. Osvald Siren, *The Chinese on the Art of Painting* (New York: Schocken, 1971), pp. 95, 97.

58. Herbert Guenther, *Buddhist Philosophy in Theory and Practice* (Baltimore: Penguin, 1971), p. 21.

59. Translation by Edward Conze, *The Perfection of Wisdom in Eight-Thousand Lines* (Bolinas, Calif.: Four Seasons Foundation, 1973), p. 110.

60. Ad Reinhardt, "Timeless in Asia," *Art News* 58, no. 9 (January 1960): 32–35.

61. *Ad Reinhardt,* exh. cat. (New York: The Jewish Museum, 1966), p. 10.

62. "Twelve Rules for a New Academy," in Barbara Rose, ed., *Art as Art: The Selected Writings of Ad Reinhardt* (New York: Viking, 1975), pp. 203–6.

63. Mark Rothko, "The Romantics Were Prompted," *Possibilities,* no. 1, (Winter 1947–48): 48.

64. Mark Rothko to Harold Rosenberg, *The Dedefinition of Art* (New York: Collier Books, 1973).

65. Mark Rothko to Dore Ashton, as related to the author in a conversation.

66. From a statement written and signed by filmmaker John Huston in Houston, Texas, April 9, 1977; Rothko Chapel Archives.

67. Rosenberg, *The Dedefinition of Art,* pp. 100–8.

68. Sandler, *Triumph of American Painting,* pp. 175, 183.

69. Brian O'Doherty, *American Masters* (New York: Dutton, n.d.), pp. 154, 155, 156, 157, 165, 166.

70. Robert Motherwell, "What Abstract Art Means to Me," *Museum of Modern Art Bulletin* (Spring 1951), reprinted in Frank O'Hara, *Robert Motherwell* (New York: Museum of Modern Art, 1965), p. 45.

71. Robert Motherwell, "A Tour of the Sublime," *Tiger's Eye* (December 15, 1948), reprinted in ibid., p. 45.

72. Ibid., pp. 41, 42.

73. Mark Rothko, cited in Rosenberg, *The Dedefinition of Art.*

74. Robert Rauschenberg, cited by Lawrence Alloway, *Robert Rauschenberg,* exh. cat. (Washington, D.C.: Smithsonian Institution, 1976), p. 3.

75. Ibid.

76. Brice Marden, in ibid.

77. Bob Law, *7Aus London,* exh. cat. (Bern: Kunsthalle, 1973), n.p.

3. THE OPPOSITE OF EMPTINESS

1. Dusty Sklar, *The Nazis and the Occult* (New York: Dorset, 1989); James Webb, *The Occult Establishment* (LaSalle, Ill.: Open Court, 1991).

2. Clement Greenberg, *Art and Culture: Critical Essays* (Boston: Beacon Press), p. 7.

4. *GREY GEESE DESCENDING*

1. Quoted in Lawrence Alloway, "Agnes Martin," *Agnes Martin,* exh. cat., Philadelphia Institute of Contemporary Art, 1979, p. 9.

2. Identifiable as cat. no. 3 in *Agnes Martin,* exh. cat., Munich: Kunstraum, 1973.

3. Identifiable as cat. no. 17 in ibid.

4. Identifiable as cat. no. 19 in ibid.

5. Identifiable as cat. no. 4 in ibid.

6. Agnes Martin, "The Untroubled Mind," *Agnes Martin* (Philadelphia), p. 20.

7. Quoted in Thomas Hess, *Barnett Newman,* New York: Walker and Company, 1969, p. 37.

8. Martin, notes for "On the Perfection Underlying Life," a lecture delivered in 1973. The notes are in the archives of the Institute of Contemporary Art, University of Pennsylvania, Philadelphia. This and all quotations from archive materials are courtesy of the ICA. Some of the notes are published in the Munich and Philadelphia catalogues. The Munich catalogue, incidentally, reprints from the ICA archive a text entitled "A Personal Statement," issued by the Betty Parsons Gallery in 1958 and attributed to Martin. Martin, however, says that she did not write it and that it does not express her point of view.

9. See Hess, *Barnett Newman,* exh. cat., New York: Museum of Modern Art, 1971, p. 111 and elsewhere.

10. See Arthur Waley, *The Way and Its Power,* New York: Grove Press, Inc., 1958, p. 166.

11. See ibid., pp. 178 and 183.

12. In an interview of Martin by Kate Horsfield, in "On Art and Artists: Agnes Martin," *Profile* 1 no. 2, Chicago: Video Data Bank/School of the Art Institute of Chicago, March 1981.

13. From a telephone conversation with the author, April 1987.

14. Ibid.

15. Martin, "The Still and Silent in Art," note dated 1972 in the ICA archives.

16. Martin, notes for "What Is Real," a lecture delivered in 1976. The notes are in the ICA archives.

17. Martin, untitled notes dated 1972 in the ICA archives.

18. Ibid.

19. Ibid.

20. Martin, "What Is Real."

21. Martin, untitled notes dated 1972 in the ICA archives.

22. Ibid.

23. Martin, "On the Perfection Underlying Life."

24. Martin, untitled notes dated 1972 in the ICA archives.

25. Martin, "On the Perfection Underlying Life."

26. Ibid.

27. Ibid.

28. *The Complete Works of Chuang Tzu,* trans. Burton Watson, New York and London: Columbia University Press, 1968, chapter 1.

29. Martin, "On the Perfection Underlying Life."

30. Martin, untitled notes dated 1972 in ICA archives.

31. Ibid.

5. ABSENCE MADE VISIBLE

1. See, for example, Yve-Alain Bois, "Surprise and Equanimity," *Robert Ryman: New Paintings,* exh. cat., New York: Pace Gallery, 1990, n.p.

2. Kenneth Baker, "Ryman Art Opens New Work Series," *San Francisco Chronicle,* 29 January 1988, p. E3.

3. For example, Bois, in "Surprise and Equanimity."

4. Quoted in the past and confirmed in a conversation with the author, 28 February 1992, New York.

5. Thomas McEvilley, "Heads It's Form, Tails It's Not Content," *Artforum* XXI no. 3, November 1982, pp. 50–61. Republished in McEvilley, *Art and Discontent: Theory at the Millennium,* Kingston, N.Y.: McPherson and Company, 1991, pp. 23–62.

6. See, for example, Michael Fried, "Art and Objecthood," *Artforum* V no. 10, June 1967, pp. 12–23.

7. Robert Ryman, speech delivered at the Dannheiser Foundation, New York, on 9 January 1991, for the Solomon R. Guggenheim Museum's "Salon" series. The Pace Gallery, New York, provided me with a typescript of the text.

8. Piet Mondrian, "Neoplasticism in Painting," 1917, in Hans L. C. Jaffe, ed., *De Stijl,* New York: Harry N. Abrams, 1971, p. 76.

9. Ryman, quoted in Grace Glueck, "The 20th-Century Artists Most Admired by Other Artists," *Artnews* 77 no. 6, November 1977, p. 100.

10. Piero Manzoni, 1960, quoted in Marcia Hafif, "True Colors," *Art in America* 77 no. 6, June 1989, p. 135.

11. Other terms have also been used for this approach, including "Radical Painting" and, in reference to Ryman specifically, "plain painting." The latter term may have been as coined by Robert Storr, in

his "Robert Ryman: Making Distinctions," in Christel Sauer and Urs Raussmüller, eds., *Robert Ryman,* exh. cat., Paris: Espace d'Art Contemporain, 1991, p. 41.

12. See Hafif, pp. 138, 139.
13. Rini Dippel, quoted in Hafif, p. 139.
14. Conversation with the author.
15. See Hafif, p. 133.
16. Quoted in ibid., p. 135.
17. Storr, p. 37.
18. Kuspit, "Red Desert and Arctic Dreams," *Art in America* 77 no. 4, March 1989, pp. 120–25; and Dan Cameron, "Robert Ryman: Ode to a Clean Slate," *Flash Art* 24 no. 159, Summer 1991, p. 93.
19. See Karl H. Potter, ed., *Encyclopedia of Indian Philosophies, Indian Metaphysics and Epistemology: The Tradition of Nyaya Vaiśeśika up to Gangeśa,* Princeton: at the University Press, 1977, pp. 143–47.
20. In Phyllis Tuchman, "Interview with Robert Ryman," *Artforum* IX no. 9, May 1971. Reprinted in Gary Garrels, *Robert Ryman,* New York: Dia Art Foundation, 1988, p. 22.
21. Cameron, p. 91.
22. Kuspit, p. 121.
23. Conversation with the author.
24. *New York Post,* 28 February 1992, p. 10.
25. Meyer Raphael Rubinstein and Daniel Wiener, "Robert Ryman, Dia Art Foundation," *Flash Art* no. 144, January/February 1989, p. 121.
26. Cameron, p. 91.
27. Vernon Watkins, *Unity of the Stream: Selected Poems,* Reading, Conn.: Black Swan Books, 1978, p. 20.
28. *The Egyptian Book of the Dead: The Papyrus of Ani,* trans. E. A. Wallis Budge, New York: Dover Publications, 1967, pp. 288–91 and elsewhere.
29. *The Tibetan Book of the Dead,* trans. W. Y. Evans-Wentz, London and New York: Oxford University Press, 1960, pp. 109–10.
30. The ample evidence of Greco-Roman authors describing Egyptians is that they were in general darker than Greeks but lighter than Ethiopians – that, in other words, they were in antiquity pigmented much as they are today. See, for example, Frank M. Snowden, Jr., *Before Color Prejudice: The Ancient View of Blacks,* Cambridge, Mass., and London: Harvard University Press, 1983.

8. THE WORK OF "GEORG BASELITZ"?

1. In conversation with the author, August 20, 1990, with Mathias Rastorfer acting as interpreter.
2. This doctrine is ultimately Platonic, expressed most clearly in a little regarded passage of Plato's *Philebus* (51 c).
3. For a more detailed exposition and critique of formalism, see McEvilley, "Heads It's Form, Tails It's Not Content," *Artforum,* November 1982.
4. For more on this development, see McEvilley, "Read This," in *Julian Schnabel,* exh. cat. (New York: The Pace Gallery, 1989), reprinted as Chapter 14, this volume.
5. The last-quoted phrase could have been uttered by Clement Green-

berg himself in 1947, but it was in fact written by Rudi Fuchs in 1990. See *Georg Baselitz*, exh. cat. (Madrid: Fundación Caja de Pensiones, 1990), page 20.

6. Andreas Franzke, *Georg Baselitz* (Munich: Prestel Verlag, 1989), pages 7–8.

7. Ibid., pages 12 and 92.

8. Eric Darragon, *Parkett*, number 11, 1986, page 58.

9. Ibid., page 40.

10. Greenbergians in general tried to collapse the content question into form. See McEvilley, "Heads It's Form, Tails It's Not Content."

11. Georg Baselitz, *Vier Wände und Oberlicht oder besser kein Bild an der Wand*.

12. Darragon, page 46.

13. Ibid.

14. Ibid., page 58.

15. Franzke, page 112.

16. In this year, Greenberg's "Lament of an Art Critic" was published in *Artforum*.

17. It would be more accurate to refer to it as anti-Modernism than post-Modernism. Cf. Frederick Jameson: ". . . there will be as many different forms of postmodernism as there were high modernisms in place, since the former are at least initially specific and local reactions against those models." In "Post-modernism and the Consumer Society," in Hal Foster, ed., *The Anti-Aesthetic: Essays on Postmodern Culture* (Port Townsend, Washington: Bay Press, 1983), pages 111–12.

18. In conversation with the author, August 20, 1990, with Mathias Rastorfer acting as interpreter.

19. Ibid.

20. Ibid.

21. Ibid. Jurgen Harten spoke to me, in Jerusalem on September 4, 1990, of his belief that the eagle image in Baselitz is related to the use of this image by the nineteenth-century German realist painter Menzel. This type of relationship in Baselitz's work remains to be fully investigated. It is interesting, as pointed out to me by Harten on that occasion, that Marcel Broodthaers neglected to include a Baselitz eagle in his "eagle exhibition," perhaps because of the specific political and historical associations just mentioned.

22. Darragon, pages 44–47.

23. In conversation with the author, August 21, 1990, with Mathias Rastorfer acting as interpreter.

24. As a youth Baselitz applied to the local school of forestry.

25. The *Orange Eaters* (1980–81), for example, and the portrayals of figures drinking from glasses suggest communion rites.

26. Darragon, page 40.

27. All this may be implied by the difficult relationship between two statements in Baselitz's manifesto, *Vier Wände und Oberlicht oder besser kein Bild an der Wand:* "The picture has nothing in common with the wall it hangs on" and "It is better to have no picture at all on the wall."

28. This distinction harks back to the formalist rejection of "subject matter" – implying a specific named content, as in representation of this or that – along with the general attempt to infuse the painting

with a feeling of vast universality, tragic in terms of the individual self but liberating and salvific in terms of its universality.

29. In conversation with the author, August 21, 1990, with Mathias Rastorfer acting as interpreter.

30. Ibid.

31. This was mentioned to me by Jurgen Harten on September 4, 1990.

32. The pictorial format has been described as "childishly simple . . . a head at the center of each panel." Kay Heymer, "Georg Baselitz," *Flash Art,* May/June 1990, page 149.

33. In conversation with the author, August 21, 1990, with Mathias Rastorfer acting as interpreter.

34. "Works of art have an existence independent of their setting, and of the act of viewing them: They exist by virtue of their own inherent quality and the artist's intention . . ." *Vier Wände und Oberlicht oder besser kein Bild an der Wand.*

9. CARLO MARIA MARIANI'S DIALOGUE
WITH HISTORY

1. The Hegelian, or so-called analytic, art historians, such as Heinrich Wölfflin, are the authoritative sources of these ideas.

2. Donald Kuspit, in *Carlo Maria Mariani: Italia Biennale di Venezia 1990* (exhib. cat., Milan: Studio d'Arte Cannaviello, 1990), n.p.

3. Robert Rosenblum, in *Andy Warhol: A Retrospective,* ed. Kynaston McShine (New York: Museum of Modern Art, 1989), p. 25.

4. The layer on top of classical Greek art is Hellenistic or later Greek art, the art of the Alexandrian period when the *polis,* or Greek cultural state, had been violently terminated and a nostalgic craze arose for copies and imitations of classical works, both in literature and in the visual arts. That period already deserves the title "neoclassical" (though that term is not usually applied to it). The same is true of the third layer, that of Roman art, which was also a neoclassicism (though not called such), consisting primarily of works made in direct imitation of classical Greek works or in a more generalized imitation of their styles.

5. In addition, Mariani's works seem in part to parallel Ficinian allegory, with its fixation on Plato's conception, in the *Symposium,* of the celestial and terrestrial Aphrodites.

6. It was the beginning, at least, of the articulation of Euro-Modernism. For the idea that there have been other earlier Modernist periods see Thomas McEvilley, "Histoire de l'Art ou Histoire Sainte?" *Cahiers du Centre Pompidou,* 1987, republished in English as "Art History or Sacred History," in Thomas McEvilley, *Art and Discontent* (Kingston, N.Y.: McPherson, 1991).

7. These ideas were powerfully articulated by Edmund Burke in his seminal book *Inquiry into the Origin of Our Ideas of the Sublime and the Beautiful* (1757), which fixed the concepts in more or less the form in which Kant passed them on in his *Critique of Judgment* (1790). It was Kant's text that Mariani was influenced by.

8. The overtowering dark thickets looming behind the tiny human festivities in Fragonard's landscapes, the devouring ground of the sea taking down all figures in Turner's late seascapes, the vastness of Caspar David Friedrich's mountain and seashore vistas, are examples

217

of the sublime as a landscape theme. In the twentieth century the sublime has been primarily an abstract theme born in Malevich's *Black Square* (if its date of 1913 is correct) and culminating in the passionate phase of monochrome painting in the decade or two following the Second World War. For more on the latter phase, see Chapter 2, this volume.

9. In the Hellenistic period the sublime began to be separated from the beautiful, as is testified in *On the Sublime,* written in the first century A.D. by the Greek critic known as Longinus. Longinus said, for example, that in a sublime picture the whole world might be being torn apart.

10. The paradigm is Goethe's Young Werther, who in effect fell in love with the sublime and killed himself ecstatically.

11. Quoted in Michael Kohn, *Paradise Regained* (exhib. cat., Los Angeles: Michael Kohn Gallery, 1988), p. 2.

12. Mariani believes that in erasing the moustache from Mona Lisa in 1965 Duchamp was realizing the tragic mistake of *LHOOQ* and symbolically retracting it.

13. Mariani, like Rothko, plays music in his studio while he works, and it is generally music in the sacred tradition of European culture, from Orlando di Lasso to Gesualdo, Palestrina, and Bach. While out of the studio, however, especially while driving his car, he might play Pink Floyd and Jimi Hendrix.

10. PAT STEIR AND THE CONFRONTATION WITH HISTORY

1. Magritte is an artist whom Steir is not aware of being influenced by, but whose example was prominently in the air at the time. As painting, in the wake of color field abstraction, was feeling its way back toward forms of representation, Magritte provided an avenue of approach that avoided the sense of naïveté that representation brings with it after a long period of abstraction. In America Jasper Johns, Robert Rauschenberg, Arakawa, and others had lately incorporated some of the areas which had been colonized for art by Magritte, such as the interplay between linguistic and pictorial elements. In Steir's hands in 1969 the reference was not so much to Magritte himself as to the recent reappearance in the tradition of themes similar to those that had preoccupied him.

2. See Chapter 4, this volume.

3. The title is based on lines from T. S. Eliot's *Four Quartets,* which imply the reverse – "The way away from New Jersey," Steir's birth state – as she invokes, then denies, a variety of sentimental nuances.

4. It is worth mentioning in this connection Steir's early experiences with philosophy, in which both the world-constructing rationalism of Leibniz and the critical subversions of Voltaire left lasting influences. Her flower shows something of a Leibnizian affirmation of the full possibility, or indeed necessity, of form in ontology, while the X or cancellation represents the ever-present Voltairean skeptic in her personality and her work – her "capacity . . . to *deny,"* as one critic put it.

5. See Thomas McEvilley, "Sapphic Imagery and Fragment 96," *Hermes* 101 (1973).

6. Two smaller versions of this work exist, both of which were sketches for the large one; in each of these the Brueghel painting was divided into 16 (4 × 4) rectangles; in one it was repainted in sepia tone, in the other a pale green.

7. With panels referring to the styles of Piet Mondrian, Sandro Botticelli, Max Ernst, Franz Kline, Ad Reinhardt, Sol LeWitt, Ellsworth Kelly, Marsden Hartley, Pablo Picasso, Albert Pinkham Ryder, Jean-Baptiste Chardin, Antoine Watteau, Jackson Pollock, James A. M. Whistler, Arthur Dove, Alexei von Jawlensky, Paul Cézanne, Henri Matisse, Richard Diebenkorn, Cy Twombly, Clyfford Still, Odilon Redon, Georgia O'Keeffe, J. A. D. Ingres, Vittore Carpaccio, Hans Hofmann, Kazimir Malevich, Arshile Gorky, Philip Guston, Max Beckmann, Edgar Degas, Willem de Kooning, Claude Monet, Georg Baselitz, Gustave Courbet, Edouard Manet, Vincent Van Gogh, Pat Steir, Mark Rothko, J. M. W. Turner, Rembrandt van Rijn, Vassily Kandinsky, Brice Marden, Paul Gauguin, Jacques-Louis David, Terry Winters, Jean-Michel Basquiat, and tendencies associated with various periods or groups.

8. *Pat Steir, The Brueghel Series (A Vanitas of Style)*, exh. cat. (Minneapolis College of Art and Design, 1985), p. 8.

9. Some texts which Steir consulted are gathered in Osvald Siren, *The Chinese on the Art of Painting* (New York: Schocken, 1963). See also Mai-mai Sze, *The Way of Chinese Painting* (New York: Random House, Vintage Books), 1959.

10. Tyeb Mehta, an Indian artist of the generation of the Bombay Progressives, referred to the first Indian approach to Modernist abstraction when he said, "It took courage, at that time, to pick up a brush, to make a mark on a canvas" – that is, a mark that was undetermined by tradition, a primal demonstration of an individual sensibility expressing itself at will.

11. This technique echoes Conceptual pieces from 1966 in which William Anastasi threw a gallon of paint at a wall, exhibiting the resulting mark, but with a different mood and purpose. Steir's use of the method does not involve the deconstruction of painting as a mode so much as its reinvigoration.

12. Jürgen Habermas, "Modernity – An Unfinished Project," speech given in September 1980, upon accepting the Adorno Prize.

11. FLOWER POWER

1. For more on this view of Beuys' trajectory, see Thomas McEvilley, "Hic jacet Beuys," *Artforum* 25 (May 1986): 130–31, and "Was hat der Hase gesagt? Fragen über, für, und von Joseph Beuys," in Heiner Bastian, ed., *Joseph Beuys, Skulpturen und Objekte* (Schirmer/Mosel, Munich, 1988), pp. 30–35, reprinted in *Suddeutsche Zeitung* (February 21, 1988): 147.

2. For further interesting suggestions on interpreting this image, see Barbara Reise, "Who, What is Sigmar Polke?" Part IV, *Studio International* (January–February 1977): 40.

3. See *Sigmar Polke Fotografien*, exh. cat. (Staatliche Kunsthalle Baden-Baden, Edition Cantz, Stuttgart, 1990).

4. For example, John Caldwell, *Sigmar Polke*, exh. cat. (San Francisco Museum of Modern Art, 1990), p. 12.

1. Leon Golub, quoted in an unpublished interview with Bruce Hooten, 1965, p. 4.

2. Hilton Kramer, in the movie *Painters Painting: The New York Art Scene, 1940–1970,* dir. Emile de Antonio, Turin Film Corporation, 1972 (Mystic Fire Video, 1989).

3. The best discussion of this group and their work is in Irving Sandler, "Interview: Leon Golub Talks with Irving Sandler," *Archives of American Art,* New York (1978).

4. Golub, quoted in Gerald Marzorati, *A Painter of Darkness: Leon Golub and Our Times* (New York: Viking, 1990), p. 165.

5. Hooten, Interview, p. 6.

6. Marzorati, *Painter of Darkness,* p. 165.

7. Ibid.

8. Leon Golub, "A Law unto Himself," in *Exhibition Momentum,* exh. cat., Chicago, 1950.

9. Marzorati, *Painter of Darkness,* p. 165.

10. Leon Golub, Unpublished statement beginning "Buchenwald and Elugelab," 1954.

11. Much of this material is collected in Francis Frascina, ed., *Pollock and After: The Critical Debate* (New York: Harper & Row, Icon Editions), 1985.

12. Edward Said, "The Text, the World, the Critic," in Josue V. Harari, ed., *Textual Strategies: Perspectives in Post-Structuralist Criticism* (Ithaca, N.Y.: Cornell University Press, 1979), p. 171.

13. Sandler, "Interview," p. 16.

14. Lean Golub, "A Critique of Abstract Expressionism," *The Art Journal* 14 no. 2 (Winter 1955): 142–7.

15. Marzorati, *Painter of Darkness,* p. 167.

16. Golub's *Charnel House* refers in part to Picasso's 1946 picture of the same title. Picasso connected his *Charnel House,* portraying stacked bodies, with the first published photographs from Dachau – but the painting had in fact been nearly completed before those pictures appeared. (Marzorati, *Painter of Darkness,* noticed this too.) It is possible, in other words, that Golub confronted this subject matter in his work before any prominent European artist had done so.

17. It was exhibited at the Arts Club there Oct. 2–10.

18. Leon Golub, "Interview with Ann Stubbs," *Fire in the Lake* 1, no. 4 (July–August 1976).

19. Including Rauschenberg's early assemblages, Bruce Conner's fetish objects, and much more.

20. Stubbs, "Interview," p. 5.

21. See, e.g., Donald Kuspit, *Leon Golub, Existential/Activist Painter* (New Brunswick, N.J.: Rutgers University Press, 1985), pp. 41–9.

22. Unpublished 1956 statement of the artist.

23. Hooten, Interview, p. 8.

24. Golub thought of the truncated limbs of *Damaged Man* as semaphore devices sending a distress signal.

25. Hooten, Interview, p. 4.

26. Ibid., p. 7.

27. This point was made by Kuspit in *Leon Golub,* p. 37.

28. Leon Golub, artist's statement, in *Leon Golub – New Paintings* (New York: Allan Frumkin Gallery, 1963).

29. Golub lays down several layers of color, then applies solvent and scrapes the canvas. For a while in 1961 he experimented with laying two partially dried canvases on one another until they bonded, then tearing them apart. The tortured, scraped, eroded surface, artificially aged or antiqued on the one hand, is ripped raw and laid newly bare on the other, like fresh flesh. In the earlier works, made with lacquer, he would sometimes apply as many as ten layers; in the acrylic paintings usually only two or three, occasionally four or five.
30. Golub, in *Leon Golub – New Paintings*.
31. Leon Golub, quoted in Humphrey Wanjihia Oguda, "An American Artist at Work: Leon Golub," *Presence* (Nairobi, Kenya) (September–October 1988).
32. Kate Horsfield and Lyn Blumenthal, "On Art and Artists: Leon Golub" (interview), *Profile* 2, no. 2 (March 1982): 5–23, cited at 9.
33. Speaking generally, in terms of the ancient motif, the male sphinx is Egyptian, the female Greek. Golub's sphinx is rooted in the Greek tradition rather than the Egyptian, but is nevertheless always male.
34. Hooten, Interview, p. 4.
35. Sandler, "Interview," p. 68.
36. Golub, *Leon Golub – New Paintings*.
37. Ibid.
38. Michael Newman, Interview with Leon Golub, in *Leon Golub: Mercenaries and Interrogations,* exh. cat. (London: The Institute of Contemporary Art, 1982), p. 4.
39. Hooten, Interview, p. 9.
40. Newman, Interview, p. 4.
41. Hooten, Interview, p. 4.
42. Leon Golub, unpublished manuscript, 1984.
43. Newman, Interview, p. 5.
44. Ibid.
45. The works were made unstretched, first affixed to the wall with pushpins and later through grommets. At the suggestion of a dealer, Golub stretched them to make them less susceptible to theft from the gallery.
46. Newman, Interview, p. 5.
47. Scott Burton gave Golub a copy of this publication, and Golub then subscribed for one year.
48. Hooten, Interview, p. 3.
49. Interview with Leon Golub, *Pataphysics* (Melbourne, 1990).
50. Ibid.
51. Newman, Interview, p. 4.
52. Donald Kuspit, "Crowding the Pictures: Notes on American Activist Art Today," *Artforum* 26 (May 1988): 111–17, cited at 117, observed that the large scale tends to heroize or mythologize the figures.
53. Newman, Interview, p. 7, questioned the seemingly transcendentalizing gesture of "painting them . . . out of context, on an abstract field."
54. Ibid., p. 9.
55. In de Antonio, *Painters Painting*.

56. Carter Ratcliff noticed this in "Theater of Power," *Art in America* 72, no. 1 (January 1984): 74–82, cited at 76. "Their heavy red backgrounds are scaled-up New York School color fields."

57. Newman, Interview, p. 5.

58. This has been remarked on before. See, e.g., Jon Bird, "Leon Golub: 'Fragments of Public Vision,' " in *Leon Golub: Mercenaries and Interrogations,* p. 17.

59. Golub has remarked that we are looking at them and they at us as if their photograph were being taken and we were either the photographers or onlookers. Something of the gaze of the figures at the hypothetical painter in Velazquez's *Las Meninas* is echoed.

60. Newman, Interview, p. 7.

61. *Pataphysics.*

62. Thomas Lawson, "Leon Golub," *Artforum* 31 (February 1983): 73.

63. Bird, "Leon Golub," p. 15.

64. Which represents the stance from which the gods on Olympus watched the Trojan War in Homer's *Iliad.*

65. "Leon Golub: Interview," *Arts Magazine* 55, no. 9 (May 1981): 167–76, cited at 169.

66. Newman, Interview, p. 9.

67. Ibid., p. 5.

68. Linda Nochlin, *Realism* (New York: Penguin, 1971), p. 46.

69. Ibid.

70. At least two hostile critics have compared Golub's imagery to advertising (Peter Fuller, "The Avant-Garde Again," *Art and Design* 3 [1987]: 21–7, cited at 22, Jed Perls, "Golub's Message," *The New Criterion* 4, no. 7 [March 1986]: 45–52, cited at 52). It does of course use media imagery and sometimes billboard-like size, but clearly its goals are opposed to those of advertising images.

71. Nochlin, *Realism,* p. 31.

72. Paul Valery cited in ibid., p. 45.

73. Paul Signac cited in ibid., p. 50.

74. Leon Golub cited in Fuller, "Avant-Garde Again," p. 22.

75. Max Beckmann cited in Wolf-Dieter Dube, *The Expressionists* (London: Thames & Hudson, 1972), p. 161.

76. Sandler, "Interview," p. 181.

77. Barnett Newman, in de Antonio, *Painters Painting.*

78. Nowadays it would be felt that the white skin presumed by Greek sculpture was itself a *differens;* but in another sense the stone surfaces from which the paint has long ago worn off may be viewed as neutral or indefinite in terms of skin color.

79. Newman, Interview, p. 6.

80. Ibid., p. 7.

81. Ibid., p. 6.

82. Hooten, Interview, p. 5.

83. See Sir Karl Popper, *The Open Society and Its Enemies: Volume 1: The Spell of Plato* (Princeton, N.J.: Princeton University Press, 1962).

84. In fact, the odd situation that a theory of art became a standard part of what was expected of a philosopher, from Aristotle to Hume to Kant to Hegel to Heidegger to Foucault and Baudrillard, derives from Plato's elevation of the topic to a metaphysical issue.

85. This derives both from the *Phaedrus* and from *Philebus* 51c, where Socrates is represented as saying that, although pleasures in general

are bad for the soul, pleasures such as contemplating the difference between a straight and a curved line are not harmful – i.e., the pleasure of abstract art, which relates to the pure geometric forms.

86. Horsfield and Blumenthal, "On Art and Artists," p. 13. Compare Golub's remarks about Picasso's *Guernica* in "Guernica as Art History, II," an unpublished manuscript of around 1968: "Rhetorically, *Guernica* might be interpreted as a vehicle for disseminating 'news', a painterly equivalent of a newspaper."

INDEX

225